A Century of Color in Design

A Century of Color in Design

David Harrison

250 innovative objects and
the stories behind them

Introduction 6

1920—50—60—70—80—

10 38 68 114 136

Josef & Anni Albers 32 Verner Panton 108
Alexander Girard 62 Alessandro Mendini 130

Notes 304 Image Credits 312
Bibliography 306 Acknowledgments 318
Index 307

—90——2000——10——20

152 169 230 303

Hella Jongerius 170 Scholten & Baijings 222
Doshi Levien 200 Bethan Laura Wood 262

Introduction

Writing a book and making selections that cover a century of furniture, lighting and other interior design objects is an enormous and somewhat daunting task. Thankfully, applying the filter of color enabled a refinement of the process to only those objects in which color is integral both to their story and to their design success.

It's interesting just how little importance was given to the application or integration of color into domestic objects prior to World War I. While color in rugs, artworks and upholstery have always been part of even the most modest interior, until relatively recently, furniture remained largely made of natural timber. It took a concerted push by forward-thinking designers, developments in industrial processes and consumer demand to change all that.

The Bauhaus movement that began in 1919 proposed a new modern aesthetic where art and industry worked together to deliver highly functional objects, but despite an emphasis on color theory its application in architecture and objects remained relatively rare. It was the De Stijl movement of the same period that kickstarted the use of primary colors. But between the two rival doctrines, a new era that embraced form and function gained traction, and color in designed objects became part of the changing landscape.

By the late 30s and early 40s, color was starting to pervade the everyday lives of millions of people, as can be seen by the phenomenal take-up in the U.S. of the American Modern range of tableware by Russel Wright (page 21), which would sell more than 250 million units during its twenty years of production. In Britain in 1935, Herbert Terry & Sons, manufacturers of the already successful industrially inspired Anglepoise light

(page 20), decided that the addition of color might help the product break into the domestic market. A revamp of their Model 1227 design saw it produced in red, blue, green and yellow to great success.

Color really came into its own after World War II with a plethora of new plastics, such as melamine, ABS, polycarbonate and polypropylene, becoming readily available to manufacturers. A growing thirst for products appropriate for an increasingly mechanized lifestyle led to radical new approaches to design. Italy turned itself around from vanquished state to industrial powerhouse, pumping out cars, motor scooters, clothing and footwear alongside a new, innovative style of furniture and lighting. If the Bauhaus was obsessed with grids and cubes, postwar Italian designers were captivated by more expressive shapes, choosing bright colors to accentuate their sculptural forms. Red in particular was often used to dramatic effect, as was the case with Marco Zanuso's revolutionary Antropus armchair, designed in 1948 (page 30), and his glamorous Lady armchair a couple of years later (page 47).

By the 60s, freedom of choice, experimentation and confidence in new synthetic materials were at a peak. This era embraced color and pattern in clothing in a major way, and interiors were not far behind. There was an explosion in the development of brightly colored plastic chairs, tables, lights and other accessories for the home, which continued throughout the 70s and into the early 80s, culminating in the Memphis movement, in which color and pattern were purposefully taken to excess.

The steady growth of interest in color slowed in the mid-80s and 90s when, as a reaction to the extremes of the previous decade, minimalism became the predominant style across both fashion

and interiors. Products designed in this period were generally fine in form, visually clean and often monochromatic, or else in that catch-all color between beige and gray—"greige."

Since the turn of the 21st century, the use of color in interior products has found a return to form that started slowly and has gained such momentum that the choice of color for an object is now discussed early in the design process rather than as an afterthought. Designers are having their say, choosing, and sometimes creating, their own palette, with ever-increasing complexity, while colors are also constantly updated to keep in tune with global trends.

In fact, color has become such a key element in contemporary design that progressive Swiss furniture company Vitra appointed Dutch designer Hella Jongerius (page 170) as art director for colors and materials in 2007. In the process of creating the Vitra Color & Material Library, she has highlighted the benefit that designed objects receive from a carefully considered application of complex colors.

It is designers like Jongerius, who have a deep understanding of color, and interior items that address color in innovative ways, which are the focus of the following pages. This book doesn't claim to be a definitive treatise on 20th- and early 21st-century design—rather the aim is to offer a series of snapshots that explore the changing use of color in interiors over the past century. From the subtle accent to the flamboyant statement, the dynamism and energy that result when color marries with design are undeniable.

It remains to be seen how long we can sustain the obsession with colorful objects in our homes before saturation occurs and we again seek sanctuary in the simple, calm and unadorned. For now, however, we are riding a high that can feasibly be traced back 100 years, when Bauhaus director Walter Gropius created cut-away, cube-shaped chairs with dense yellow upholstery and installed them in his own office surrounded by dark red cabinets, and De Stijl convert Gerrit Rietveld decided to apply sheets of red and blue to a once plain wooden chair.

A NOTE ABOUT DATES

This book lists objects under their date of design rather than the more common date of their first manufacture. The reason is that design is a creative endeavor and as such there are times when a designer's creativity is beyond the realms of manufacturing possibilities or opportunity. Joe Colombo's Model 4801 armchair (page 76) for Kartell was conceived in 1963–64 to be made in plastic but the manufacturer was forced to use plywood instead, due to the limitations of plastic technologies, until fifty years later when the chair was re-editioned in thermoplastic. Colombo, as ever, was way ahead of his time, pushing the boundaries of what was possible.

Equally, designs can be perceived as too progressive for the consumer. Achille and Pier Giacomo Castiglioni's Sella stool (page 55), designed in 1957, was not produced until 1983. To list it under its production date would mean the sheer audacity of the design, given the era in which it was created, would be lost.

Every effort has gone into ensuring that the design dates are correct. Where records are not available and the designer is no longer practising or has passed away, *circa* (*c.*) is used to indicate that the object was designed on a date close to that listed.

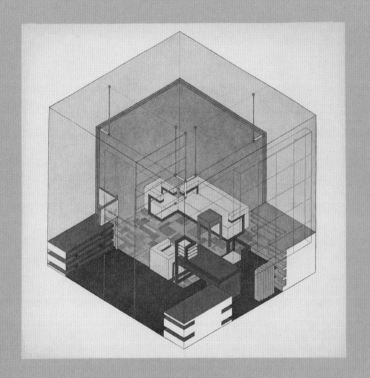

ISOMETRIC PERSPECTIVE DRAWING OF WALTER GROPIUS'S OFFICE
AT THE WEIMAR BAUHAUS, 1923. DESIGN BY WALTER GROPIUS,
DRAWING BY HERBERT BAYER.

F51 ARMCHAIR

Walter Gropius

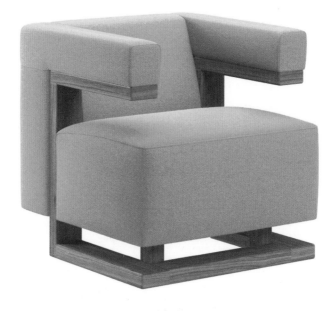

1920

This radical chair, a 70-centimetre cube, was designed for Bauhaus director Gropius's own office, a 5-metre cube. Upholstered in yellow wool, it sat on a blue and yellow geometric rug by Bauhaus weaving student Gertrud Arndt. The timber framework forms a rigidly geometric 'C' in profile – two posts supporting the seat prevent it from being the first cantilever chair, but it probably inspired Mart Stam's 1926 S33 chair. Presented at the 1923 Bauhaus exhibition, it was never serially produced but since 1986 has been manufactured to original dimensions and in different colours by Tecta.

BAUHAUS CRADLE

Peter Keler

Inspired by the colour theory of abstract artist Wassily Kandinsky, in which colours were assigned geometric forms (red a square, yellow a triangle and blue a circle), Keler managed to cram all three into one object. Made from lacquered timber and metal, with woven cane side panels, the cradle has a cylindrical weight in black at its base to lower its centre of gravity. Designed for the 1923 Bauhaus exhibition, the cradle went into production through German manufacturer Tecta in 1975 and now comes in two sizes – the original plus a much smaller version developed for use as a magazine holder.

1922

RED AND BLUE (635) CHAIR

Gerrit Rietveld

 1918-23

While we can now only imagine the chair in block colour, it was originally presented in plain wood and, in 1921, painted white. The Dutch architect's angular construction is commonly known today as the Red and Blue Chair, after a 1923 version in the bright colours of the De Stijl movement.

The name is even more misleading as that version is, in fact, predominantly stained black, with yellow paintwork on the ends of its timber battens, a red lacquered back and a blue lacquered seat. The De Stijl configuration came about after Rietveld joined the Dutch art movement. Like other members of this group, Rietveld began using blocks of colour both on his furniture designs and his architecture, the most famous of which is the Schröder House, built in his home town of Utrecht in 1924.

One major philosophy of De Stijl artists was to reduce all two- and three-dimensional works to a horizontal and vertical geometric arrangement, with the colour palette consisting of only red, yellow, blue, black and white.

As a furniture piece, the Red and Blue Chair with its strict form and lack of upholstery can be baffling to the uninitiated. Rietveld's preoccupation was to design a chair with minimal mass, creating a virtually see-through object that allowed interior space to continue uninterrupted while also providing the potential for mechanised production.

When reissued by Cassina in 1973, the chair was released in its best known and most colourful form. In 2007, the Rotterdam-based Studio Minale-Maeda worked out that it was possible to re-create an almost exact copy in Lego. Because of the constraints of the brick size, it ended up being just 6 per cent larger than the original; however, due to the fact that it was an infringement of copyright, it was prohibited from being mass-produced.

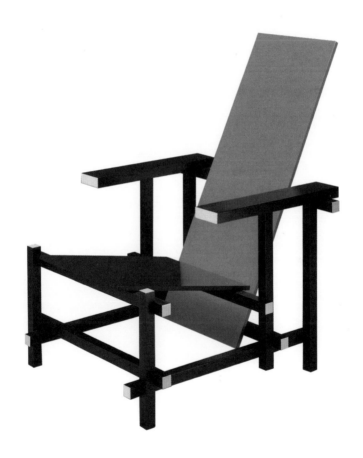

WASSILY (B3) CHAIR

Marcel Breuer

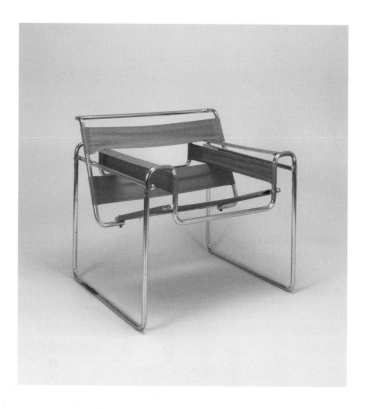

1925-27 The story goes that Bauhaus student-turned-teacher Marcel Breuer was inspired to use tubular steel for his furniture design after looking at the handlebars of his bicycle. A dissection of the traditional club chair rendered in fine tubular metal, B3 is more void than solid material. An instant hit, it was used throughout the Bauhaus buildings (often in its B1 auditorium or B4 folding form) and in the house of Russian artist and Bauhaus painting master Wassily Kandinsky. The slings were initially woven at the Bauhaus using Eisengarn (German for iron yarn), a strong waxed-cotton thread, in red, orange or green, but since 1968 New York company Knoll has produced it mainly in leather.

BLUE MARINE RUG

Eileen Gray

Intended for her experimental E1027 house on the French Riviera, the rug delivers a strong sense of seaside joie de vivre and encapsulates some of Irish-born, French-based designer Eileen Gray's preoccupations – the blue of the Mediterranean, lifebuoys (one hung on E1027's balcony) and the number 10, for 'J', the 10th letter of the alphabet, signifying her lover, Jean Balderici, for whom she designed the house. Gray and colleague Evelyn Wyld opened a rug atelier in Paris around 1910, after observing weaving and dyeing techniques on a trip to Morocco.

1925-35

PH3/2 TABLE LAMP

Poul Henningsen

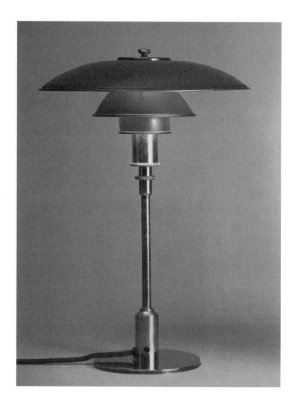

1926-27 Taking inspiration from a logarithmic spiral, the Danish designer
introduced a revolutionary three-shade system with his award-
winning PH lights, among which is PH3/2 (the '3' refers to the
30-centimetre diameter of the largest shade). Within the first five
years of its release by lighting company Louis Poulsen, 30,000 PH
lights were sold, with early examples featuring shades of copper,
enamelled in Japanese red or forest green, and of white opaline
glass. Used in spaces as diverse as railway stations, cafes, bars
and houses, the fittings were hugely popular for their ability to
offer soft, pleasing light with minimal glare.

WEISSENHOF DINING SETTING

J.J.P. Oud

The sky-blue colouring of this tubular steel setting was at odds with the finishes of its era, standing out against the popular polished chrome, and inconsistent with the dark blue favoured by De Stijl. Oud, known for his austere style, was a member of the Dutch movement alongside the likes of Gerrit Rietveld and Piet Mondrian, and one of fifteen architects chosen to design examples of modern housing for the exhibition at Stuttgart's Weissenhof Estate (now a UNESCO World Heritage Site). The setting was installed into only one of the thirty-three dwellings in the exhibition, but Hague-based manufacturer Kollektor Perpetuel produced an edition of 100 pieces fifty years later.

1927

HALLWAY CHAIR
Alvar Aalto

1929

Sometimes the choice of colour is determined by more than aesthetic appeal. Commissioned to design the architecture, interiors and furniture for the Paimio Sanitorium in Finland, Aalto and his wife, Aino, consulted with physicians to select colours based on their 'medical' value in enhancing the wellbeing of tuberculosis patients. In collaboration with artist Eino Kauria, they developed a complex scheme using sunny tones of yellow and ochre orange alongside calming sky blue and pale green, applying it to everything from walls, floors and ceilings to the chair itself, a stackable design in solid birch and plywood for reception areas, patient rooms and hallways. Originally called Model 51, it was later produced by Artek as Model 403.

SAVOY VASE

Alvar Aalto

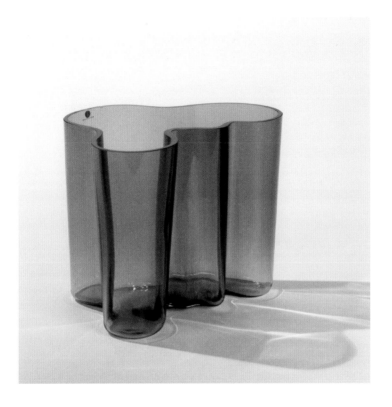

Named after the fashionable Restaurant Savoy in Helsinki, where it had a feature role in the decor (also designed by Alvar Aalto and his wife, Aino), this iconic design is now sold as the Aalto vase. Its gentle biomorphic shape, which changes with every viewing angle, won the vase first prize at a competition held by Iittala glassworks, after which it was presented at the 1937 Paris World's Fair. Ever the rationalist, Aalto chose the translucent shades of sea green, azure blue, smoke, amber and clear for their availability as much as their subtlety. It wasn't until the 50s that more intense colours were offered.

1936

MODEL 1227 ANGLEPOISE LIGHT
George Carwardine

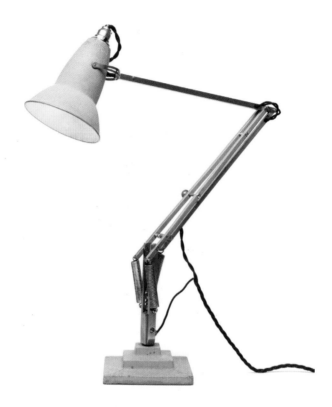

1934

Starting life as an industrial light, the early Anglepoise was designed for workshops and the medical profession, and produced in black, chrome or cream. Perceiving its obvious potential in the domestic market, Carwardine, a British automotive engineer who specialised in suspension systems, quickly redesigned his creation to feature a more elegant base and shade, and it was taken on by British spring manufacturer Herbert Terry & Sons. Through their energetic promotion and the release in 1935 of the new Model 1227 in blue, red, green and yellow, along with black and chrome, Anglepoise became an aspirational object for the modern household.

AMERICAN MODERN TABLEWARE

Russel Wright

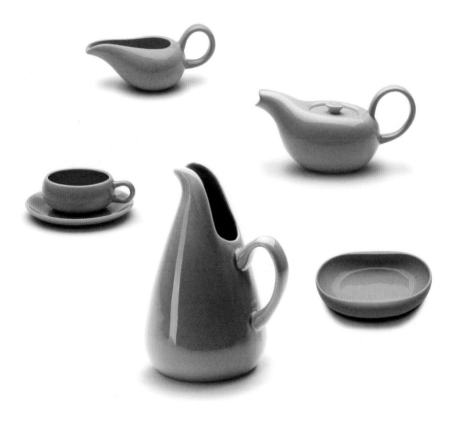

With nature-inspired names like Bean Brown, Chartreuse, Coral, Granite Grey and Seafoam, its sophisticated, slightly muddy colours and organic shapes distinguished this ceramic collection from competitors of the period. American Modern went into production with the Steubenville Pottery Company of Ohio in 1939 and was only discontinued twenty years later after selling more than 250 million pieces. From their homewares to their fabrics, set designer and self-taught industrial designer Russel Wright and his wife, Mary, had a profound effect on the way Americans embraced modernism. In 2008, Los Angeles-based Bauer Pottery reissued the collection.

1937

SOFA 3031

Josef Frank

c. 1940

Originally upholstered in fourteen shades of blue-green linen, the five-seater began as a custom commission and, unsurprisingly at more than 3.5 metres in length, is also known as the Long Sofa. Constructed with feather and foam cushions and turned beech legs, the restrained design shows how Swedish furniture can naturally accommodate unusual upholstery choices. The sofa is simple enough to handle Josef Frank's outrageously colourful floral fabrics but revels in the subtle shades he and Estrid Ericson, founder of interior design company Svenskt Tenn, initially specified. The company's most prominent designer, Frank created 2000 furniture sketches and 160 textile prints for Svenskt Tenn over a thirty-three-year period.

STANDARD CHAIR

Jean Prouvé

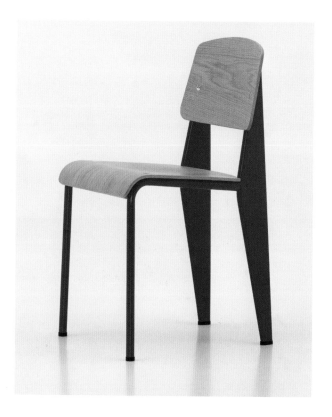

1944

After decades of development and various versions in different materials, Prouvé's Standard Chair is a testament to his engineering prowess and experiments in sheet metal, tubular steel and aluminium. Prouvé focused on structure in this design, and how the user's weight is supported by the back legs rather than the front, moving beyond an earlier fixation with a collapsible chair to design this final lighter, yet stronger, version. Devoted to material honesty, Prouvé was not opposed to colour, and offered his furniture in sixteen shades, including the dashingly named Rouge Corsaire.

TEXTILE MANHATTAN

Josef Frank

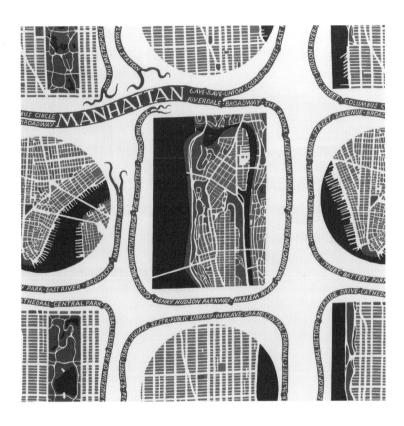

An Austrian émigré who settled in Sweden, Frank lived in New York
with his Swedish wife, Anna, from 1941 to 1946, and Textile Manhattan
is something of an homage to the city. Frank found the plan of New
York fascinating for its overwhelming simplicity, and his design depicts
a map of the famous island screen printed in red, green, blue and
grey on an off-white linen background. While heavily based on real
cartography, the design retains the whimsical nature of Frank's earlier
creations for Swedish interior design company Svenkst Tenn, with
organic, ribbon-like flags signalling landmarks such as Washington
Bridge and Times Square.

1943–45

CHILDREN'S FURNITURE

Charles and Ray Eames

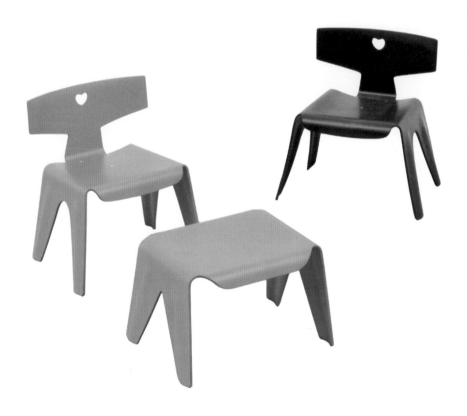

1945

A playful result of wartime experiments in moulding plywood (the pair designed leg splints for the US Navy), this children's range, comprising a chair, stool and table, was actually the famous couple's first foray into commercial furniture. Produced by Californian company Evans Products, who were also developing the Eames' first full-scale moulded plywood chair (the LCW), the furniture was made from moulded birch plywood and dyed in red, blue, yellow, magenta and black, with the chair featuring a charming cut-out heart that doubled as a carry handle. Only 5000 pieces were made, although in 2004 Vitra released a limited edition of 1000 chairs and stools in both natural and red-stained birch.

WOMB CHAIR

Eero Saarinen

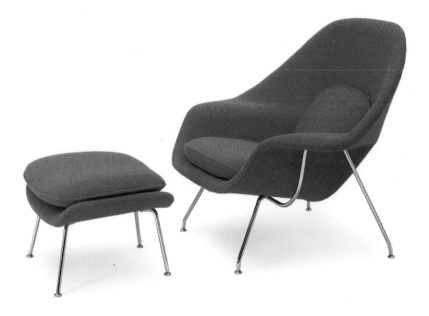

1946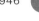

Finnish-born American architect Saarinen designed this modernist icon at the behest of his friend Florence Knoll, head of furniture design at Knoll Furniture Company, who wanted something she could 'really curl up in'. Starting out as the Model 70, it quickly became known as the Womb Chair for its comfort, which owes more to the body-hugging curve of its shell than the cushioning beneath its upholstery. The first mass-produced fibreglass chair in America, it initially used sisal to reinforce its expansive form. The chair's first advertisement, depicting a soot-laden chimney sweep sitting in a bright red Womb Chair, ran in *The New Yorker* for thirteen years.

BALL CLOCK

Irving Harper and George Nelson

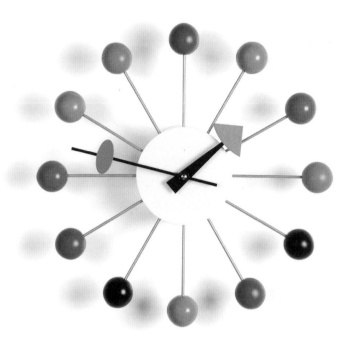

1947

Produced by the Howard Miller Clock Company, Michigan, from 1949 in six shades, the Ball Clock became most widely recognised in its multicoloured form, a symbol of the atomic era in which it was created. Like many products designed at George Nelson Associates, it was credited to Nelson but was actually conceived by the studio's design director, Irving Harper. However, Nelson (with friend and fellow designer Isamu Noguchi) was involved in brainstorming the first clock collection in 1947, and his studio would go on to design more than 130 timepieces for Howard Miller over the next thirty years. In 1999, the Ball Clock and several other Howard Miller wall and desk clocks were reissued by Vitra.

GRÄSHOPPA FLOOR LAMP

Greta M. Grossman

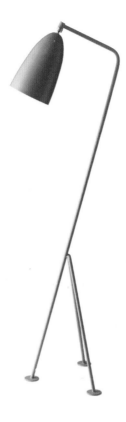

With its delicately angled legs, flexible, elongated shade and tilted
tripod stand, this insect-like floor lamp has become one of Grossman's
most iconic products. The Swedish architect and designer immigrated
to the US in 1940 and set up a studio on Rodeo Drive in Los Angeles
shortly after, where her creations would play an influential part in the
development of mid-century Californian modernism. Gräshoppa
was produced in America by Ralph O. Smith and in Sweden by
Bergboms, but its 2011 re-edition in nine colours by Danish brand
GUBI offered it a new incarnation on a global scale.

1947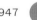

ANTROPUS ARMCHAIR

Marco Zanuso

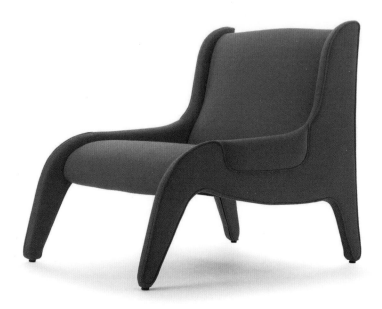

1948

With Zanuso commissioned as set designer, the armchair's first major appearance was in attention-seeking red on a Milan stage, in Thornton Wilder's play *The Skin of Our Teeth* (*La Famiglia Antrobus*). Earlier that year Ar-flex (now arflex), a new furniture arm of the Italian tyre company Pirelli, had commissioned Zanuso to explore the use of latex foam in furniture. In a serendipitous moment, the two projects came together. Antropus's sinuous, athletic form was a monumental shift from conventional armchairs but perhaps a little too radical, as Zanuso's more conventionally beautiful Lady armchair (page 47), created a few years later, received far more acclaim.

EAMES STORAGE UNIT (ESU)

Charles and Ray Eames

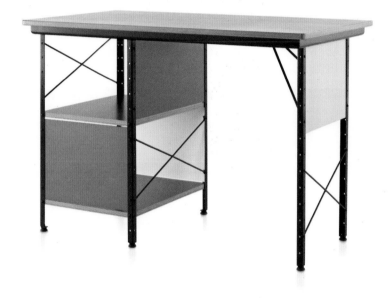

The most striking features of this piece are the lacquered Masonite side and back panels that create a harlequin effect in seven shades, including bright yellow, red and blue. Like the Eames House in Pacific Palisades, Los Angeles, completed in the same year, the storage units and desks that form this collection openly display their industrial origins. Still available from the original manufacturer, Herman Miller, in different sizes and configurations, the units consist of birch- or walnut-faced shelves that attach to zinc-plated steel supports. Sliding 'dimple' doors in moulded plywood can be added to the storage units, while the desks have flat plywood drawers.

1949

Josef & Anni Albers

'The more we see that colour always deceives us, the more we feel able to use its action for visual formulation,' said Josef Albers (1888–1976), an artist, educator and colour theorist with a passion for facilitating learning through the intensity of experience rather than the didacticism of teaching.

Having already studied teaching and painting and worked as a printmaker, he started as a student in 1920 at the newly established Bauhaus in Weimar, Germany, where the disciplines of craft, art and architecture were aligned under the philosophy of Walter Gropius. There he met Annelise Elsa Frieda Fleischmann (1899–1994), a student from Berlin who'd joined the weaving workshop (one of the few in which women were allowed to enrol). The two were married in 1925 – the same year Josef became the first student to join the faculty as a master and the Bauhaus moved to Dessau.

Friends to the likes of Paul and Lily Klee and Wassily and Nina Kandinsky, the pair were at the vanguard of creativity in Europe when the Nazi regime shut down the last vestiges of the Bauhaus in 1933. Josef and Anni were both invited to the newly formed progressive liberal arts school Black Mountain College in North Carolina, USA.

Josef Albers's explorations of colour, in his own series of paintings *Homage to the Square* (1950–76) as well as his influential book *Interaction of Color* (1963), defined his life's work. His influence was profound, as he trained a generation of art teachers in America and Europe during his lively classes, which were visually rich and action-orientated to encourage alternative ways of seeing the world of colour.

Anni Albers's work is both experimental and timeless, something that was encouraged by her colleague and head of the weaving workshop at the Bauhaus, Gunta Stölzl. Anni understood that skilled technique was only a servant to further innovation. Her early creations focused heavily on grid patterns, depicting larger blocks intersected with fine stripes in alternating colours. Her ability to take geometry to a place where it is alive with visual movement shows in how her colour selections vibrate against their neighbour and patterns appear to ebb and flow.

Mixing traditional fibres such as jute and linen with rayon, cellophane and metallic threads, Anni produced wall-hangings that eschewed the representational in favour of exquisite pattern making – sometimes subtle in tone, at other times full of energy, blending bold colour with natural hues. In 1949, indicating her status as one of the most famous textile artists of the 20th century, Anni became the first to be honoured with a solo exhibition at the Museum of Modern Art in New York. Her seminal book *On Weaving*, published in 1965, is still in print today.

Like her husband, Anni continued teaching into the 1950s. She offered private lessons at their home in New Haven and later giving guest lectures to architecture students at Yale (where Josef also taught) and other schools across America.

Anni and Josef worked in parallel rather than together. They shared a love of Mexican culture, visiting the country fourteen times over a thirty-year period and collecting artefacts on their travels. 'In Mexico, art is everywhere,' they noted – for a couple utterly committed to the artist's life, this was the ultimate accolade.

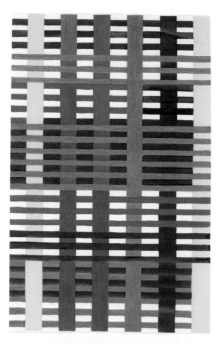

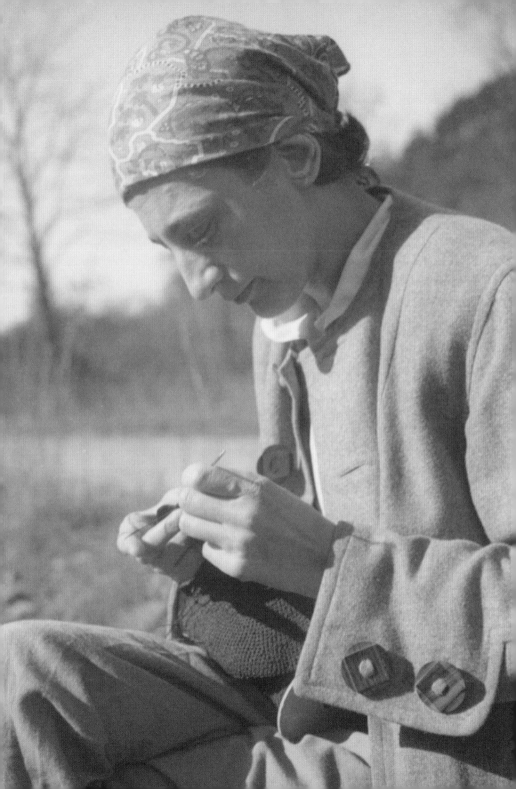

OPPOSITE PAGE Josef Albers
at Black Mountain College, 1944.
Photograph by Barbara Morgan.

CLOCKWISE FROM TOP RIGHT
Josef Albers, *Park*, c. 1923, glass, metal,
wire and paint (49.5 x 38.1 cm); Josef Albers,
Stacking tables, c. 1927, ash veneer, black
lacquer and painted glass; Josef Albers,
Interaction of Color, first published by Yale
University Press in 1963 and currently
available as a 50th anniversary paperback
edition (2013); Josef Albers, *Never Before*,
c. 1976 (48.3 x 50.8 cm), from a portfolio
of twelve screen prints.

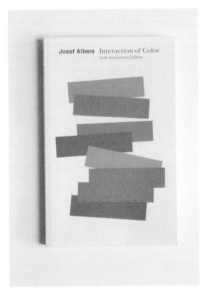

FAIENCE SNURRAN VASE

Stig Lindberg

c. 1950

The ingenious Snurran (Swedish for spinning), with its conical shape resembling a child's spinning top, combines two products in one: vase and candleholder. Produced as a single piece or in groups of three or five, Snurran was just one of 150 models that formed the Faience collection produced by Swedish ceramics company Gustavsberg from 1942 until the late 50s. Hand-painted in all manner of colours and patterns, featuring geometric and abstracted natural motifs, Faience pieces were initially designed by Gustavsberg's artistic director Wilhelm Kåge, but Lindberg, a prodigy who had joined the company in 1937 as a twenty-year-old trainee direct from art school, soon took over, becoming art director in 1949.

FLAG HALYARD CHAIR

Hans Wegner

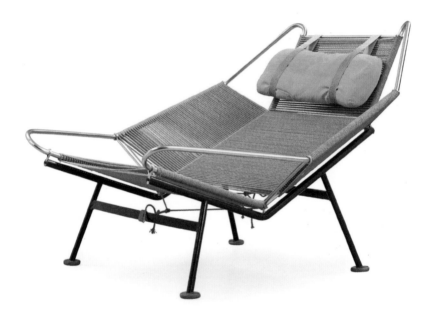

1950

While the first version of this metal and rope chair was painted white, Wegner chose an olive-green frame with contrasting orange head cushion for the production version. The frame's dark colour grounded the design and separated base from seat. The Danish designer conceived the idea while at the beach with his children, scooping out a shape in the sand in which to sit. Impressed with its comfort, he recreated the same basic shape in woven rope (hence the name). The unusual design was produced as the GE225 by Getama, a traditional mattress company turned furniture manufacturer, and is currently produced as the PP225 by PP Møbler, in white with a natural rope seat or in all black.

GEOMETRIC RUG

Antonín Kybal

The fine, sine wave-like lines and layered shapes of this rug, which was also made in a blue colourway with flesh-pink highlights, are notable features of Kybal's creations from the 50s. The curvilinear designs he favoured during this period marked a movement away from the Bauhaus influences his work displayed in earlier decades. The pioneering Czech textile designer went on to create large-scale tapestries for the Czechoslovakian presidential villa in Prague and the interior of a train carriage gifted to Stalin on his 70th birthday. Kybal's work can be found in London's Victoria and Albert Museum and the Museum of Decorative Arts in Prague.

c. 1950

MOULDED FIBREGLASS CHAIRS
Charles and Ray Eames

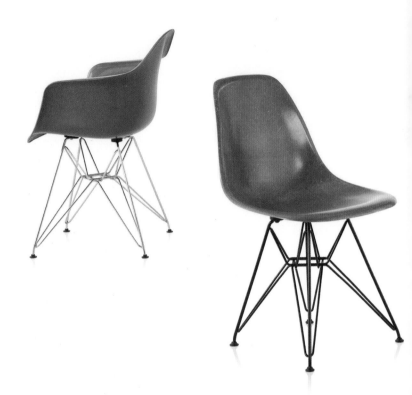

1950–53

Available in an impressive range of colours and base options, these chairs brought a democracy of design to the broader market and heralded an era of affordable modernity. Usually referred to as 'Eames chairs' or 'Eames fibreglass chairs', they were universally popular – the couple themselves used several different models in their own home and studio.

The chairs came about as part of the Eames' research into organic seating that had started with their moulded plywood products during World War II, when they developed such diverse products as leg splints and training glider parts.

While the general form may have been part of a continuous approach, the outcome and material were very different. The two shell designs – a side chair and an armchair – were teamed with a huge array of bases, including several dining chair types and low lounge chair versions, linked auditorium seating and even a rocker.

Their palette was every bit as varied. Charles and Ray Eames spent time mixing pigments to develop special hues with evocative

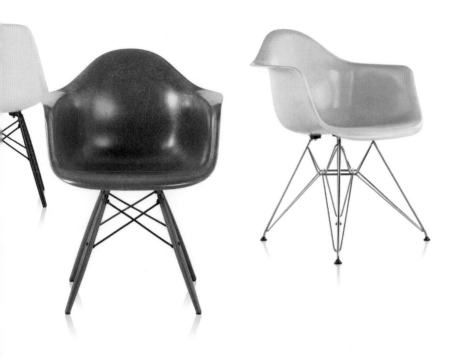

names like Elephant Hide Grey ('a black with feeling', according to Charles Eames), Sea Foam Green and Seal Brown. In an era in which standardisation was considered a noble goal, creating a range of twenty-seven colours gave the customer enormous freedom to bring personality to their home or work environment.

The material and its method of manufacturing added an unintended but welcome uniqueness to each piece. Michigan-based company Herman Miller produced the chairs in polyester resin reinforced with glass-fibre, and it was the random way in which these substances took up colours that created the chairs' much-loved individuality.

For environmental reasons, the chairs were discontinued in 1993 but rereleased five years later by Vitra using recyclable polypropylene. Unfortunately, these greener chairs didn't have the same organic quality as the original material and in 2013, Herman Miller brought out a new fibreglass version using eco-friendly bioresins, offered in many of the early colours.

ANTELOPE CHAIR

Ernest Race

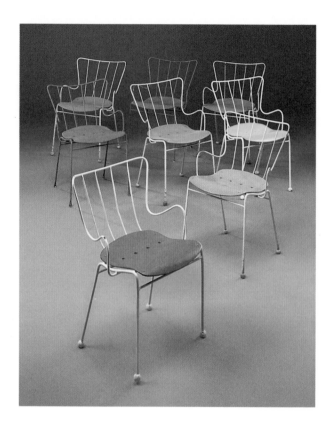

1951

Commissioned to design outdoor furniture pieces for the 1951 Festival of Britain, Race created the Antelope chair together with a two-seater Antelope bench, a stacking chair called Springbok and a table named Gazelle. The Antelope chair and bench were made from a minimal amount of bent steel rods with cast aluminium ball feet and a moulded plywood seat painted in the festival colours of yellow, red, blue and grey. Favourably received by the 8.5 million visitors, the chair went into commercial production after the festival closed and later won a silver medal at the 1954 Milan Triennale. The chair and bench were reissued in 2011 by Race Furniture.

BIRD CHAIR
Harry Bertoia

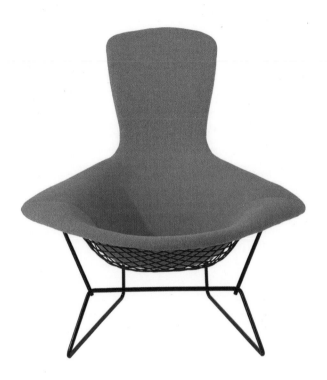

The uniquely shaped Bird chair is one of five wire pieces created 1950-52
by the Italian-born artist, designer and sculptor. Developed over two
years for American furniture company Knoll, the collection was a
continuation of earlier wire chair concepts undertaken by Bertoia
while working at the Eames Office, but with a more sculptural approach.
Studying ergonomics at a Naval laboratory in the late 40s helped
Bertoia deliver a surprising level of comfort in his visually delicate
forms. He described the Bird chair and its companions as being
'mainly made of air', but with the addition of thin seat pads in yellow,
red, blue and green, the chairs became abstract colourful shapes.

CALYX FABRIC

Lucienne Day

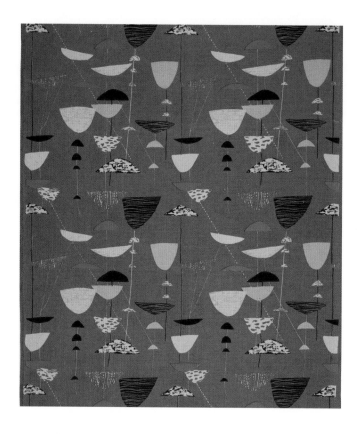

1951

One of more than sixty abstract botanical and geometric patterns Day created for British interiors store Heal's during the 50s and 60s, Calyx was first exhibited at the 1951 Festival of Britain, at the entrance to the Home Entertainment section of the Homes and Gardens Pavilion. An instant international success, it went on to win a gold medal at the Milan Triennale that same year, followed by the International Design Award of the American Institute of Decorators in 1952. The original version of Calyx, named after the outer casing of an unopened flower bud, was screen printed in yellow, orange, black and white on an olive linen background.

LADY ARMCHAIR

Marco Zanuso

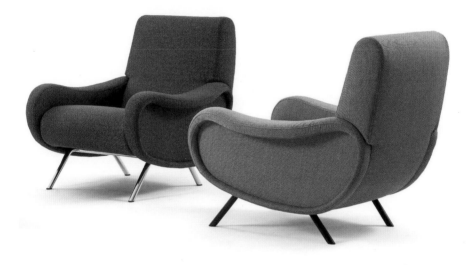

A gold medal winner at the 9th Milan Triennale exhibition in 1951, the Lady armchair is one of Zanuso's greatest furniture triumphs, utilising experimental polyurethane foam developed by Pirelli's arflex company. The timeless organic shape was most famous in bright red wool fabric, but the chair subsequently became popular in mustard yellow, royal blue and forest green. Early examples featured a wooden frame, later replaced by pressed metal, with wooden armrests covered in variable densities of foam and fabric. A two-seater sofa version was also produced. Lady was one of several of Zanuso's furniture pieces re-editioned by Cassina in 2015.

1951

T-5-G TABLE LAMP

Lester Geis

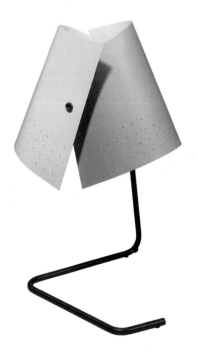

1951

American architect and lighting salesman Lester Geis won an honourable mention for this lamp at the New York Museum of Modern Art's low-cost lighting competition, New Lamps, in 1951. The interlocking aluminium shades are painted in yellow and grey, a popular combination in the 50s, and pivot on a brass rod bent at ninety degrees that forms the lamp's base. The adjustable shades can focus the light directly for reading, be spread for general illumination or flipped to become an uplighter. Geis's T-5-G was one of ten lamps selected from the competition to go into production with New York's Heifetz Manufacturing Company.

HANG-IT-ALL COAT RACK

Charles and Ray Eames

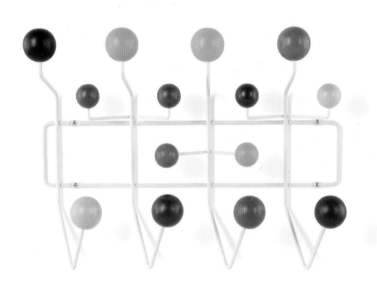

With its multicoloured, lacquered maple balls suggestive of molecular models, this versatile coat rack was a result of the Eames' interest in making toys and furniture for children. Like their earlier creation The Toy, a modular building plaything, Hang-It-All was designed for Tennessee-based Tigrett Enterprises. The colours were selected and positioned by Ray Eames, who also designed the graphics for the box, installation swing-tag and advertising. The metal frame used techniques perfected in the pair's LTR table and Wire chair designs. Produced from 1953 to 1961, Hang-It-All was reissued by both Herman Miller and Vitra in 1994 and also comes in black or white versions with walnut spheres.

1953

KRENIT BOWLS
Herbert Krenchel

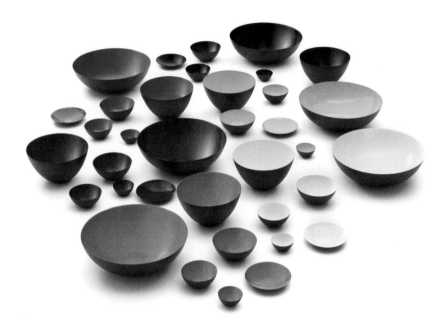

1953

The bowls' glossy, jewel-like colours combined with a matt-black steel exterior delivered a graphic punch to the 50s dinner table. Beautiful enough to put on display yet robust enough to work in the kitchen, they won a gold medal at the 1954 Milan Triennale. Originally available in eight stackable sizes and six bright colours as well as black, white and grey, the bowls were reissued in 2008 and are currently available in five solid colours and two metallic colours in five sizes. Their name comes from the merging of 'Krenchel' and 'Eternit', a fibre cement the designer used to model his shapes.

MARSHMALLOW SOFA

Irving Harper

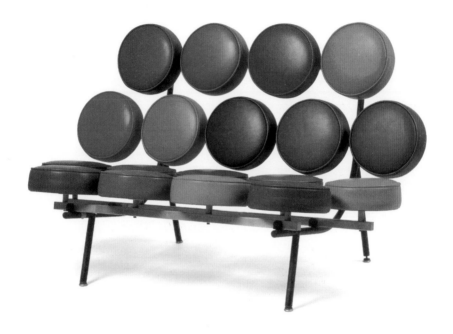

Although widely attributed to George Nelson, this multicoloured confection was actually the work of the chief designer at Nelson's studio. Harper designed it over one weekend after discovering a 'self-skinning' foam process that eliminated the need for traditional upholstery but could only be made in diameters of up to 12 inches (30 centimetres). When prototyped, however, the one-step cushion process didn't work as planned, forcing a return to high-cost conventional methods. Only around 200 of the boldly hued sofas were produced before it was discontinued, but the original eighteen-cushion love seat version was reissued in 1999 by Herman Miller.

1954

P40 ARMCHAIR

Osvaldo Borsani

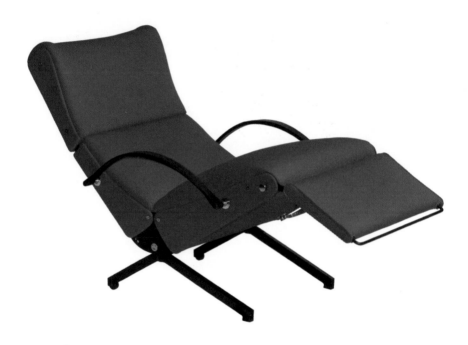

1955

The P stands for *poltrona* (Italian for armchair), but this is unlike any other armchair, before or since. With 486 possible positions and rubber-coated spring-steel arms, the chair, designed by Borsani for his company, Tecno, can be adjusted to the utmost comfort of each individual user and is a clear demonstration of the designer's tremendous technical skill and innovation. While it has always been available in a range of colours, red seems best suited to P40's Ferrari-style looks and capabilities. The chair's extreme adjustability was successfully applied two years later to another of Borsani's designs, the L77 daybed.

MEZZADRO STOOL

Achille and Pier Giacomo Castiglioni

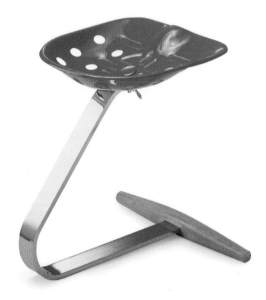

Exhibited at the 11th Milan Triennale and released by Zanotta in 1957 for a short period, Mezzadro (Italian for sharecropper) was one of the Castiglioni brothers' readymade objects, where everyday items are repurposed in interesting new ways. The seat of an early 20th-century tractor has been mounted on its steel support bracket (chromed and flipped upside down for more bounce), with a wooden footrest added for stability. Early versions featured the seat enamelled in the exotically named colours Amaranth, Caterpillar Yellow, Tractor Orange, Sand, Veronese Green and Indigo, but after production started in earnest in 1971, a more conventional palette of red, yellow, black and white was chosen.

1957

COCONUT LOUNGE CHAIR

George Nelson Associates

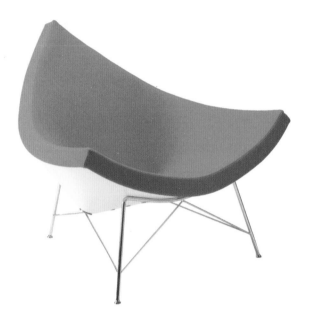

1955

A chair that looks like a piece of coconut – that was the idea of George Mulhauser, who presented an early version of the design as part of his portfolio when applying for a job at George Nelson's New York design studio. The shell was made from sheet steel until 1963, when it was changed to fibreglass – always in white. The Coconut lounge chair was produced by Herman Miller and, from 1988, Vitra, in a range of fabrics, Naugahyde vinyl and, more recently, leather, but it's the brightly coloured Hopsak fabrics of Alexander Girard, which adorned many early examples, that best convey the tropical mood of Mulhauser's original concept.

SELLA STOOL

Achille and Pier Giacomo Castiglioni

There's a reason Sella (Italian for saddle) is only available in one
colour. With its leather bicycle seat, it alludes to Italy's equivalent of
the Tour de France, the Giro d'Italia, in which the leading rider wears
pink. An ironic choice for a stationary object, but the Castiglioni
brothers were always full of harmless mischief. The seat is attached
to an adjustable column and rubber-coated, cast-iron rocking base,
a result of the designers' interest in the appropriation of everyday
objects. This Dada-esque combination, which didn't go into
production until 1983, is actually highly ergonomic.

1957

KREMLIN BELLS DECANTER

Kaj Franck

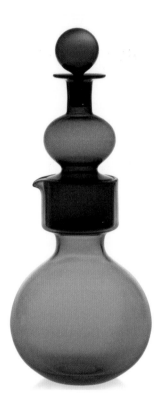

1957

With its sensuous shape and subtle colour accents in tangerine, aquamarine, amethyst, ink blue and ruby red, this piece goes well beyond its utilitarian dual purpose as juice and water jug, delivering a thing of outstanding sculptural beauty. Exhibited at the 1957 Milan Triennale, it took another five years to go into production with Finnish glass company Nuutajärvi Notsjö. Customers could select the colour of the upper decanter and stopper. Like many products from this period, the design began with a model number (KF1500) – the name came later, with its popularity, and refers to the orb-like roofs of Moscow's bell towers.

EGG CHAIR

Arne Jacobsen

One of Jacobsen's greatest furniture pieces, the Egg chair – together with the equally famous Swan and Drop chairs – was actually part of a larger project. Commissioned in 1955 to design a landmark hotel for Scandinavian Airlines System (SAS), Jacobsen not only delivered Copenhagen's first skyscraper and Denmark's tallest building but also designed the hotel's interiors, right down to the lights, door handles and keys. Fifty Egg chairs were placed in the lobby, upholstered in soft turquoise fabric and leather. Made by Fritz Hansen since 1958, the Egg chair is upholstered by hand – using 1200 stitches – to follow the elliptical design's defined curves.

1958

PH5 PENDANT LIGHT

Poul Henningsen

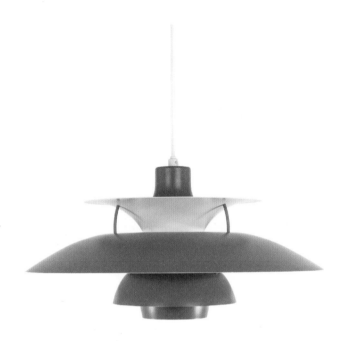

1958

This quintessentially 50s piece is the culmination of years of research into directing and filtering electric light to create a soft, even glow. Its shape is derived from the first PH light designed in 1924, reportedly inspired by a stacked cup, saucer and bowl. Sold for nearly five decades in a matt painted finish in blue, white, purple and red, PH5 has been re-editioned by Louis Poulsen in new colours in 2008, 2013 and 2018. The latest release, for its 60th anniversary, offers eight palettes where the five metal shade components are rendered in subtle variations of the one hue.

LUTRARIO CHAIR

Carlo Mollino

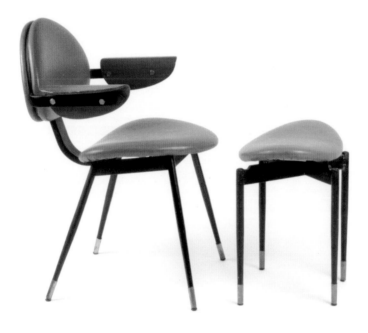

Created for a dance hall built on the site of a disused scrapyard in Turin, this chair couldn't have had a more colourful debut. Mollini transformed the hall's interior with the magical theme of a midsummer night's festivities in the forest. The Italian designer had been commissioned by entrepreneur Attilio Lutrario to design the interiors for his club, Le Roi Dancing, and the theme played out across furniture, lights and table linen, amplified by mirrored doors and terrazzo floors. Named after the club's founder, the chair was upholstered in a vinyl-style material called Resinflex and appeared in a charming array of shades – dark red, pale pink, sage green and grey-blue.

1959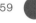

HEART CONE CHAIR

Verner Panton

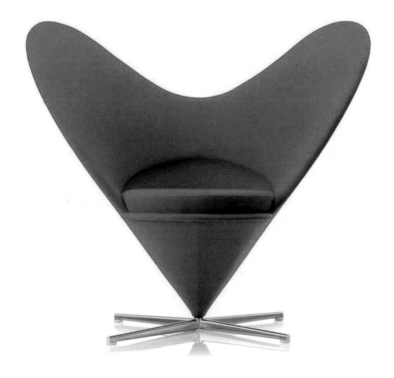

1959

A striking work by the Danish architect, the chair is an offshoot of his first major commission – the refurbishment of his father's restaurant, in which Panton designed everything from carpets to staff uniforms in varying shades of red. His Cone Chair from that project was so well received that a company, Plus-linje, was set up to manufacture it. One of the early additions to the collection was the Heart Cone, with its distinctive heart-shaped backrest, which allowed the sitter to either sit conventionally or sideways, with an arm draped casually over the 'V'. This extraordinary design was reissued by Vitra in 2004.

CARIMATE CHAIR

Vico Magistretti

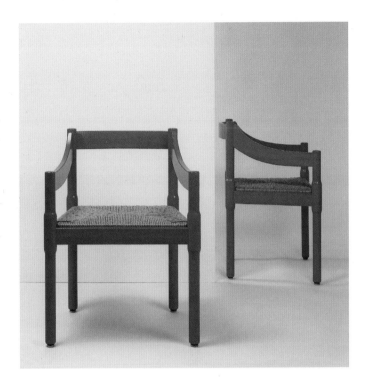

From the Milanese designer often seen wearing bright red socks, it seems fitting that this chair was conceived in that bold colour. Created for the dining room of the Carimate Golf Club in Lombardy, this humble piece, with its traditional woven-rush seat and coloured frame, became a huge success once Cassina began to produce it for a wider audience from 1963. The Carimate chair (Model 892) would form part of a collection of sixteen pieces, with beds, armchairs, tables and sofas added through the 60s – all in beech with clear, red, black or white lacquered frames. From 2001 to 2009, the chair was produced by De Padova.

1959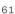

Alexander Girard

Melding the disciplines of architecture, textiles (he designed more than 300 fabrics), graphics and furniture design, Alexander Girard (1907–1993) embodied a particular type of creative spirit that defined the excitement of mid-century design in America.

A childhood spent with his American mother and French–Italian father saw New York-born Girard grow up in Florence and graduate from architecture school in both London and Rome. With a worldly outlook, he set up a design office in New York in 1932, but it was a move to Detroit and a fortuitous encounter with Charles Eames (both had designed radios for the Detrola Corporation) that eventually led to him meeting George Nelson, director of design at Herman Miller.

Girard had a magpie instinct for folk art and cultural artefacts, collecting and recording everything from dolls to artworks, masks to clothing. He also kept scrapbooks and binders full of reference material, often themed under topics like colour, pattern and fabrics, so when Nelson appointed him head of textiles in 1952, Girard had a personal library of images and ideas to draw on.

There is a great deal of play and joy in Girard's designs, as noted by Hugh De Pree, head of Herman Miller at the time: 'Girard taught us that business ought to be fun, that part of the quality of life was joy, excitement and celebration.' Girard himself saw his folk art obsession as a way of recapturing that childlike sense of wonder.

Girard's ground-breaking textiles, such as Arabesque, Millerstripe, Quatrefoil and Palio – many of which still remain part of the Herman Miller (and later Maharam) collection – spearheaded the aesthetic direction for the brand alongside his era-defining graphic design work and a fierce determination to support the modernist furniture of designers like Charles and Ray Eames.

Ahead of his time in terms of conceptualising and executing a complete theatrical experience, Girard designed the Latin American-themed La Fonda del Sol restaurant in New York's Time & Life Building in 1960. It was a complete work of art, with Girard's creative hand on everything from sun murals to matchboxes, banquette fabrics to a bar enclosed in adobe. Distilling the essence of Latin American culture, he also showcased collections of folk art from Mexico and Peru.

Colour and pattern were Girard's calling cards, whether the commission was a 55-metre-long, three-dimensional mural for the John Deere Company (a producer of farm machinery) in 1964, or the complete rebranding of America's Braniff International Airways a year later.

Briefed to oversee the 'end of the plain plane', Girard went to town on the aircraft's interior, developing seven colour schemes with fifty-six fabrics in solids, checks and stripes, and introducing reds, scarlets and vermilion. Seven different colours were used for the fuselage, with Italian designer Emilio Pucci embracing the bold vision, creating uniforms in multicoloured patterns and futuristic plastic hats to protect hair on the runway.

The Braniff advertisement announcing the redesign has all the tongue-in-cheek humour of the era. 'Nothing was left untouched. Tickets and ticket offices were redesigned. Dishes and flatware. In-flight stationery. Our passenger lounges. The packages that hold the sugar for the coffee. Even the tissues in the lavatory. In little more than six months, Girard and Pucci initiated 17,543 changes. We have the most beautiful airline in the world.' And all created through the joy of colour.

CLOCKWISE FROM TOP RIGHT
Palio textile for Herman Miller, 1964, reissued by Maharam, 2012; Colour Wheel Ottoman in Girard's Jacobs Coat textile, 1967, reissued by Herman Miller, 2014; one of a collection of plates for Georg Jensen, 1955; Crosses printed linen textile for Herman Miller, 1957; Braniff International Airways Lounge Armchair, 1965, reissued by Herman Miller, 1967.

OPPOSITE PAGE Alexander Girard in his studio in Grosse Pointe, Michigan, 1948. Photograph by Charles Eames.

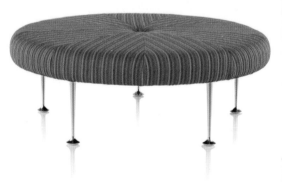

ALEXANDER GIRARD

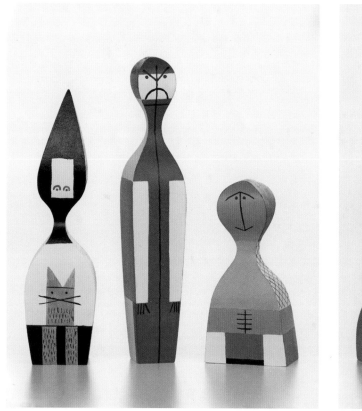
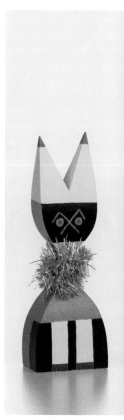

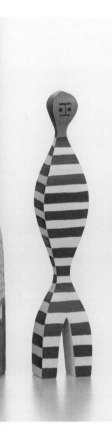

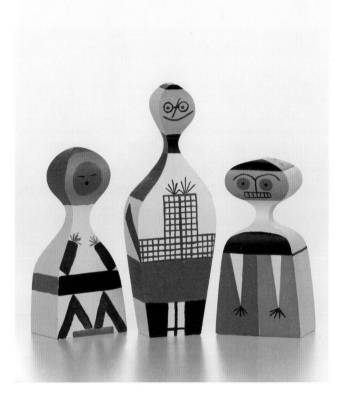

WOODEN DOLLS — 1960-65

Inspired by the array of dolls and cultural artefacts he collected on his travels, Girard's hand-carved and painted figures strike a balance between the ritualistic and a child's toy. Girard made the dolls for his own amusement, using them as decorative objects in his home in Santa Fe but perhaps also with the idea of displaying them alongside his fabrics at the Herman Miller Textiles & Objects store in New York. Varying in height from 14 to 27 centimetres, these cartoonish forms borrow freely from a wide range of eras and cultures as well as the fantastic world of Girard's own imagination. The dolls were released for the first time in 2006 by leading Swiss design house Vitra, and the collection has now grown to thirty.

TULIP CHAIRS

Pierre Paulin

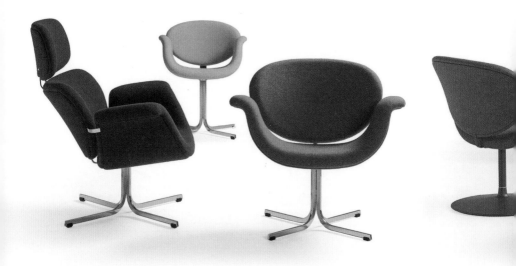

1960-65 This collection of three chairs – Little Tulip (F163), Tulip Midi (F549)
and Large Tulip (F545) – was designed in the 60s, but given its
conventional construction of moulded plywood, foam and fabric,
it still has a firm foot in the 50s – soon after, French designer Paulin
became much more experimental in his approach to material and
form. The delicate floral-inspired shape lends itself to solid colours,
such as pink, purple, red, yellow and orange, and is enhanced by
the beautifully executed cruciform base. A swivel version on a
disc-shaped base was added later, which feels more 60s in style
but also less delicate.

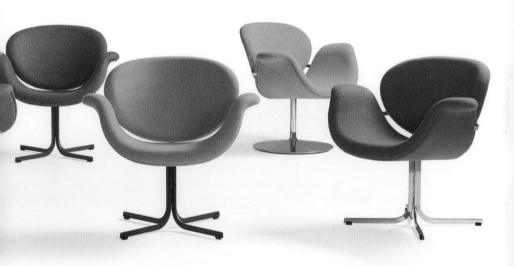

ORANGE SLICE (F437) ARMCHAIR

Pierre Paulin

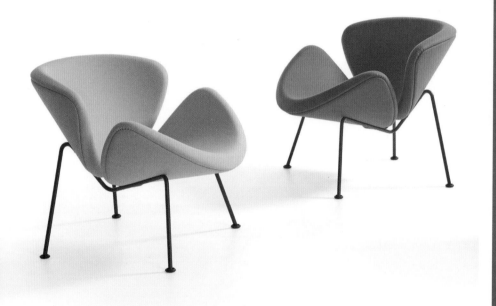

1960

Red, orange and yellow are the signature upholstery colours for this design, partly due to its shape and name but also because of its generally sunny demeanour. Made from two identical moulded plywood shells covered in foam and fabric, the chair relies on careful positioning of the seating angle for its remarkable comfort. It remains a best-seller for Dutch brand Artifort, who have had fun in recent years with colourful base options, offering it in forty-three shades plus black, white and the original chrome. The chair comes in two heights and a scaled-down Orange Slice Junior for children. Paulin also designed a matching footstool for the chairs (P437).

TRIANGLE PATTERN BOWL AND VASE

Aldo Londi

Textured triangles in yellow, green, white and black give these pieces a muted harlequin effect that feels far more 50s than swinging 60s. Londi began working in ceramics in 1922, at the age of eleven, and became creative director of Italian manufacturer Bitossi in the late 40s, a position he held for more than fifty years. Among the 1000 objects he designed during his time there, ranging from animal figurines to ashtrays, jugs and vases, were the lidded '1377' bowl and tall '1948' vase, which were reissued in 2006 and 2017 respectively, both in limited editions of 199.

1960

GLOVE CABINET
Finn Juhl

1961

Designed for his wife, Hanne Wilhelm Hansen, Juhl's Glove Cabinet contrasts a gradation of hot colours on one set of drawers with cool on the other side of its vertical hinge. Utilising the Danish designer's signature crescent-shaped cut-out as the drawer handle, the drawer fronts have the enchanting appearance of horizontal ribbons of coloured fabric. Presented at the Cabinetmaker's Guild Exhibition in 1961, the idea of coloured drawers in a gradient of shades was first used by Juhl in his iconic Sideboard for Bovirke from 1955. The cabinet has been manufactured since 2015 by House of Finn Juhl in oiled Japanese cherry wood with a wenge handle, brass hinges and castors.

CORONA (EJ5) CHAIR
Poul Volther

Despite its extroverted appearance – four elliptical segments
often upholstered in red leather or textile – the Corona chair did not
command attention overnight. Inspired by time-lapse photographs
of solar eclipses with their flaming red silhouette and developed
with pure ergonomics in mind, the first Corona was supported by
a conventional wooden base with four legs. The now iconic version,
with its swivelling spring-steel base, was presented to the public
by Danish manufacturer Erik Jørgensen in 1964 but received a
lukewarm response. It wasn't until 1997 that the chair was finally
recognised as a design classic, and today it is the company's
biggest selling item, with more than 3000 sold each year.

1961-64

GULVVASE BOTTLES

Otto Brauer

1962

Initially produced in translucent glass in cobalt blue, amber, smoke grey and deep green, the Gulvvase (meaning floor vase in Danish) is credited to Brauer, master glassblower at Fyens Glasværk, one of several glassworks owned by Danish company Kastrup Holmegaard. A variation on a bottle-like design from 1958 by Per Lütken, one of Holmegaard's key glass visionaries, the hand-blown vase was produced from 1962 to 1980 in five sizes and four colours, and in the late 60s in a two-tone encased form in more attention-seeking shades such as turquoise, red, yellow and apple green, with each colour blown over an internal layer of white glass.

CUBO (TS502) RADIO

Marco Zanuso and Richard Sapper

Released in 1964 in orange, yellow, black and white, the portable radio known as Cubo, for obvious reasons, was a massive success for Italian electronics company Brionvega. Its rounded, dice-like exterior opens up like a glossy futuristic clam shell to reveal the speaker grill, tuning and volume controls, which, in stark contrast, are matt black with oversized dials. Most famous in its orange casing, Cubo crams a lot into a small package (basically two 13-centimetre cubes) including AM and FM radio, a retractable aerial and auto on/off function when the cube is opened and closed. A technically updated version, the TS522, is still offered by Brionvega.

1962

MODEL 4801 ARMCHAIR

Joe Colombo

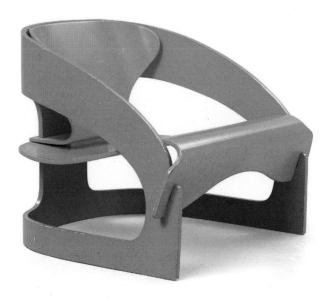

1963-64 While Colombo is famous for his work in plastic, this armchair was
created a year after he opened his studio, when the material was still
in its infancy. Comprising just three parts, which slot together without
fixings or glue, the Model 4801 was made by Italian plastic specialist
Kartell in moulded plywood (the company's only all-wood object).
Early prototypes were in natural beech plywood while production
versions were heavily lacquered in orange, green, white or black
for a plastic-like effect. It was not until 2011 that Kartell re-editioned
the chair in PMMA, a type of thermoplastic also known as Perspex,
Plexiglas or Lucite.

BALL CHAIR

Eero Aarnio

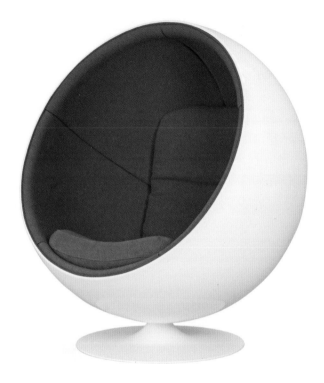

It has starred in the 60s TV series *The Prisoner*, as well as major films such as *Dazed and Confused*, *Mars Attacks* and *Tommy*, and it continues to be a symbol of tongue-in-cheek futurism. Debuting at the 1966 Cologne Furniture Fair, the Ball chair took Finnish designer and fibreglass pioneer Aarnio from unknown to world renown virtually overnight. It was originally produced by Finnish furniture company Asko Oy, Lahti, then in the 70s by German manufacturer Adelta, with its interior in red, orange or black wool and its fibreglass exterior and aluminium swivel base in white. Aarnio became well known for his unconventional exploration of plastic technologies.

1963

USM HALLER STORAGE

Fritz Haller and Paul Schärer

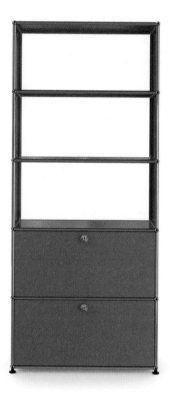

1963

Office furniture received a colourful makeover courtesy of architect Fritz Haller who, together with USM owner Paul Schärer, developed a furniture system that translated into a series of storage cabinets, bookshelves, mobile trolleys and desks for the Swiss metal products manufacturer. The versatile modular system used a chrome-plated steel frame with corners connected by a unique ball-joint structure and powder-coated steel panels. Although it was designed purely for USM's factory offices, international exposure of Haller's architecture led to requests for the brightly hued range, propelling it into production in 1969. Originally released in green, yellow, blue, black and white, it is currently available in fourteen colours.

NESSO TABLE LAMP

Giancarlo Mattioli,
Gruppo Architetti Urbanisti Città Nuova

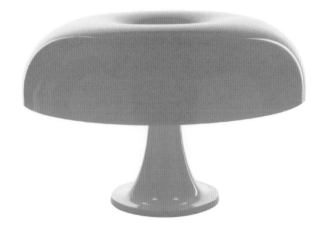

Mattioli's bold mushroom-shaped lamp won first prize at the Studio
Artemide/Domus competition held at the 1965 Milan Triennale.
Early versions used a fibreglass shade and ABS plastic base but
became entirely ABS when Artemide released the lamp in 1967
in orange, purple and white. Like many early Artemide designs,
the name is linked to Greek mythology – in this case Nessus, the
famous centaur. The 54-centimetre-diameter shade houses four
bulbs that evenly distribute the light across a large area, creating
a soft, even glow. While Nesso remained a two-part design even
when produced in the one material, its overall expression is that
of a continuous form, like a colourful fountain.

1965

LOCUS SOLUS SUNLOUNGER

Gae Aulenti

1964

With its striking tubular frame in yellow, orange, green, blue or white and its bullseye fabric, this bold piece is part of a collection of outdoor furniture with clear references to the Pop art movement. *Locus solus* means a unique, solitary place in Latin – it was Aulenti's assertion that strong colours have a natural connection with the outdoors. Poltronova was the original producer, with some pieces re-editioned from 1977 by Zanotta. In 2016 another Italian company, Exteta, reissued the entire range of sunlounger, floor lamp, side and dining tables, dining chair, armchair and love seat, including the original cushions with their multicoloured target pattern.

BOFINGER CHAIR

Helmut Bätzner

1964-65 Known as the BA1171 then later as the Bofinger chair, after the company that helped develop and manufacture it, the design was not finished in coloured lacquer like many early plastic chairs but dyed all the way through, in yellow, red, blue, green, brown, orange, black or white. Created as additional seating for the State Theatre in Karlsruhe, Germany, a project undertaken by Bätzner's architectural office, it was probably the world's first mass-produced one-piece plastic chair. Light, stackable, compact and weatherproof, Bofinger took only five minutes to make, with more than 120,000 produced from 1966 to 1969.

UNIKKO TEXTILE

Maija Isola

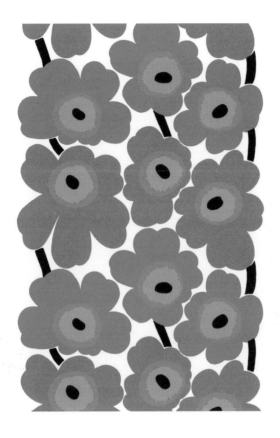

The iconic Unikko (poppy) pattern began as a protest against an
edict from Finnish textile company Marimekko to its designers that
while bright colours were encouraged, florals would not be tolerated.
Maija Isola, one of the company's longest serving designers, wasn't
going to be told what to draw. Her enduring design has been applied
to countless products, from printed cotton clothing, curtains and
bedding to objects such as teapots, mugs and umbrellas – even
Finnair has a Unikko-patterned aircraft (in navy blue and yellow).
While the original hot pink and red colourway remains the most
popular, Marimekko now offers Unikko in more than eighty
different combinations.

1964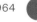

DJINN LOUNGE CHAIR

Olivier Mourgue

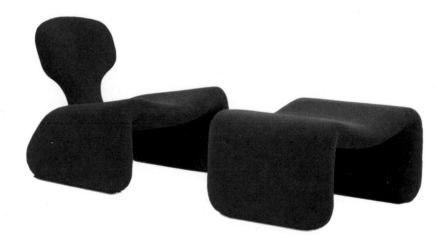

1964-65 The future looked fuchsia in Stanley Kubrick's 1968 film *2001: A Space Odyssey*, in which a cluster of Djinn chairs were immortalised, upholstered in the bold hue. Given the chair's starring role and its futuristic 60s look, it's strange that it was originally called the conventional-sounding Low Fireside Chair. Much more intriguing, the name Djinn possibly comes from the French for genie. Part of a collection designed by Mourgue for French furniture company Airborne International, it was produced in a range of colours from 1965 to 1976 in tubular steel, jute webbing, foam and fabric. The collection included a chaise longue, two-seater sofa and footstool, all in the same wave-like style.

ALLUNAGGIO GARDEN CHAIR

Achille and Pier Giacomo Castiglioni

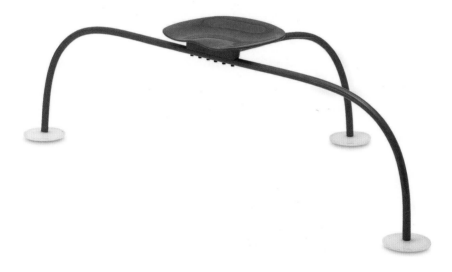

Like a lunar landing module itself, Allunaggio (Italian for moon landing) drew on the world's obsession with Moon voyages, which would reach its peak four years later with the successful mission of Apollo 11. Produced by Zanotta in just the one colour, grass green, the chair with its stylised tractor seat is more for the brief contemplation of nature than any longer term task like relaxing or reading. The three feet of its tripod base are exceptionally widely spaced in order to cast as little shadow as possible on the lawn or plants below.

1965

DALÙ TABLE LAMP

Vico Magistretti

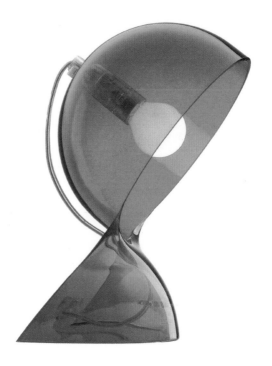

1966

A hollow sphere, split at a 60-degree angle and reconstructed to form both light and base – Italian architect and designer Magistretti had a unique ability to reduce domestic objects to their core elements. While Dalù had none of the mechanical dexterity of Magistretti's Eclisse table lamp (page 93) designed the same year, its simple beauty lay in its shape, with the two polycarbonate pieces seamlessly fused through the use of injection-moulded plastic. The lamp was produced by Artemide from 1966 until 1980 in three opaque colours – red, black and white – and re-editioned in 2005 in opaque black and white plus translucent red and orange.

RIBBON (F582) CHAIR
Pierre Paulin

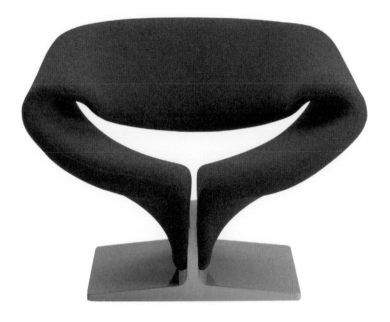

With its obvious link to the Möbius strip, the Ribbon chair swoops in
one continuous gesture to form backrest, arms and seat, delivering
a spectacularly sculptural shape (Paulin studied stone carving and
clay modelling in Paris in the 50s). The main structure is made from
tubular steel interlaced with springs and layered with foam, its two
ends slotting into a lacquered wooden base, offered in silver-grey,
red, black and white. Artifort, the chair's manufacturer, recommends
Kvadrat Tonus, an original 70s fabric by Nina Koppel, as the most
suitable to follow the chair's complex shape without pleating. The
Ribbon chair is typically upholstered in strong, plain colours like
royal blue, red and purple, but Tonus comes in forty-seven shades.

1966

MODO 290 CHAIR

Steen Østergaard

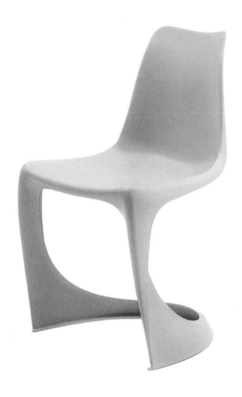

1966

In creating the world's first single-process injection-moulded chair, Østergaard delivered a design genuinely suited to mass production – something that had eluded his countryman Verner Panton when developing his earlier 'S'-shaped chair design. Made from fibreglass-reinforced polyamide, the Modo 290 has excellent stacking ability (up to twenty-five chairs can be stacked and moved on a storage trolley). Originally produced by Danish company Cado in red, white, blue, green, brown and beige, the chair was reissued by Nielaus in 2012 in a similar palette plus a vibrant yellow. An armchair version, Modo 291 (developed in 1969), appeared in the 1977 James Bond film *The Spy Who Loved Me*.

BOLLE VASES

Tapio Wirkkala

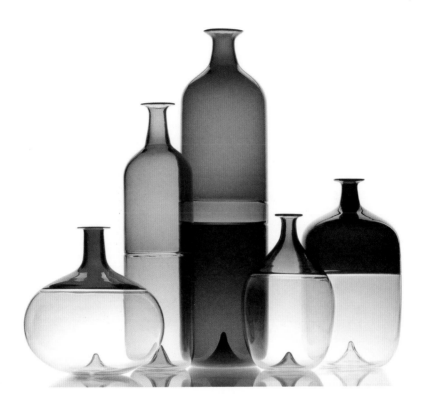

The creations of Finnish designer Tapio Wirkkala, these complementary
delicate forms (*bolle* is Italian for bubbles) were made using the
incalmo technique, where two glass elements are blown separately
then fused with heat. Their unusual colour palette is anchored by
the common use of elegant taupe-grey, with the shade balanced
by another translucent colour in every vase but the largest, where
three shades come together: plum, yellow and green. Produced at
the famous Venini glassworks on the Venetian island of Murano,
each vessel has exceptionally thin walls and features an interesting
cone shape at its base.

1966

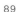

PRATONE LOUNGE CHAIR

Giorgio Ceretti, Pietro Derossi and Riccardo Rosso

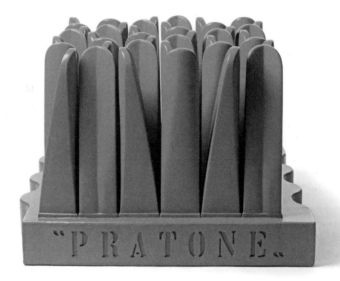

1966-70

The grass doesn't get greener than when its blades are blown up to 100 times their size and reimagined as a seat. Pratone (Italian for meadow) was created by three radical Italian designers for Piedmont-based producer Gufram and challenges the sitter to submit to the unpredictability of one-metre-high flexible stalks of polyurethane foam finished by hand in Guflac® – a leather-look finish specially developed by the manufacturer. The design was part of the famous 1972 exhibition *Italy: The New Domestic Landscape* at New York's Museum of Modern Art. In 2016 a limited edition of twenty Nordic Pratone were produced in white.

GAIA ARMCHAIR
Carlo Bartoli

Based on a cut-away cube with rounded corners and gently curved walls, Gaia was one of the first armchairs to be made entirely of fibreglass-reinforced epoxy resin. Manufactured by arflex in 1967 in bold red, yellow, British green, white and black and, later, with a leather seat and back pad that followed its deep contours, the chair is part of the permanent collection of New York's Museum of Modern Art. The design, which uses shallow arches to add structural strength, was a precursor to Bartoli's highly successful 4875 dining chair for Kartell, the first chair to utilise an injection-moulded polypropylene seat.

1966

KARELIA LOUNGE CHAIR

Liisi Beckmann

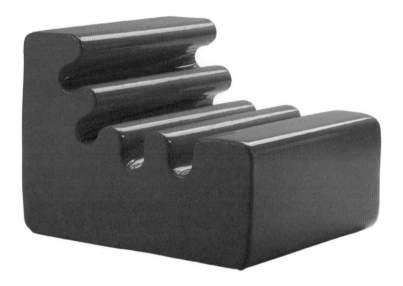

1966

Its unusual shape, with sculptural, exaggerated 'ribs', and glossy exterior suggest a hard seating item, yet due to its solid polyurethane structure, Beckmann's creation is actually extremely comfortable. Named after the Finnish designer's birthplace, Karelia was originally released in a wide variety of colours, including an unusual shade of lilac, along with the more familiar red, yellow, orange, green, white and black – all in vinyl. Reissued in 2007 by its original manufacturer, Zanotta, the chair has since been available in a range of leathers as well. A number of chairs can be pushed together to create an armless sofa that is just as remarkable.

ECLISSE TABLE LAMP

Vico Magistretti

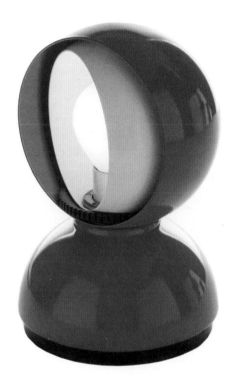

The Italian designer's first sketches show the lamp in red, a colour that seems to best express its personality. At just 18 centimetres high, Eclisse has had to fight for attention, but it remains an icon of 20th-century design. Two half spheres of spun steel set inside one another are supported by a third dome, with a rotating inner shade that can shield the glare of the bulb, creating an 'eclipse' effect from which the lamp takes its name. Still available from original manufacturer Artemide in red, white and orange, Eclisse was awarded the Compasso d'Oro in 1967, the year it was released.

1966

EXPO MARK II SOUND CHAIR

Grant and Mary Featherston

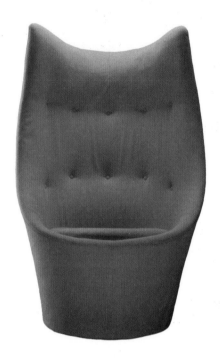

1966

What became known as the Talking Chair offered the sitter a unique experience. Designed and manufactured in Melbourne in just twenty-four weeks for the 1967 Montreal Expo, the chair featured a pressure switch in its seat that triggered a remote tape recording of prominent Australians, which played through speakers concealed inside a headrest. The rigid expanded polystyrene shell was wrapped in foam, with most of the 250 chairs for the exhibition upholstered in an earthy green fabric and seventy with bright orange seats, the different hue signposting that their narratives were in French. A huge success, the chair went into commercial production in 1968 with the addition of ten buttons to the upholstery, integrated speakers and a volume knob on one side of the base.

OZOO DESK AND CHAIR

Marc Berthier

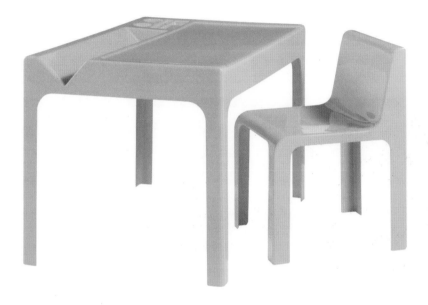

A pioneer of moulded plastic forms, Berthier designed his child-friendly pieces for mass production, but early examples by French brand Roche Bobois were made by boat builders in a more manual process. The collection, made from fibreglass-reinforced polyester, also featured beds and storage units, and its success led to an expanded range including tables and cocktail tables for adults. The simple shapes are derived from monolith-like blocks with all but the bare minimum material cut away. On its 50th birthday, in 2017, Ozoo was rereleased by Roche Bobois in its five original colours of yellow, red, white, black and the very French-sounding Marron Glacé.

1967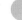

BOBORELAX LOUNGE CHAIR

Cini Boeri

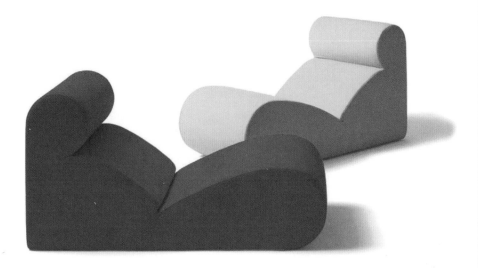

1967

Stretch fabric in vivid shades of red, yellow, orange, violet and ultramarine provides the outer skin to this boldly curvaceous form. The chair, manufactured by arflex, was one of the first to be made entirely from polyurethane foam with no internal support structure or frame. Boeri had worked with Marco Zanuso, the pioneer of polyurethane foam, for several years and it was her understanding of its properties that allowed her to conceive of a monobloc design using multiple layers in different densities. These experiments led to Boborelax and the sofa Bobodivano in 1967, with several equally extraordinary designs following shortly after.

SACCO CHAIR

Piero Gatti, Cesare Paolini and Franco Teodoro

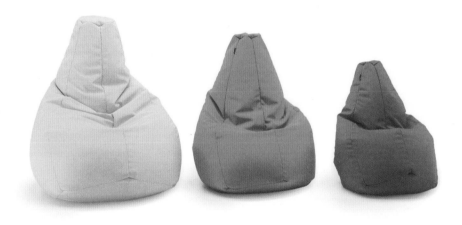

Described by manufacturer Zanotta as an 'anatomical easy-chair', prototyped as Shaped By You and put into production as Sacco (Italian for bag), the world's first beanbag has gone by many names. Looking for a chair that moulded to the body, its designers were inspired by the traditional peasant's mattress, where a hessian sack was stuffed with chestnut leaves. Its first incarnation, a transparent PVC bag filled with polystyrene pellets, caused a stir, with Macy's New York ordering 10,000 before its designers had even approached a producer. Launched at the 1969 Paris Furniture Fair in a nylon fabric developed for the chair, Sacco was an instant hit and came to symbolise an era.

1968

VOLA TAPWARE

Arne Jacobsen

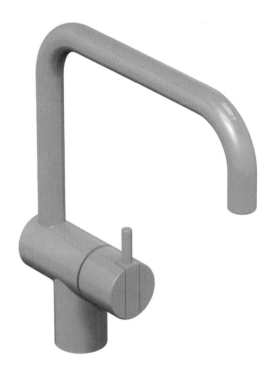

1968

The minimalist architect and designer might have preferred his taps in pale, concrete-like grey, but he recognised the allure of colour, and ten shades were chosen for the product, which made its debut in Jacobsen's design for the National Bank of Denmark. Verner Overgaard, owner of tap manufacturer Vola A/S, had suggested a revolutionary concept with pipework housed in the wall and only the spout and handle visible. Jacobsen embraced the idea, creating an entire collection of modern, super-minimal tapware including the bench-mounted HV1 and KV1 (pictured here). The range is now available in fifteen colours, six of which remain from the original palette.

CARNABY VASES

Per Lütken

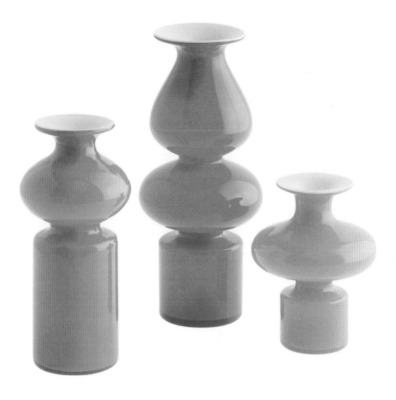

Like the London street of 60s fame that shares its name, the
Carnaby series was colourful and brash – a world away from the
Danish designer's earlier work for local glass company Kastrup
Holmegaard, which was all about restraint. Its curvy outlines and
bright hues (yellow, coral, turquoise) were tailor-made for the times,
with its internal white glass amplifying the candy-like appearance
of its coloured exterior – a marked difference from traditional
translucent glass. While best known for Lütken's onion-shaped
vessels, along with a pitcher and vase with swooping outlines,
Carnaby also includes one vase by Swedish designer Christer
Holmgren, which is often mistaken for a candlestick.

1968

MODEL 75 ANGLEPOISE LIGHT

Herbert Terry & Sons

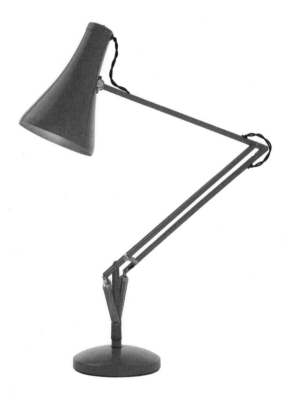

1968

Continuing the engineering principles of earlier versions, the Model 75 Anglepoise, introduced thirty-odd years after George Carwardine's highly successful Model 1227 (page 20), took on a more fluid look synonymous with the 60s. The base changed to a round steel cover over a cast-iron counterweight, replacing the previously stepped square base in cast metal. An on/off 'rocker' switch was added to the top of the shade and a narrower, streamlined shade adopted, giving the design a lighter, more modern and refined appearance. Colour became an even greater feature, with avocado added to the stalwart tones of cream, grey, yellow, red, white and black.

GARDEN EGG CHAIR

Peter Ghyczy

Open or closed, this smooth ovoid piece lives up to its name as well as delivering a burst of colour inside and out. Its lacquered shell has appeared in hues such as red, yellow, tangerine and olive green, with the internal upholstery (of foam and fabric or leather) in a variety of contrasting brights plus black and white. The chair was designed for West German company Elastogran GmbH, who manufactured its main ingredient, polyurethane polymer. The high labour costs involved in perfecting the gloss finish saw production move to East Germany, where it was considered an icon of modern design. In 1998 the rights reverted to Ghyczy, who now produces the chair in the Netherlands under his own name.

1968

UP5_6 ARMCHAIR AND OTTOMAN

Gaetano Pesce

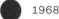 1968

A feminist statement is rare in Italian design, but Pesce insists that the meaning behind his armchair and ottoman has always been about women's enforced servitude to men, with the connected ottoman symbolic of a ball and chain. The armchair's curvy shape, inspired by that of ancient fertility goddesses, has earned it names such as La Mamma and Donna, but the title UP came about due to its startling material mix.

The chair was conceived while Pesce was in the shower, observing how a squeezed sponge expands once released. Taking advantage of the properties of polyurethane foam which, even by the late 60s, was still providing fertile ground for design experimentation, he explored the possibility of creating a self-inflating armchair covered in stretch-knit fabric. Originally sold vacuum packed, the chair was made from a thin skin of polyurethane foam that self-inflated (hence the name UP) once the packaging's vacuum seal was broken.

Released by C&B Italia in five colours and two bold striped patterns (the latter greatly accentuating the voluptuousness of the form), the shape of UP5 changed considerably during early production, with the final version far more upright. Colourways also changed, along with the orientation of the stripes. The early green and beige fabric preferred by Pesce was dropped, with advertising focusing on a red and beige striped version as well as solid colours.

The chair made a theatrical debut at the 1969 Milan Furniture Fair, with numerous examples self-inflating to the amazement of the assembled audience. Unfortunately it was later discovered that Freon 12, the gas embedded in the polyurethane that enabled its inflation, was a major contributor to the depletion of the ozone layer, and UP was reluctantly discontinued in 1973. The same year, C&B (Cassina & Busnelli) Italia was taken over by Piero Busnelli and the name changed to B&B Italia. The chair had become an international sensation in just three years but was consigned to history until 2000, when B&B Italia reissued the UP series in conventional moulded polyurethane foam.

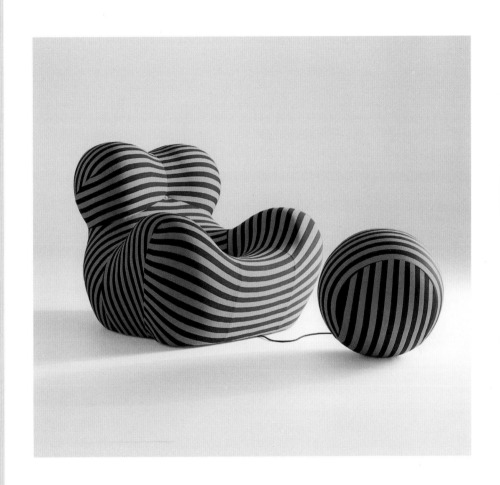

VALENTINE PORTABLE TYPEWRITER

Ettore Sottsass and Perry King

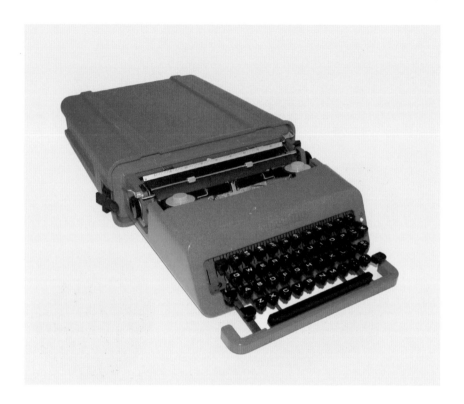

1969

Its moulded plastic form spoke to a new generation, and its bright red colour marked a radical break with convention (white, green and blue were also offered but far less popular). Created in collaboration with British designer Perry King, Valentine was just one of five typewriters Sottsass worked on for Olivetti during his twenty-two years as design consultant to the company, but it shows the Austrian-born, Milan-based designer at his best. An integrated handle united the typewriter with its hard plastic case and doubled as the carry handle, making Valentine an embodiment of the new concept of workplace mobility and a potent symbol of a modern, carefree lifestyle.

COMPONIBILI STORAGE

Anna Castelli Ferrieri

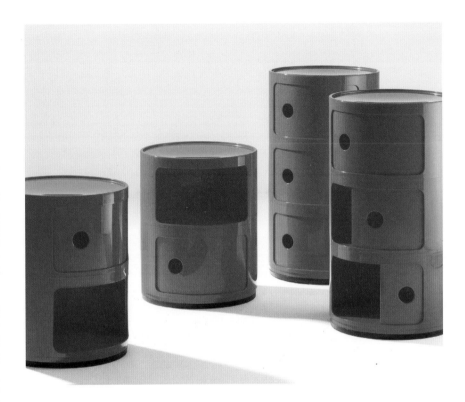

Although designed in a soft-cornered square format in 1967, it was the round version of Ferrieri's storage system, released in four heights by Kartell in 1969, which took the world by storm. With its bold colours, sliding doors, finger holes instead of handles and optional castors, Componibili (Italian for modular) was produced in ABS plastic – a very innovative material at that time – and has since sold more than 10 million units. In 2019 Kartell introduced Componibili in Biomaterial, a substance made from agricultural waste, in pastel shades of pink, yellow, green and cream. These joined regular ABS versions in red, blue, green, violet, black, white and silver, plus metallic chrome, gold and copper.

1967–69

UTEN.SILO WALL STORAGE

Dorothee Becker

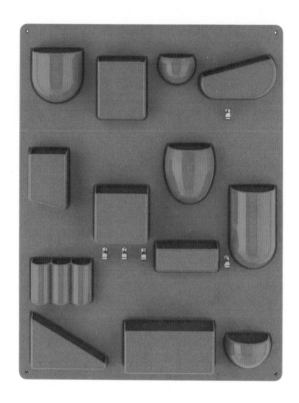

1969

The colourful appearance of Becker's groundbreaking wall organiser comes as much from its eventual contents as the piece itself. Uten.silo consists of a single sheet of ABS plastic with an assortment of moulded pockets and metal hooks and clips. Becker and her husband, lighting designer Ingo Maurer, invested the equivalent of US$400,000 to produce Uten.silo, which was known as the Wall-All in America. It was initially a huge success but production became too expensive during the mid-70s oil crisis and it was discontinued by 1976. The Vitra Design Museum reissued Uten.silo in three colours – red, white and black – and two sizes in 2000.

TUBE LOUNGE CHAIR

Joe Colombo

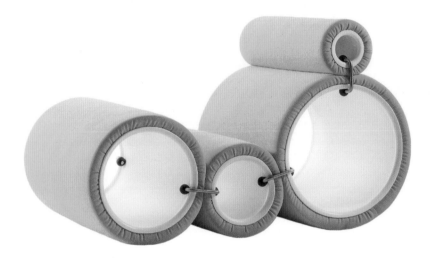

In bright shades including yellow, orange and turquoise, Tube Chair's
four hollow cylinders deliver a colourful sculptural quality and intriguing
silhouette. The different sized tubes, covered in polyurethane foam and
fabric or leather and held in place by fastening clips, can be assembled
in multiple configurations, slipping neatly inside one another when
not in use. A favourite of design museums, Tube reflects Colombo's
obsession with versatility and synthetic materials. Originally produced
by Flexform, it was reissued by Cappellini in 2016 and described by
creative director Giulio Cappellini as 'a milestone in the history of
contemporary design'.

1969

Verner Panton

As a child, Verner Panton (1926–1998) dreamt of becoming an artist. While he chose architecture instead, his work is as close to art as interiors, furniture, fabrics and lighting can possibly be. Best remembered for his outrageous use of colour and his passion for curvaceous forms and swirling motifs, the Danish designer also had a keen intellect, observing the effects of geometry and repetition and utilising mathematics and the scientific (rather than emotional) properties of light and colour.

From his first major commission in 1958 at the Kom Igen Kro, where he added a two-storey modernist pavilion to a traditional village inn, Panton strove for a visually stimulating experience with geometry and colour at its core. The new restaurant, managed by Panton's father, drew much attention, becoming known as the Red Ruby due to the five shades of red used across its decor. Panton designed everything from the uniforms to the inverted cone-shaped dining chairs. Within a year of the restaurant opening, the furniture company Plus-linje was established to manufacture and market his Cone collection.

Shortly after, Panton questioned the need for traditional upholstery altogether, delivering virtually transparent furniture based on repeating chromed wire rings (the Wire Collection of 1959–60) and experimenting with modular seating made of inflated plastic cubes and heat-formed sheets of Plexiglas.

Two key mentors influenced his early years – the author, architect and designer Poul Henningsen and the architect Arne Jacobsen, two of Denmark's most respected mid-century figures and leading proponents of Danish modernism. Panton worked for Jacobsen between 1950 and 1952 while completing his studies in architecture at the Royal Danish Academy of Fine Arts. In Jacobsen's office, he was mainly involved in furniture design and was part of the team that developed Jacobsen's famous Ant chair. This project is key to understanding Panton's fascination with materials and influenced his direction in furniture design.

Panton's cantilevered plywood S-Chair (Models 275/276), designed in 1956 and produced by Gebrüder Thonet in 1965, achieved his goal of a chair in one continuous form and singular material, but Panton was keen to push further and looked to synthetic materials to achieve this. His now iconic Panton Chair, developed with Vitra and first shown to the press in 1967, was the culmination of this intense period of research.

The following year Panton embarked on the first of a series of large-scale exhibitions for German chemical company Bayer. On a multilevel ship docked on the Rhine during the annual Cologne Furniture Fair, he created a vibrant immersive environment in which to promote the company's new synthetic fabrics. Here, he installed vast numbers of his Flowerpot lights (pages 112–13) as part of a complete sensory experience. Later projects, such as his *Visiona 2* exhibition in Cologne (1970) and the Varna restaurant in Aarhus, Denmark (1971), would take his theories on colour zoning and emotionally stimulating spaces to mind-blowing new levels.

A prodigious designer, Panton was motivated by his desire to innovate and stimulate, with a rare ability to do this across a multitude of mediums. (In textiles alone, he created hundreds of vibrant, predominantly geometric patterns for Danish textile company Unika Vaev and Swiss fabric house Mira-X.) 'Most people spend their lives living in dreary, grey-beige conformity, mortally afraid of using colours,' he said. 'I try to show new ways, to encourage people to use their imagination and make their surroundings more exciting.'

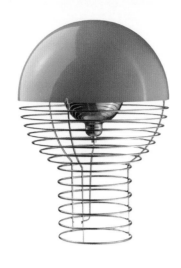

CLOCKWISE FROM TOP LEFT
Wire lamp, 1972, re-editioned by Verpan, 2009;
Curve fabric from the Decor 1 collection for
Mira-X, 1969; Panton Chair, designed 1958–67,
produced by Vitra, 1967–79 and 1990 to the
present; VP08 rug, 1965, produced by Designer
Carpets; *Living Sculpture*, one of two prototypes
for Kill und Metzeler Schaum, Cologne
Furniture Fair, 1972.

OPPOSITE PAGE Verner Panton in his
Living Tower design, *c.* 1969.

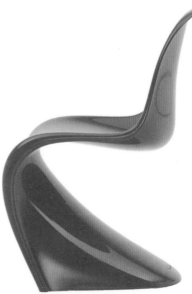

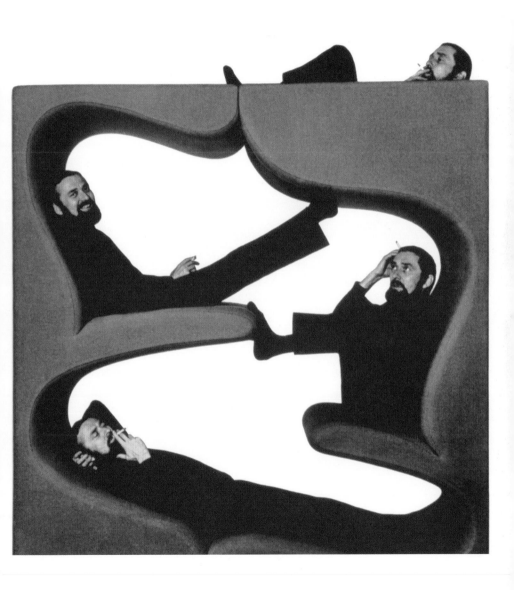

VERNER PANTON

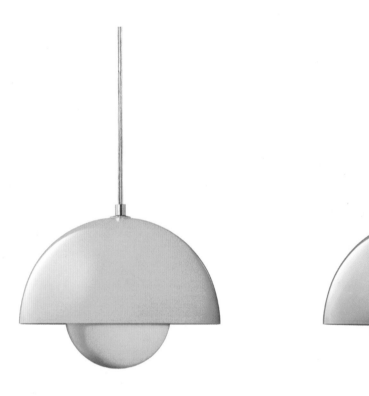

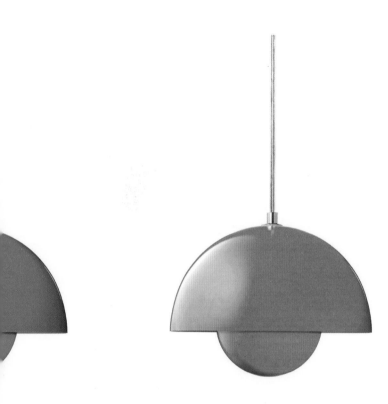

FLOWERPOT PENDANT LIGHT — 1968

A year after San Francisco's Summer of Love, the presentation of massed groups of colourful Flowerpot lights at Cologne's 1968 *Visiona* exhibition was Danish architect Verner Panton's witty response to the hippie flower power movement. Exhibiting his pursuit of mathematical precision, the top dome of the shade is exactly twice the size of the lower upturned hemisphere, which was positioned to reduce glare from the bulb. Originally released by Danish lighting company Louis Poulsen in glossy red, turquoise, white and orange, later versions were overlaid with psychedelic swirls. The light is currently produced by another Danish company, &Tradition.

MULTICHAIR

Joe Colombo

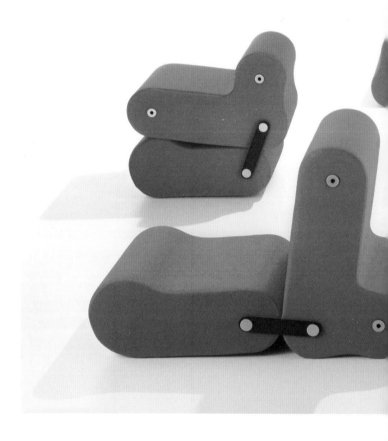

1970

As its name suggests, this chair can be different things to different people, encouraging an individual approach to sitting and lounging as it challenges the user to configure its two seating elements any way they want. Both cushions comprise an internal steel structure covered in polyurethane foam and stretch fabric, and are held together in their various positions by small leather belts, pins and buckles. Originally manufactured by Bieffeplast in red, black and electric blue, Multichair has since been reissued by fellow Italian company B-Line in just the former two colours.

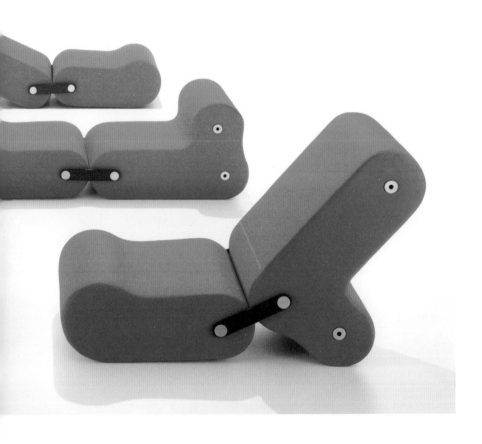

BEOLIT (400/500/600) RADIOS

Jacob Jensen

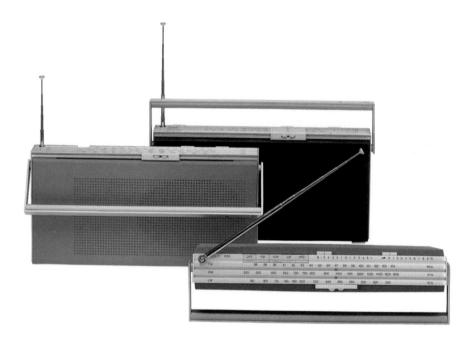

1970

Referred to simply as 'the colour radios' by many at the time, these immaculate products, created for Danish electronics company Bang & Olufsen, revolutionised radio design and set the style for many high-fidelity products that followed. Aesthetically, radios had been stuck in the 50s, looking more like clunky handbags than electronic devices. By contrast, the different Beolit versions, produced in aluminium with plastic clip-on covers in a range of jaunty colours, delivered a design that was highly architectural but with plenty of flair, winning them design awards and entry into New York's Museum of Modern Art Design Collection as early as 1972.

BOBY STORAGE TROLLEY

Joe Colombo

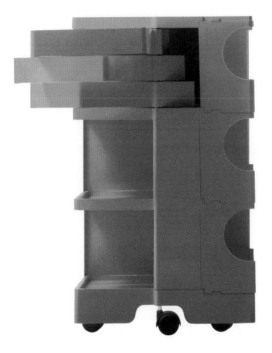

Like most of Colombo's products, the colourful, compact Boby offers
great versatility and flexibility for the user. Its detailed, injection-moulded
ABS plastic body provides a multitude of storage compartments and
pivoting drawers, while polypropylene castors make it easy to move
around. Boby was released by Padua furniture and lighting manufacturer
Bieffeplast, and although production stopped when the company
closed in 1999, it was picked up the very same year, and in the same
city, by B-Line. Available in four heights, Boby now comes in red,
yellow, verdegris, white, grey and black.

1970

REVOLVING CABINET

Shiro Kuramata

1970

It may have only been produced in one colour, a glossy red, but that shade suits the energy of the cabinet, which, like a kinetic sculpture, defies the notion of static furniture. Standing just over 1.8 metres high, it comprises twenty identical acrylic drawers that pivot around a vertical rod. While the drawers can be aligned in one streamlined block, the cabinet is at its dynamic best when creatively chaotic or with the drawers sequentially shifted to create a spiral effect. Kuramata, a member of the Memphis movement, came to the attention of Giulio Cappellini, whose company put the cabinet into production in 1987.

ETCETERA CHAIR

Jan Ekselius

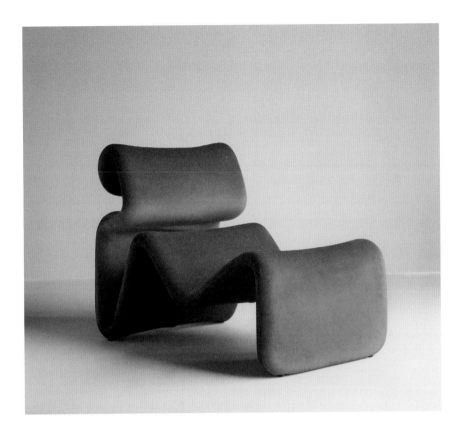

Considering the fluid shape and range of bold colours – not to mention a brown velour version – it would be hard to find a chair more in tune with its time. Etcetera was a hit for its original Swedish manufacturer, J.O. Carlsson, in the early 70s and became known simply as the 'Jan chair' in the US. The current producer, Ekselius Design, has made internal changes to the sling material to improve comfort, but the chair still comprises a tubular steel frame and stretch cotton-velour fabric in green, yellow, blue, two reds, brown, beige, grey and white. A matching footstool is also available.

1970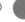

LE BAMBOLE ARMCHAIR

Mario Bellini

1970-72 The outrage caused by Le Bambole's advertising campaign, featuring Warhol muse Donna Jordan sprawling topless across armchairs and sofas, guaranteed newly formed furniture brand B&B Italia plenty of media attention, but it is the design's inviting qualities and casual air that have ensured its exceptional longevity. Originally marketed in virginal white, Le Bambole (Italian for dolls) is now more widely known in vibrant red. While the armchair appears to be made solely of cushions, it contains a flexible structure embedded in the polyurethane foam that helps to maintain its shape. The range, which also included beds and a pouf, won the Compasso d'Oro in 1979, seven years after its launch.

CACTUS COAT STAND

Guido Drocco and Franco Mello

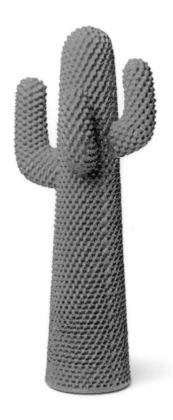

More of a subversive art piece than a household item, Cactus
began life in emerald green, although that edition is now more likely
to be seen in a design museum than a domestic interior. Since its
audacious debut, the 170-centimetre-high soft polyurethane stand
has been released by avant-garde Italian brand Gufram in different
shades, including white (Biancocactus, 2007), red (Rossocactus,
2010), black (Necrocactus, 2010), green with orange tips, as if burnt
by the sun (Metacactus, 2012), and even a multicoloured version in
collaboration with fashion designer Paul Smith (Psychedelic Cactus,
2016). Regardless of whatever colour is in production, the cheeky
concept continues to surprise.

1972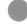

OMKSTAK CHAIR

Rodney Kinsman

1972

With its lively colours, low-profile lines and circular perforations, Omkstak stood out as a robust and thoroughly modern British design. It was also in tune with the new high-tech style finding favour through the work of architects like Richard Rogers, whose industrial yet colourful concept for Paris's Pompidou Centre was creating a sensation. Constructed from two pressed sheets of steel fastened to a chromed tubular steel frame, Omkstak makes a feature of practical solutions. The handle cut-out allows for easy carrying, while the lean frame and perforations reduce its weight, enabling the stacking of up to twenty-five chairs. Omkstak has sold more than one million units and is now offered with colour-matched frames.

MODUS CHAIR

Centro Progetti Tecno

The Modus chair was conceived around a seat shell component with a variety of bases to suit all the activities required in the modern office. Produced in glossy polyamide (nylon), the shell was offered in four vibrant colours: red, yellow, green and blue, plus black and white. Manufactured by Italian furniture company Tecno, the collection was designed by their newly established in-house R&D group, Centro Progetti Tecno, and included a bench seating option for waiting areas, swivelling chairs and a height-adjustable drafting chair with foot ring. Armrests and upholstered seat and back pads could be added, while a brilliantly simple 'X'-shaped trolley (seen above) facilitated the stacking of ten chairs.

1972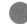

EKSTREM LOUNGE CHAIR

Terje Ekstrøm

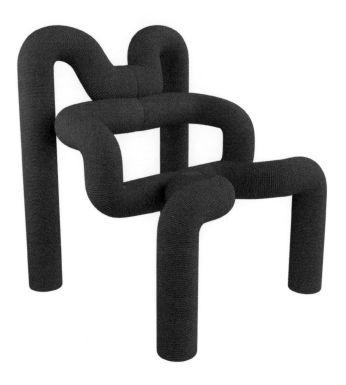

1972

Its vivid colours and strong graphic shape eventually made Ekstrem (Norwegian for extreme) an 80s icon, but that was a long time coming given that it didn't go into production with Norwegian company Hjellegjerde until 1984. Ekstrem marked a major break from most Norwegian designs, which followed the functional modernist model found in Denmark and Sweden. Its unique squiggly lines are created by bent tubular steel covered in polyurethane foam and a stretch-knit fabric. The voids between the tubes are as central to the design as the tubes themselves, allowing the user to sit comfortably in many different ways, even backwards.

SHIVA VASE

Ettore Sottsass

In what other colour but flesh pink could you make a 23-centimetre-high, penis-shaped vase? The answer is gold. Shiva may seem like a schoolboy prank, but to Sottsass it was a spiritually significant and architecturally meaningful piece of design. He created the stylised piece during a turbulent affair with an artist from Barcelona. Travelling between the Catalan capital and his home in Milan weekly for close to four years nearly led to his studio's ruin, but Sottsass described it as 'three years of ecstasy'. Shortly before his death in 2007, he approved the production of the gold Shiva vase, which was released by BD Barcelona Design in an edition of fifty in 2014.

1973

TOGO SEATING

Michel Ducaroy

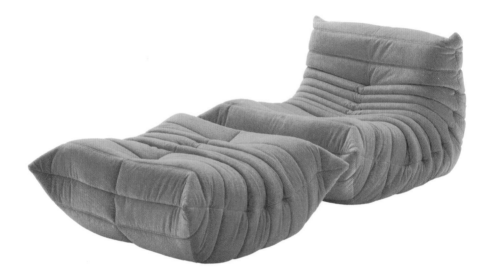

1973

Where many objects are designed in a limited range of specific colours, the Togo collection of low modular seating has embraced everything from brights to florals, checks and even metallics during its impressive life span. At the time of its fortieth anniversary, in 2013, the collection was offered by French furniture brand Ligne Roset in an astonishing 899 shades of fabric and leather. Togo sofas, lounge chairs (pictured here) and poufs have no internal structure, just three different densities of foam. The collection's squishy, pleated forms embodied the counter-culture spirit of the 70s and remain a sensation, having sold more than 1.5 million pieces to date.

HOMAGE TO MONDRIAN CABINET

Shiro Kuramata

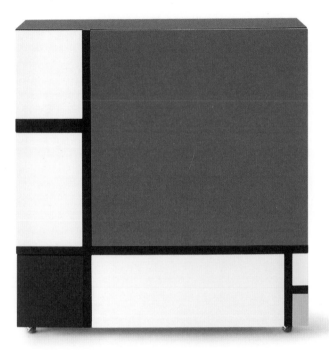

The name immediately conjures up the dynamic blocks of primary
colour and bold black lines for which the Dutch abstract artist was
famous. And Kuramata's creation works as an artwork in itself while
also delivering functional surprises, with doors and drawers concealed
behind some – but not all – of the graphic shapes. The celebrated
Japanese designer fashioned two styles: one of which (pictured here)
appears to be a direct representation of Piet Mondrian's *Composition
II in Red, Blue, and Yellow* from 1930; the other of the lesser known
Composition with Yellow from 1936. Cappellini has produced the
design since 2009.

1975

SINTESI LAMP

Ernesto Gismondi

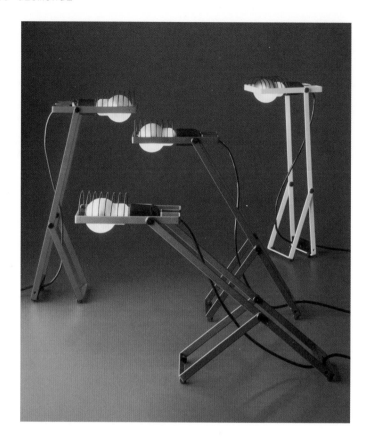

1975

Stripped of all but the bare framework required to operate, Sintesi (Italian for synthesis) happily morphs between table lamp, task lamp and even wall light thanks to its folding and articulating design. Produced in a range of strong colours including a vivid green, bright orange and blue, the range also included a floor lamp, small wall appliqué and wall-mounted, swing-arm version. Particularly interesting are the fine arched wires, which form the shape of a shade without actually acting as a reflector. Sintesi was the first lighting design of Gismondi, who founded renowned lighting company Artemide in 1960.

SPAGHETTI CHAIR (101)

Giandomenico Belotti

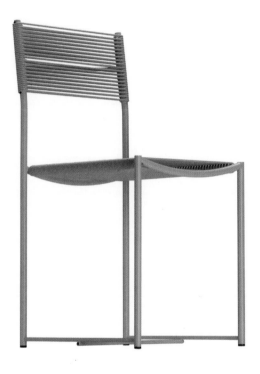

Delicate in transparent PVC cord but full of personality in solid primary colours (and, later, more subtle hues), this chair owes its ultimate success to the unwavering determination of designer Giandomenico Belotti, a man with an enormous capacity to refine and perfect, and entrepreneur Enrico Baleri. Created for Baleri's experimental Pluri company in 1974, Odessa – as the chair was then named – was perhaps too minimal for the era. After five years of fine-tuning, it was the first offering for Baleri's new company, Alias (founded with Carlo and Francesco Forcolini and Marilisa Decimo in 1979), and proved extremely popular when exhibited in New York that same year. Referred to simply as the Spaghetti chair, it was suddenly a hit, its look at last in harmony with the times.

1974–79

Alessandro Mendini

Architect, designer, artist, author and critic Alessandro Mendini (1931–2019) is known as much for his Anna G corkscrew as for his major architectural work – the Groninger Museum in the Netherlands – and his years of editing influential design magazines *Casabella*, *Modo* and *Domus*. Designed in the 90s for Italian metal specialist Alessi, the corkscrew's colourful appearance and friendly personality reveal a humanistic approach to design that is a defining attribute of Mendini's work.

With a highly analytical mind, a deep interest in art from the Pre-Raphaelites to Cubism and a dedication to using colour, pattern and symbols in his work, Mendini constantly questioned the artist's role in design and vice versa, suggesting design was a 'subspecies of art'.

Mendini began studying engineering at the prestigious Politecnico di Milano, but found the aesthetic choices in architecture more interesting and switched courses. During this period he lived in an apartment with his aunt Marieda Di Stefano and her husband, Antonio Boschi, surrounded by art. The 'artistic direction' of the entire building was overseen by prominent Milanese architect Piero Portaluppi and the apartment, filled with the couple's art collection, is now preserved as a museum.

In 1965 Mendini joined Nizzoli Associati, a highly regarded graphic and product design studio. Here and later, through his work for design magazine *Casabella* (he was managing editor from 1970 to 1976), he met key proponents of the Italian Radical movement such as Archizoom, Superstudio, Ettore Sottsass and Gaetano Pesce. It was also the period of provocative magazine covers and Mendini created designs that he referred to as his 'spiritual' objects. One such example was a simple geometric wooden chair perched on a shallow pyramid, which was set on fire outside *Casabella*'s offices and photographed for the July 1974 cover. Mendini would go on to launch his own magazine, *Modo*, in 1977, and work as editor-in-chief of *Domus* from 1980 to 1985.

In 1978 Mendini became a member of the avant-garde design group Studio Alchimia, joining notables such as Ettore Sottsass, Andrea Branzi and Michele De Lucchi. A precursor to Memphis, Studio Alchimia advocated decoration, humour and irony in reaction to the doctrine of form and function. Mendini's now iconic Poltrona di Proust (Proust chair, page 135), a replica 18th-century chair painted in a Pointillist style, was an intellectual exercise he set himself at this time and shows his interest in both the blurred line between artist and designer and the permeability of historical and cultural references.

Mendini often made reference to 'serious play' and his work with Alessi in the 90s and 2000s delivered dozens of objects that were fun and perfectly functional. 'All my objects are like characters,' he said. 'One is good, another one is bad. It's a kind of comedy and tragedy.'

In 1989 he formed Atelier Mendini with his younger brother, Francesco, collaborating with a variety of brands from highly crafted artisan operations like Venini to major global accessories companies like Cartier, Hermès, Swatch and Swarovski to furniture groups like Zanotta, Cappellini and BD Barcelona Design.

Mendini's work was playful and dramatic with a strong use of pattern and a keenly observed approach to colour – both of which are gloriously evident in the golden yellow tower, giant polychrome staircase and mix of deconstructed and geometric forms he designed for the Groninger Museum. 'I have always treated the matter of colour in a very instinctive way,' he said. 'I may rely on rules and methodologies, but they spring from instinct, not from optico-scientific or spiritualistic facts.'

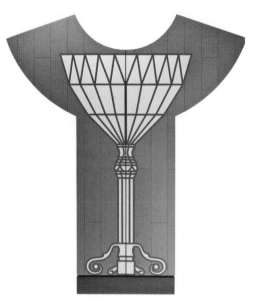

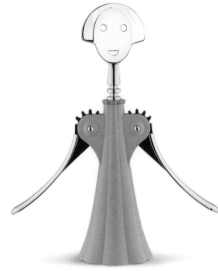

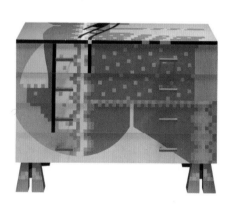

CLOCKWISE FROM TOP LEFT
Cristallo cupboard for BD Barcelona Design,
2018; Anna G corkscrew for Alessi, 1994; Zabro
table chair, 1984, re-editioned by Zanotta,
1989; Calamobio cabinet, 1985, re-editioned
by Zanotta, 1989.

OPPOSITE PAGE Alessandro Mendini in his
studio in Milan, 1997. Portrait by Gitty Darugar.

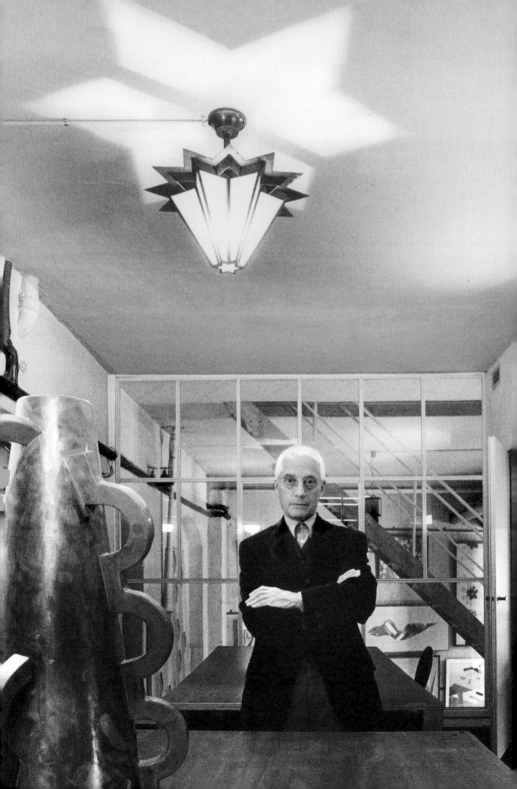

ALESSANDRO MENDINI

FANDANGO (SLR100) — 1994

Summery, fun and a little madcap, Mendini's watch designs for Swiss
company Swatch represent the perfect antidote to the serious,
heavily engineered watches favoured by the older generation.
Mendini designed a number of watches for Swatch, delivering his
idiosyncratic colour combinations – sugary pastels of coral, mint
green and purple meeting turquoise and Bordeaux red – often
overlayed with primary hues. Fandango, a musical watch, has
many of the hallmarks of Mendini's Studio Alchimia period with
its light-hearted reinvention of everyday objects and love of bold
geometric patterns – in this case, playful symbols of beach life such
as umbrellas, flags and stripes. The watch's alarm plays a theme by
French contemporary composer Jean-Michel Jarre.

POLTRONA DI PROUST — 1978

An Italian avant-garde designer imposing French Impressionist
techniques on a Rococo-style chair – no wonder its name
references Proust's writings on time and place. The chair owes its
vivid blur of dotty colour to Pointillist painter Paul Signac – Mendini
projected a slide of one of Signac's paintings onto an existing
Rococo revival-style chair and had the pattern hand-painted
directly over its entire surface, frame included. The production
version, released by Cappellini in 1993, still with hand-painted
frames, has printed upholstery available in two colour palettes.
In 2009, Cappellini brought out a third version with upholstery
in a bold Mendini-designed geometric fabric.

CARLTON ROOM DIVIDER

Ettore Sottsass

 1980

A totemic room divider, bookshelf and chest of drawers all in one, this iconic design by Ettore Sottsass, a founding member of the Memphis Group, was presented at the group's first exhibition in 1981. The exhibition brought together the talents of more than a dozen designers including Martine Bedin, Andrea Branzi, Hans Hollein, Shiro Kuramata, Michele De Lucchi, Javier Mariscal, Nathalie Du Pasquier, Peter Shire, George J. Sowden, Matteo Thun and Marco Zanini.

The Milan-based movement turned its back on functionalism and perfect proportions, embracing the excessive application of colour and pattern, along with the use of 'ordinary' materials like plastic laminate and printed cottons. Often operating on the cusp of what was deemed bad taste, the group was ultimately short-lived, disbanding in 1988, three years after Sottsass had left to focus on his architecture studio.

The designer had questioned the longevity of Memphis as a movement but felt there was an overwhelming need for a new approach where excitement, irony and unbridled decoration were part of architecture and design. Having caused a fundamental shift in creative thinking, Memphis certainly remains a landmark in the history of 20th-century design and continues to influence contemporary designers to this day.

The Carlton structure resembles some sort of futuristic tribal deity or colourful totem, with a stick-figure symbol of man balanced at its apex. Like his Tahiti table lamp (page 139), designed the same year, Sottsass's Carlton shelving is set on a plinth made from a squiggly patterned laminate in black and white called Bacterio. This plastic material was designed by Sottsass for Abet Laminati in 1978 and used extensively across Memphis furniture and lighting pieces.

In combination with this grounding element, solid-coloured laminates in characteristic Memphis tones are used across the geometric structure, with most of the bookshelf's verticals positioned at highly unconventional angles. While these appear haphazard at first glance, the various horizontal shelves and leaning uprights are perfectly symmetrical in their placement and colour, creating a complex yet ultimately balanced object.

WINK (111) ARMCHAIR

Toshiyuki Kita

1980

Prone, it sits just centimetres off the floor and stretches out to offer 2 metres of colour-blocked bliss. Upright, it becomes a lounge chair with a comparatively small footprint. This transformative quality, together with its playful use of colour, made Wink an overnight sensation for producer Cassina at the onset of the 80s. Of course, adding to its popularity were the individually adjustable headrests resembling Mickey Mouse ears, lending an unusual manga-meets-Disney cuteness. The design features removable fabric covers in one-, two- or three-colour versions that can unify the piece in a single tone, highlight just the headrests or celebrate each separate upholstery component.

TAHITI TABLE LAMP

Ettore Sottsass

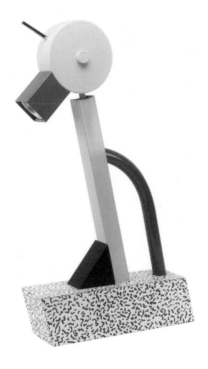

In one small, distinctive object, this lamp sums up the approach
to design taken by the Memphis Group, of which Sottsass was a
co-founder. Its friendly duck-like appearance is the total opposite
of the controlled modernism sought by most designers and reflects
the group's love of combining garish colours and energetic patterns
in a way that was to become one of the overwhelming features of
Memphis. Made from lacquered metal in startling shades of flesh pink,
dark red and bright yellow, with a base of Sottsass-designed Bacterio
laminate, the Tahiti table lamp has a compelling anthropomorphic
quality and a childish naivety. It is still being produced using the
original Abet Laminati laminate from the 80s.

1981

SINDBAD (118) LOUNGE CHAIR

Vico Magistretti

1981

Inspired by the beauty of English stables, Magistretti designed a steel structure with a black lacquered wooden base and draped it with colourful upholstery reminiscent of a traditional woollen horse blanket. The Sindbad collection, designed for Italian furniture company Cassina (with whom Magistretti had been regularly collaborating since the late 50s), also included a sofa, footstool and crescent-shaped, oak-topped coffee table. The upholstered pieces were offered in yellow with black herringbone trim, bold green with red trim, and red with navy blue cotton binding. Appearing to be nonchalantly thrown into place, the coverings were in fact secured by just two buttons.

FLOWER VASES

Marco Zanini

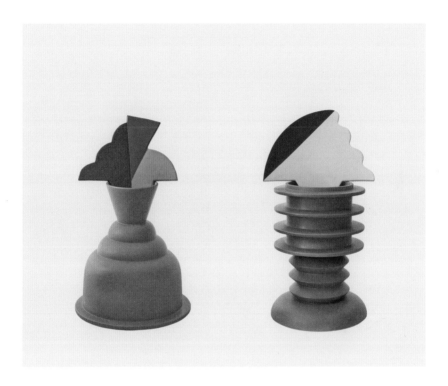

The boldly coloured abstract 'flowers', which fit atop these vases like stoppers in a decanter, remove the need for the real thing. Individually named after three of the world's great lakes, Baykal, Tanganyika and Victoria (the latter two examples are shown here), Zanini's Flower vases were created for the second Memphis Collection, which was presented at the 1982 Milan Furniture Fair, then for the first time internationally in New York that same year. Made from turned glazed stoneware, the vases share a lilac hue but their shapes and heights (ranging from 48 to 65 centimetres) are quite different. All three vases have been produced continuously since 1982.

1982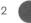

ROYAL CHAISE
Nathalie Du Pasquier

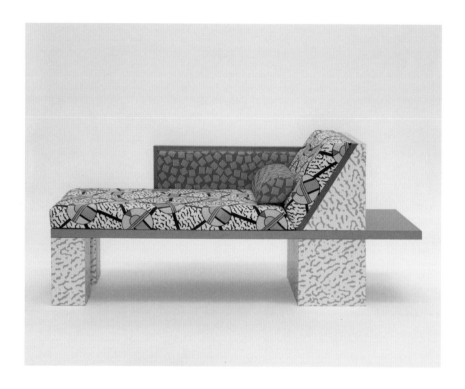

1983

The complex composition of patterns in printed fabrics and laminate, on what is otherwise quite a classic chaise longue form, owes much to Du Pasquier's fascination with wax-printed and traditional woven textiles from West Africa, injected with elements found in comics and graffiti art. While initially contributing textile and laminate designs to the early Memphis collections, by 1983 her work had begun to include rugs and furniture pieces. As well as the chaise itself, Du Pasquier designed its main upholstery, Cerchio, and its patterned laminate, Craquelé, which was produced by Abet Laminati. The fabric for the lumbar cushion and armrest was designed by fellow Memphis Group designer George J. Sowden.

CALLIMACO FLOOR LAMP

Ettore Sottsass

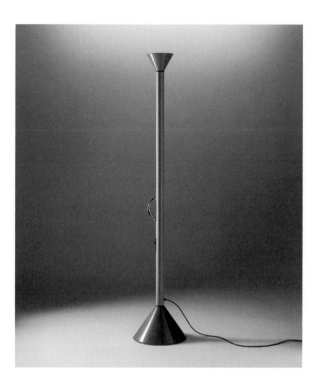

Possibly named after the Greek sculptor Callimachus, who reputedly designed the Corinthian column and carved the golden lamp that burned perpetually in the Erechtheum on the Acropolis, Sottsass's 2-metre-high floor lamp may not have burned for ever but did become known as the 'horn of light'. Designed for Artemide at the height of the Memphis era, its cylinder and cone shapes are painted in irreverent shades of yellow, red and grey. An off-the-shelf chrome drawer handle – practical for transportation but totally incongruous – adds a Duchamp-style element in gentle self-mockery of its architectural references. Recent upgrades have seen the lamp's original sliding dimmer and tungsten bulb replaced by an invisible touch dimmer and LED.

1982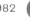

SOFA WITH ARMS

Shiro Kuramata

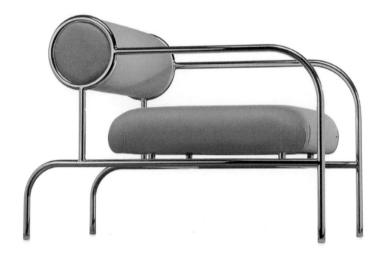

1982

Stripped back to a chromed tubular steel frame with just two upholstery elements – a square seat and cylindrical, bolster-style backrest – the chair was created by Kuramata for his friend and patron Issey Miyake (Kuramata designed most of the fashion icon's stores worldwide until 1990). Viewed in profile, it has a powerfully two-dimensional appearance, which works in the design's favour when several chairs are placed in a line to form a type of sofa divided by arms (hence the name) – in this arrangement, the backrests appear continuous. The chair's producer, Cappellini, has added the option of a black frame but continues to recognise the role vividly coloured fabrics play in the overall aesthetic.

SANCARLO ARMCHAIR

Achille Castiglioni

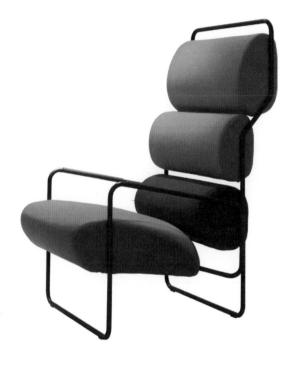

In response to a commission given by Italian furniture producer
Driade to three well-known Italian architecture and design studios,
Castiglioni's answer was simple, yet typically clever. Four cushions,
independently suspended between a tubular steel frame, form
Sancarlo's seat and back, resulting in an extremely light appearance
for an upholstered chair. The two-part frame comprises one loop
to form the front legs and armrests, another the rear legs and high
backrest. The cushions are offered in one continuous shade of
fabric or leather, or in a four-colour gradient. A two-seater sofa with
just three cushions (and therefore a lower back) was also produced,
and both were reissued in 2010 by Italian brand Tacchini.

1982

ALBERO FLOWERPOT STAND

Achille Castiglioni

1983

Likened to a 'vertical wood', the dynamic Albero (Italian for tree) stands 1.5 metres high and presents a unique figure in the domestic landscape. Originally offered in light blue, pink, dark red, green, black and white, the palette has been reduced to the final four since its reissue by Zanotta in 2018. The arms, which end in black plastic pads, can swivel 120 degrees to allow for different sized plants and to adjust to available sunlight. The tripod base can be positioned close to walls to save space, and the entire stand is demountable. The design owes a debt to Castiglioni's own Allunaggio garden chair (page 85) from eighteen years earlier, sharing similar space age-inspired attributes.

ZYKLUS ARMCHAIR

Peter Maly

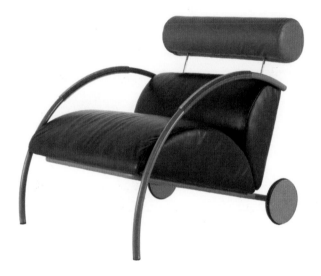

With all its elements based on a circle (*Zyklus* is German for cycle or circle), this post-modern design combines Maly's love of tubular steel furniture from the Bauhaus with the bold geometric gestures found in the Memphis movement, of which he was a member. Designed for German brand Cor, the chair came in a feast of colours, in either one shade or two (with the headrest given its own hue), and the frame either chromed or painted. While electric blue and chrome was a common choice, vintage pieces show how wide the options were, with examples including bright magenta with a purple headrest, and a red frame with black leather.

1984

KETTLE 9093

Michael Graves

1985

The soft blue that Graves chose for the handle of his stove-top whistling kettle became such a favourite with Alessi that the shade has been incorporated into other subsequent offerings by the Italian brand. Graves utilised common post-modern motifs of the cone, circle and sphere, but the moulded polyamide bird whistle was a whimsical addition to this best-selling design – more than two million have been sold since its launch. Although the kettle also comes with white or black accents, the unusual pairing of sky blue and burgundy has become its iconic iteration, forever associated with the New York-based architect and designer.

THINKING MAN'S CHAIR

Jasper Morrison

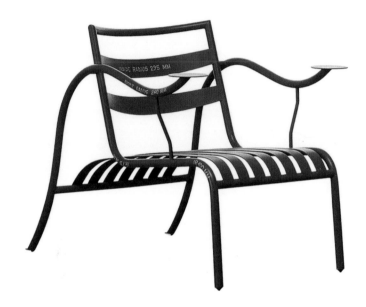

What started out as rust-proofing primer on an early limited-edition version has become the signature colourway for this design. After hand-spraying the chair in red oxide, Morrison felt it looked 'a bit raw' so he added the dimensions of each metal curve's radius in chalk, sealing the writing with hairspray. Based on an antique armchair with its cushion removed, the chair comprises twenty-two pieces of tubular and strip steel. Released in 1989, it became the first of more than thirty designs Morrison has created for Cappellini. Although it's also available in soft green, grey and white, the primer colour is the only version to incorporate handwritten dimensions.

1986

FELTRI (357) ARMCHAIR

Gaetano Pesce

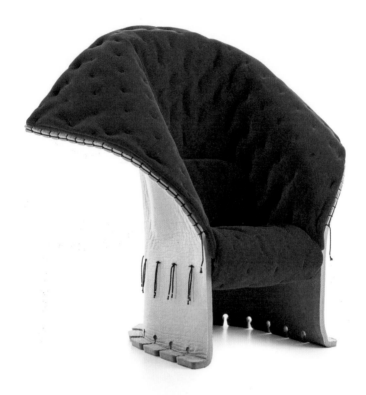

1987

The idea for Feltri hit Pesce while he was walking along a street in Hong Kong, observing the effect of rain on felt mats. The chair works like a giant quilt that hugs the sitter. Cut from one sheet of heavy wool felt, its exterior form is self-supporting, thanks to Pesce's experimentation in soaking sections with resin to create rigid and pliable zones. The soft, quilt-like interior is attached with hemp ties. Beyond the extraordinary throne-like shape, in both high- and low-back versions, the design embraces colour in significant ways, with the option for tone on tone or contrasting combinations.

FELT CHAIR

Marc Newson

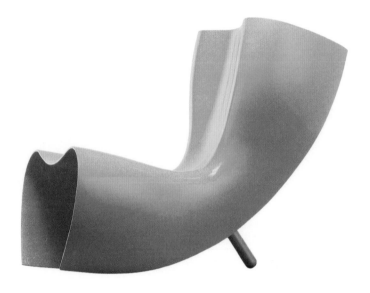

Originally conceived for Japanese company Idée as a thin fibreglass
form sandwiched between two sheets of industrial felt, the chair
has subsequently undergone several fundamental design changes.
Newson was inspired by the work of German artist Joseph Beuys,
who often worked in felt, but his concept only came alive when that
material was ditched and the design given the freedom to express
itself in two opposing forms – a highly textural, hand-woven rattan
(produced by Idée since 1990) and this smooth, glossy and brightly
coloured fibreglass version (produced by Cappellini since 1993).

1989-93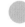

BIRD CHAISE

Tom Dixon

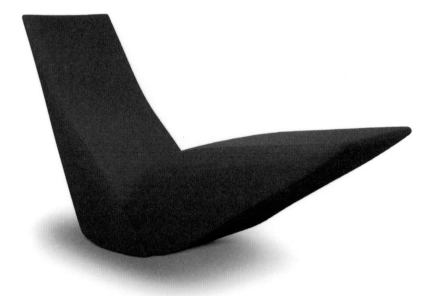

1990-91 — First designed and made in steel in Dixon's South London workshop, Bird was spotted and quickly licensed by Italian furniture label Cappellini, and reworked for release in plain, colourful fabrics – commonly in navy blue, but also red, orange and purple. Unlike the traditional chaise longue, the design's unique shape allows it to gently rock back and forth upon a small plastic pad concealed in its base. While its bird-like shape is unusual, its construction is fairly conventional, using fibreboard, wood and metal to create a frame over which foam padding is wrapped and a tight, removable cover zipped in place. Tom Dixon's own company once again produces Bird, upholstered in Kvadrat Hallingdal, Tonus or Tonica fabrics with many bright colours offered.

GETSUEN CHAIR

Masanori Umeda

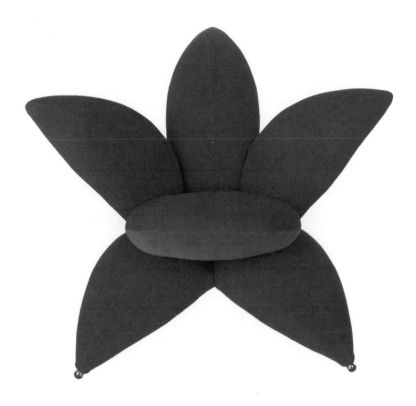

Upholstered in velvet to emulate the downy softness of petals, the lily-shaped Getsuen chair was created as a post-modern homage to nature and a reaction against global industrialisation. The flower motif continues with a stamen represented by the stitching and button tufting on the seat and a stylised stem suggested by a third leg at the rear with lime green wheels, similar to those found on skateboards – an incongruous feature but a practical solution to the challenge of moving such a large and unusually shaped chair. Getsuen is offered in twenty-two sophisticated colours – from earthy taupe tones to forest greens and a range of blues – but bright red remains the most popular choice.

1990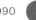

TROPICAL RUG

Ottavio Missoni

c. 1990

Design brand Missoni is synonymous with colour, and this hand-knotted wool rug exemplifies the rhythmic compositions of bold shades and geometric motifs for which it is known. An interest in European avant-garde art, from abstract artists Sonia Delaunay, Wassily Kandinsky and Paul Klee to Futurists like Giacomo Balla, has inspired the Italian fashion house since its foundation in 1953 by husband and wife Ottavio and Rosita Missoni. Ottavio typically developed his rug designs from sketches on graph paper, exploring the juxtaposition of colours and repeated shapes in fabric 'tapestries' that eventually evolved into hand-knotted rugs.

PYLON CHAIR

Tom Dixon

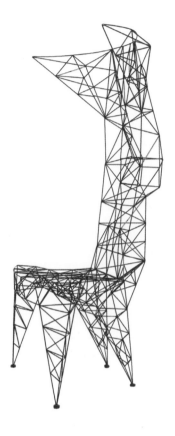

Pylon began as an attempt to make the world's lightest metal chair, 1991
using triangulation to strengthen a striking skeletal design consisting
of 3-millimetre-diameter steel rods. Dixon had enthusiastically
embraced welding in the mid-80s, pumping out 100 chairs in his first
year 'just because I could'. Originally produced in small numbers in raw
steel then in various colours (including a blue flocked version), Pylon
became best known in its bright orange iteration after Cappellini
licensed the design in 1992, releasing it solely in that colour. In 2017
it was re-editioned by Dixon's own company and is now offered only
in royal blue or white.

DOUBLE SOFT BIG EASY SOFA

Ron Arad

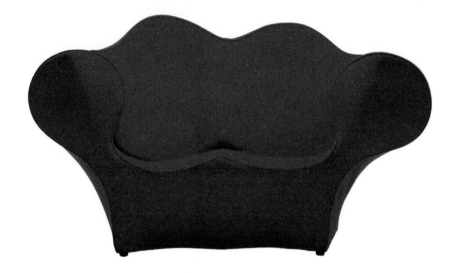

1991

This energetic piece shows the possibilities of transforming limited-edition artworks into mass-produced furniture. Patrizia Moroso, newly minted art director at her family's furniture company, approached London-based Israeli designer Arad to create a furniture collection based on Big Easy, a series of polished stainless-steel sculptural works he was exhibiting in Milan in the late 80s. In 1991 Moroso released Arad's Spring Collection, marking its change from metal to more forgiving materials like rotation-moulded polyethylene and polyurethane foam by grafting 'Soft' onto each product's name – Soft Big Easy armchair and Soft Heart rocking chair, for example. An array of colours is available, but cobalt blue and bright red remain the collection's signature shades.

VERMELHA CHAIR
Fernando and Humberto Campana

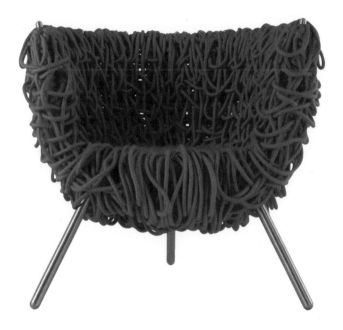

An 'homage to chaos' is Brazilian designer Humberto Campana's enticing description of Vermelha. After purchasing a large quantity of rope from a roadside stall, Humberto and his brother, Fernando, piled it on their studio table and immediately knew the tangled mess was the starting point for a chair. The resulting design consists of 500 metres of red cotton-covered rope, loosely woven over a steel frame. Italian furniture company Edra has produced Vermelha since 1998, with each chair still taking around fifty hours to complete. While also offered in silver, gold and black rope, the original variant remains the colour of choice, as indicated by its name, which is Portuguese for red.

1993

ORBITAL FLOOR LAMP

Ferruccio Laviani

1992

One of the most successful floor lights of the 90s, Laviani's debut lamp design is a pastiche of architectural High Tech and colourful retro revivalism. Its industrial glass diffusers, shaped like artist's palettes, are reminiscent of motifs found in the sculptures of Alexander Calder. Vividly hued, the diffusers are silkscreen printed on one side to soften the glare from the light source and offset by one white circular disc. The aluminium structure supporting this colourful assemblage appears to be influenced by photographers' lighting stands. Hailed as a design classic, the lamp is in the permanent collection of New York's Museum of Modern Art.

BOOKWORM SHELF

Ron Arad

Reinventing an entire genre is a tall order, but Arad pulled it off to dramatic effect with the aptly named Bookworm, a flexible shelf with integrated bookends that can be installed in a myriad of shapes. Designed in spring steel as a limited-edition piece, it was developed for mass production in extruded PVC by Kartell in 1994. While Wine Red is the most popular colour, pink, blue and yellow are also available, plus the more architectural finishes of grey, black and white. Available in 3.2-, 5.2- and 8.2-metre lengths, around 800 kilometres of Bookworm are sold each year.

1993

VILBERT CHAIR

Verner Panton

1993

It looks like a card trick, but Vilbert certainly delivers a punch with its dynamic geometric form. Designed when Panton was sixty-seven, the chair should have been the ultimate interpretation of Swedish company Ikea's flat-pack concept, and they took it on despite its costly Swiss-made origins. Constructed from just four small sheets of laminate-covered MDF screwed together, this ingenious idea was produced in two colourways: one with a blue back and red seat, the other with a purple back and blue seat. Ikea's gamble on a late-career Panton design didn't pay off, however, with only 3000 produced and the chair on sale for less than a year.

EUCLID THERMOS JUG

Michael Graves

This charming duck-shaped thermos jug was part of a larger
collection that also included a salad bowl and servers, napkin box,
tray, bottle stand/ice bucket, kitchen paper holder and storage
containers. Although an architect first and foremost, Graves became
internationally famous for his Kettle 9093 (page 148) for Italian metal
specialist Alessi, released in 1985. Produced nearly ten years later,
the Euclid range retained Graves's passion for post-modern forms
like the sphere and cube but was delivered in moulded ABS plastic
in several colourways, such as Sunrise Yellow/Sunset Orange, Garden
Green/Midnight Blue and Graves Red/Graves Blue (the last two
colours named after those used on his kettles).

1993

ALESSANDRA ARMCHAIR

Javier Mariscal

1995

Channelling the colourful biomorphic shapes of fellow Spaniard Joan Miró and American sculptor Alexander Calder, Mariscal reinvented the classic wing chair by introducing wonky, asymmetrical shapes to it and its printed fabric. Manufactured by Italian upholstery specialist Moroso, the chair is offered in a multicoloured version, where bright blobs of orange, red and yellow are juxtaposed with cobalt blue and turquoise, or in simple black and white. Mariscal, an artist, designer and comic book creator, developed Alessandra's pattern using collage techniques, cutting out shapes and playing with them on the surface of the chair to find the perfect balance.

STITCH FOLDING CHAIR

Adam Goodrum

Stitch's remarkable ability to be folded very flat in no way compromises its look when expanded. Goodrum created the chair as a response to an increasing lack of space in modern environments. Prototyping it in natural anodised aluminium sheet to perfect the folding mechanism, the Australian designer decided to spray-paint its ten separate components in ten individual colours, turning what was a clever space-saving chair into a functional kinetic artwork. The resulting multicoloured patchwork accentuates the 'stitched' appearance along the seams. From 2008, Cappellini simplified the painting process and produced a version in six Mondrian-style colours that still retained the spirit of the prototype.

1996

DISH DOCTOR

Marc Newson

1997

Breaking the rule of 'red and green should never be seen', this futuristic yet friendly creation takes washing up to a vibrant new place. Expressive curved forms have always been part of Newson's work, whether in one-off or mass-produced objects. Here, two injection-moulded polypropylene halves clip together to make Dish Doctor's rounded, barge-like form. In a sign of the coming digital era, the design was converted directly from CAD (computer-aided design) to production without any physical prototyping. Even the packaging, also designed by Newson, depicts the product's computer-generated blueprint. For the red-and-green wary, the rack also comes in blue and white.

MAGO BROOM
Stefano Giovannoni

The playful marriage of colours is a large part of its appeal, but Mago also boasts the impressive claim of being the first broom to stand up unsupported. The Italian designer added a matching wall-mount hook so the broom can be neatly stored away. Made from air-moulded polypropylene reinforced with glass fibre, Mago comes in seven contrasting colour combinations, with replaceable bristles for mixing up the hues. Fuschia with orange, blue with yellow – whichever way you look at it, this broom brings a sense of fun to the functional.

1998

iMAC G3

Jonathan Ive

1998

'Sorry, no beige' – with a simple three-word advertisement, Apple introduced a product that revolutionised the computer industry, replacing the boring monochrome boxes of old with one colourful, teardrop-shaped case in semi-translucent polycarbonate, a type of plastic. Revitalising the fortunes of a failing company, the iMac G3 was the result of giving then head designer Jonathan Ive carte blanche. Initially released in Bondi Blue, it was met with such an astonishing level of success – 800,000 units in four and a half months (that's one every fifteen seconds) – that the company brought out five 'flavours' at the start of 1999: Lime, Strawberry, Grape, Tangerine and Blueberry.

RAINBOW CHAIR
Patrick Norguet

The process of joining sheets of acrylic resin to form a
multicoloured, transparent seat was never going to be easy,
and perfecting the outcome took the French designer a year of
experimentation. The final, hynoptic result, like looking at the
refraction of light through glass, owes its seamless appearance to
five-axis CNC machining, ultrasound welding and mirror polishing,
which enhances the beautifully irregular gradation of colour
achieved through the varying sheet thicknesses. Juxtaposing
intense colour with the restrained form of an ultra-simple chair
was a fundamental part of Norguet's concept.

1999

CHAIR_ONE

Konstantin Grcic

1999-2004 The chair's name may be simple but its design process was far from it, with more than twenty-seven prototypes developed over five years. Given the opportunity by Magis founder Eugenio Perazza to create a chair utilising cast-aluminium construction, Grcic took a football as inspiration, converting the seams to metal and the flat panels to voids. Although the chair is more widely known in its stackable four-legged form, the conical concrete-based version provides a beautiful counterpoint to the skeletal seat. Chair_One now comes in six colours, including turquoise and grey-green, but the original red continues to best express this unique concept.

DOMBO MUG
Richard Hutten

Originally named Domoor – a mash-up of two Dutch words, '*dom*'
meaning 'stupid' and '*oor*' meaning 'ear' – this crazily proportioned
cup was later universally christened Dombo, in reference to
Disney's baby elephant with big ears. Hutten designed it for his
first child, to make learning to drink from a cup easier, with the two
oversized handles accentuating the act of drinking. This simple idea
turned out to be complex to make because of the differing amounts
of polypropylene required for the solid handles and thin-walled
cup. Dutch manufacturer Gispen took on the challenge and has
sold more than a million pieces in a veritable riot of colours since
launching the design in 2002.

2000

Hella Jongerius

Starting her studies at Design Academy Eindhoven, Dutch-born Hella Jongerius remarked that she'd never become a textile designer – her mother was a pattern maker. While she managed to resist the lure of the loom for the first ten years of her career, resolutely designing three-dimensional objects from the Rotterdam studio she founded in 1993, her investigations into colour and texture would ultimately lead to a fabric design called Repeat for textile giant Maharam in 2002.

This began an ongoing fascination with the construction of textiles and the ways in which new colours can be created through the layering and juxtaposition of individual threads. Jongerius currently has close to forty fabrics and rugs to her name, for international companies such as Maharam, Danskina and Kvadrat.

But it is her knowledge of colour that has raised her already considerable reputation to a whole new level. Polder (pages 174–75), her revolutionary 2005 sofa for Vitra, was offered in four palettes (red, green, brown and neutral), with each sofa upholstered in six carefully selected fabrics of slightly different shades and textures. The success of this radical departure from the conventions of sofa design triggered Vitra's realisation that the company needed a specialist within its ranks who could advise on unique colours and materials for its products.

For more than a decade, Jongerius has been Vitra's art director for colours and materials, developing the Swiss company's library to a point whereby entire palettes have been created for its classic items, and specific shades have been identified that are particularly appropriate for contemporary designers.

These colour selections are not simply imposed on the various objects. In the case of iconic products by luminaries like Charles and Ray Eames and Jean Prouvé, they are the result of intense investigation of original colours; for the contemporary pieces, selections come through a painstaking assessment of how colours work on specific shapes in different lights. Jongerius has, for example, identified that greys and light blues generally work well on pieces designed by Jasper Morrison, while the objects of Ronan and Erwan Bouroullec tend to gel with greens and burgundies.

That interest in how colour is affected by the changing nuances of light is what characterises her approach. While Pantone, NCS and others have created systems for the accurate replication of colours, Jongerius sees herself as rebelling 'against the flatness of the conventional colour industry'.

What she looks for in all her work is individuality, idiosyncrasy and elements that give industrially produced objects the warmth and personality of the hand-crafted. Her recent Vlinder sofa for Vitra exhibits all the hallmarks of the handmade, its tailored throw-like outer upholstery like a rich modern tapestry, while her Bovist pouf displays a delightfully hand-embroidered appearance. Her ceramics, from the vibrant Coloured Vases to the all-white B-Set tableware, are remarkable for their subtle differences and imperfections.

The key ingredient in her designs is the addition of richness and complexity, words Jongerius uses frequently to describe the positive experience that is possible when industrial processes are allowed to escape the straitjacket of standardisation. And, central to all, is her understanding of colour.

'Experiencing colour is completely dependent on its physical, visual, artistic and cultural context,' she says. 'It is different for every person, every surface, shape and under changing lighting conditions. This makes colour mysterious and ever-changing.'

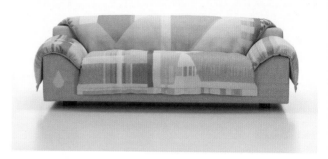

CLOCKWISE FROM TOP RIGHT
Vlinder sofa (Light Red version), 2018–19,
for Vitra; Bovist pouf (Pottery version), 2005, for
Vitra; Worker Chair, 2006, for Vitra; Long Neck
and Groove vases, 2000, self-produced;
Repeat Dot Print textile, 2002, for Maharam.

OPPOSITE PAGE Hella Jongerius in her
Berlin studio 2018. Portrait by Roel van Toer.

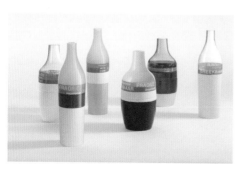

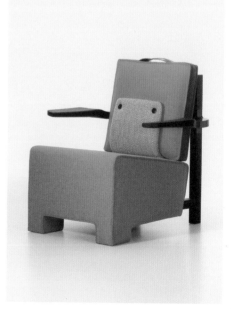

HELLA JONGERIUS

POLDER SOFA — 2005

Named after the low-lying areas of Jongerius's home country of the Netherlands, this sofa appears as an aerial view of the chequerboard landscape, an effect enhanced by its serene green palette. After countless hours observing how various materials worked together, Jongerius chose to cover Polder in six textiles from a number of fabric houses, punctuating them with handmade buttons. The fabrics are purposely close in tone to impart a feeling of subtle complexity. For the new edition of Polder, introduced in 2015, Jongerius also created a palette of muted pastels to add to the stronger red, night blue, green and golden yellow colourways.

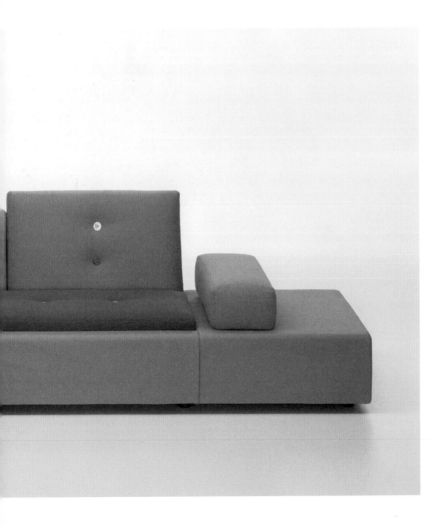

ORG TABLE

Fabio Novembre

2001

Magical invention or clever illusion? A top of transparent glass appears to be floating in mid-air supported by nothing more than a sea of red ropes. Org is a collection of tables, round, square and rectangular, manufactured by Italian brand Cappellini in different sizes and heights for use as coffee, side or dining tables. Steel legs wrapped in a woven polypropylene sleeve are hidden among the ropes, which are suspended from the underside of the table. All the more exciting with the use of red, the design has a slightly disturbing tentacle-like quality. The eight table variations (OG/1–OG/8) are also available in black or white.

VICTORIA AND ALBERT SOFA

Ron Arad

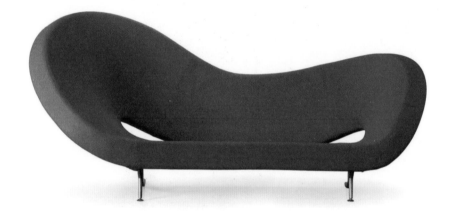

2000

Named in homage to the London museum that held a major retrospective of his work in 2000, the sofa illustrates Arad's daredevil approach, which spans design, architecture, sculpture and installation. It forms part of a collection for Moroso inspired both by the Möbius strip and the idea of a design drawn in one continuous line, with the pencil not lifted from the paper. While his design is analogue in concept, Arad was one of the first to use rapid prototyping to perfect shapes for industrial production. The sofa is traditionally upholstered in bright red, yellow or blue fabrics – bold colours that highlight the design's strengths without complicating the visual flow.

DIANA TABLES

Konstantin Grcic

Sheet steel is not a particularly welcoming material, but in the hands of Konstantin Grcic it comes to life in this characterful concept. Like letters of the alphabet, the German designer's collection of five side tables (models A, B, C, E and F) and a coffee table (D) combine to create an exciting visual language. Developed from cardboard models, the tables rely purely on cutting and bending techniques. The collection is lacquered in colours like Coral Red, Honey Yellow and Ocean Blue, as well as neutrals, black and white – a statement individually, together they speak volumes.

2001-02

CAMPARI PENDANT LIGHT

Raffaele Celentano

 2002

There have been many readymade objects over the years since
Duchamp first presented the idea in 1917, but the unique colour and
form of ten Campari Soda bottles suspended around a light source
is one of the most straightforward and light-hearted. This tribute
to the iconic Italian beverage was created by a photographer rather
than an architect or lighting designer. Available only in the one tone
– Campari red – the design utilises the bottles' thick industrial
glass as a diffuser, softening the light. A Campari Soda bottle cap
conceals a small height-adjustment mechanism that allows for
easy raising and lowering of the fitting as required.

KRATTENKAST CABINET

Mark van der Gronden

Designed just one year after van der Gronden graduated from Design
Academy Eindhoven in the Netherlands, Krattenkast (meaning crate
cupboard in Dutch) is a wildly colourful storage concept based on
industrial plastic crates. The crates, in irregular heights, colours and
moulding styles, act as drawers that sit within a raw steel framework.
Made by Dutch company Lensvelt, Krattenkast comes in three sizes
based on a standard 40-centimetre crate width – two tall designs
of one or two modules wide, and one lower, sideboard-style design of
five modules wide. As the height and colour of the crates available
from the recyclers vary, each Krattenkast is delightfully unique.

2003

CORALLO ARMCHAIR

Fernando and Humberto Campana

2003

What looks like a tangle of orange string is actually stainless-steel wire, bent and welded by hand, in an industrial interpretation of the stunning complexity of coral (*corallo* is Italian for coral – avant-garde furniture manufacturer Edra, producer of this piece, is based outside Pisa, near the Ligurian coast). The natural budding and branching of coral was the conceptual starting point for the Brazilian brothers' design, which takes approximately a week to make and file smooth, ready for painting in epoxy polyester. A functional sculpture, which can be used inside or out, the chair is only produced in orange (the original colour), white and black.

VEGETAL CHAIR

Ronan and Erwan Bouroullec

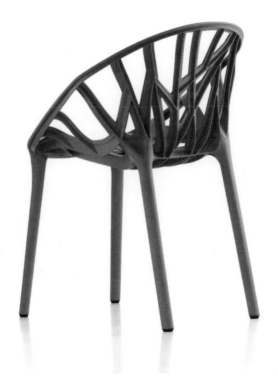

The concept was poetic and seemingly simple: to design an outdoor chair that appears to grow out of the ground. Inspired by mid-century Swedish-born American gardener Axel Erlandson, who shaped trees to form furniture and architectural sculptures, the Bouroullec brothers found the task immensely challenging when applied to a commercially produced chair made from polyamide. The finished chair was the most complex Vitra has ever produced, taking four years and countless prototypes to achieve comfort, stacking ability and strength while maintaining its plant-like traits. Of its six UV-resistant colours, Brick, Cactus and Chocolate most successfully capture the concept's organic origins.

2004-08

KAST STORAGE UNIT

Maarten Van Severen

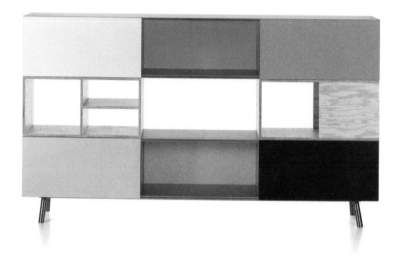

2005

Van Severen was known for his restrained approach to colour and form, usually working in one tone and one material. Yet with Kast, created for Swiss brand Vitra in the final months of his life, the Belgian designer introduced colour in a way rarely seen in his work, as well as using marine plywood made from pine in addition to his preferred anodised aluminium. The design is modular, with all three variations of the cabinet sharing the same footprint. The tallest cabinet features sliding doors in navy blue, forest green, yellow, pink, grey and brilliant white. Each unit combines coloured doors with voids for a perfectly proportioned and dynamic object.

FRAME OUTDOOR SEATING

Francesco Rota

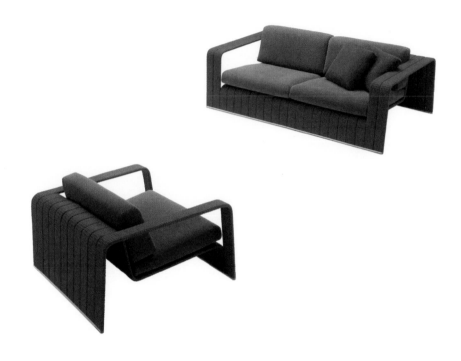

Taking the general concept of the sheet material chair pioneered by
designers like Briton Gerald Summers in the 30s and modernising it
completely, Italian designer Francesco Rota used sheet aluminium,
rope and stainless steel to create a colourful collection of outdoor
seating products with an open, fluid framework. Upholstered in thick
cushions or thin flexible pads, the sofas, armchairs, dining chairs,
benches and side tables have texture, courtesy of the woven rope,
but remain pleasingly minimal in their overall design. Manufacturer
Paola Lenti has developed a wide range of ropes in plain colours, duo
tones and 'mélange' hues to suit their outdoor furniture collections.

2005

LEAF PERSONAL LIGHT

Yves Béhar/fuseproject

 2005

From radical thinker Béhar came a sculptural innovation that used minimal materials and cutting-edge LED technology. Designed for legendary mid-century American company Herman Miller, Leaf was 95 per cent recyclable, made from 37 per cent recycled aluminium and used 40 per cent less power than an equivalent compact fluorescent bulb. It was released in red, white, black and natural aluminium, and featured ten cool and ten warm LEDs, to enhance work or relaxation respectively, plus a beautifully tactile dimmer switch. The light was initially a success but became quickly outmoded due to the rapid development of LEDs and is no longer in production. The form and concept, however, remain a technical milestone.

SMOCK ARMCHAIR
Patricia Urquiola

Playfully referencing the world of fashion, Smock reveals Urquiola's
flair for combining old-world craft with modern industrial design.
To a swivel base the Spanish designer added a deep, bowl-like
seat that she describes as feeling like a baseball mitt and looking
like a tank top. Overlaying this are the fascinating details created
by smocking, a technique developed to add flexibility to garments
before stretch textiles were invented. The armchair is available in
seventy Kvadrat Divina fabrics and thirty-five leathers, with arms
covered in leather in matching or contrasting colours. Bases come
in Oriental Red, White Chalk, Cacao, Ink and black.

2005

SHOWTIME MULTILEG CABINET

Jaime Hayon

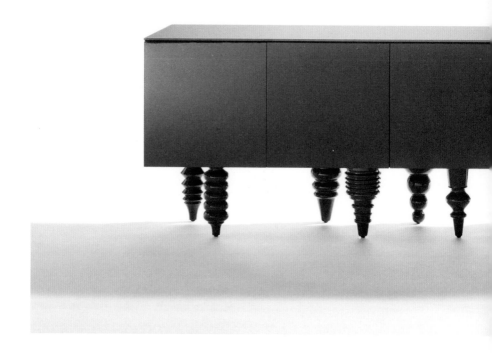

2006

Conceived, prototyped and presented within just a few short weeks, the Spanish designer's cabinet (part of his extensive Showtime collection) comes in two forms – a long sideboard with twelve individually turned alder wood legs and a more upright square cabinet with just four of the distinctive legs. Taking inspiration from a variety of eras, including Louis XIV, Art Deco and Bauhaus, the legs are designed to be randomly placed across the unit. Originally presented at the 2006 Milan Furniture Fair in a dramatic cobalt blue, the cabinet also comes in red, white and black, with a matt lacquered interior and the exterior finished in a gloss lacquer.

TWIGGY FLOOR LAMP

Marc Sadler

 2006

A fishing rod was the inspiration for Twiggy's gracefully arched arm, which owes its delicate balance of flexibility and strength to resin and fibreglass. The composite material bends naturally under the weight of its shade (also fibreglass), with the technology behind the lamp's construction remaining invisible to the user. A statement in red, white or black, the design really gained recognition through the more unconventional shades of blue and yellow, the latter sadly no longer available. According to the Austrian-born, Milan-based designer, Twiggy is a little like a Lacoste polo shirt, which changes its personality with each colour.

MR BUGATTI COLLECTION

François Azambourg

The strong use of colour is a significant part of Azambourg's work. His Mr Bugatti collection, which wittily references car designers Ettore and Jean Bugatti, came about after experiments on the effects of injecting polyurethane foam into hollow forms made from tin. The outcome looked much like a crumpled car body with the thin metal warping and crinkling; Azambourg liked the effect and set about controlling the reaction for mass production. The result is a dining chair, an armchair and a high and low stool lacquered in glossy shades of red, yellow, sky blue, grey, black and white.

2006

SLOW CHAIR

Ronan and Erwan Bouroullec

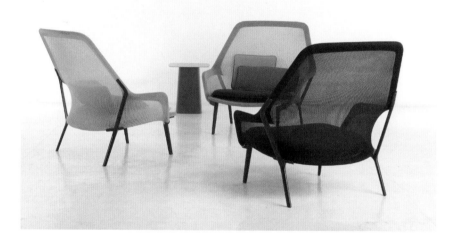

2006-07

The words 'silk tights' and 'furniture' don't usually share the same design space. But this unlikely garment was one of several 'skins' the Bouroullec brothers have tested in their search for a comfortable chair with minimal visual bulk. The result is the Slow Chair, featuring a high-tech knitted textile that stretches over its tubular frame. The translucent sling was originally offered in four tones: chocolate, black, and two blends of colours that create the impression of a third shade: red and white become pink; brown and cream deliver a greyish taupe. In 2014 Vitra added a new blue and green sling. Each colourway comes with a seat, lumbar and scatter cushion in complementary shades.

SHOWTIME VASES

Jaime Hayon

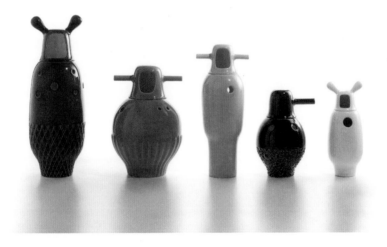

Like much of Hayon's work, these sculptural vases are imbued with
personality, whether in all white or the eclectic range of high-gloss
hues chosen by the Spanish designer, with their equally appealing
names like Napoleon Blue, Electric Yellow and Vulcan Grey. Hayon's
love of street graffiti, Japanese toys, extravagant shapes and
complex colours pervades the objects, as does his sense of humour
(the heads of the vases pop off to enable water filling). Part robot,
part animal figurine, the vases were created for Spanish brand BD
Barcelona Design as part of a larger collection including cabinets
(pages 188–89) with a multitude of different shaped legs and
several types of chair.

2006

IRIS TABLE

Barber Osgerby

 2007-08

It's rare that colour is the absolute starting point for a design object, but with Barber Osgerby's Iris table the shape was not even considered until the palettes had been deliberated over for several months and the materials and processes thoroughly explored.

The studio was commissioned in 2007 by British furniture company Established & Sons to design limited-edition objects for the brand's new gallery in London. For Edward Barber and Jay Osgerby, this was an unusual commission, imposing no constraints on function, form or price. The pair decided to approach it by investigating themes and industrial processes that they were enticed by but had not yet sufficiently explored, with colour at the top of the list.

Their concept revolved around a very personal interpretation of the colour wheel – a composition of hues based purely on intuition. Iris, which references the way colours radiate from the pupil in the eye, was a series of circular coffee and side tables made from a spectrum of individually coloured aluminium segments. Each segment was coloured through anodising, a process which, unlike applying a paint finish, leaves colour imbued in the metal rather than just coating it but requires a high level of craft to achieve precise colours.

That requirement was significant – the designers felt that for the objects to justify their limited-edition status (in this case, just five variations comprising twelve pieces each), every aspect of the design should push the boundaries of normal industrial production. The CNC machining of Iris's parts needed to be so accurate that even manufacturers of scientific instruments struggled to achieve it.

Each table had its own unique form (pictured here is the Iris 1200), designed around the personality of its colour composition. A special low-iron glass was used for the table tops to maintain the purity of the colours in the bases.

From aluminium machining to the multitude of anodised shades, Iris is an example of absolute, uncompromising precision, where technical rigour, dedication to craft and a delicate colour sense all come together.

MOTLEY OTTOMAN

Donna Wilson

2007

Its name embraces the idea of a medley of mixed-up colours, and the Scottish textile designer is famous for the bright hues of her hand-knitted pieces. This deep-buttoned, chesterfield-style ottoman was Wilson's very first furniture product. Made in the Norfolk upholstery workshop of UK firm SCP, it was first shown at the prestigious Milan Furniture Fair in 2007. Currently offered in three colourways (Rainbow, Blue Lagoon and Hot Earth), each punctuated by matching buttons and floating on a solid-colour base, the design also comes in a single-tone version using a commercial felted wool textile called Europost 2.

PXL LIGHT

Fredrik Mattson

Viewed by some as simply eye candy, the Swedish designer's range
of lamps is actually illustrating the make-up of white light as seen
in a rainbow or viewed through a prism. The shapes are based on
archetypal table and ceiling pendant lamps but, with their chunky
horizontal bands of colour, have been reworked in the pixellated
fashion of a low-resolution image – hence the name. For those
preferring a more literal interpretation of light, the lamps are also
available in white. A wall light also forms part of the collection but
is available only in unpainted galvanised steel or white.

2007

FIELDS WALL LIGHT

Vicente García Jiménez

2007

On a flight from Madrid to Valencia, the Spanish designer was entranced by the aerial view of fields below in the area of La Mancha. The patchwork of shapes that he saw became the basis for a wall light made from orange-painted aluminium and off-white methacrylate (Plexiglas). It was launched by Italian lighting specialist Foscarini in 2007 as three modules that could be installed separately or together. Combined, the modules (Field 1, 2 and 3) overlap to deliver an abstract sculptural composition while illuminating a large area of wall space, the intensity of its colour varying with proximity to the light source.

BOUQUET CHAIR

Tokujin Yoshioka

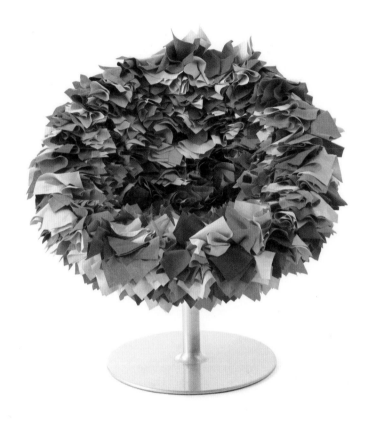

As beautiful as its name, this small, swivelling armchair blossoms
into delicately hued petals made from vast numbers of individually
hand-folded and sewn fabric squares. The concept evolved from
an ethereal installation the Japanese designer created for Moroso's
New York showroom in 2007, featuring 30,000 sheets of tissue
paper. Intrigued by the possibility of taking the idea further, Yoshioka
replaced the tissue paper with microfibre fabric for Bouquet's interior.
The chair is available in three complex shades – each composed of
three colours – as well as an all-white version for minimalists.

2008

Doshi Levien

When asked what colour defined their respective childhoods, it was the light brown of corrugated cardboard for Scotland-born Jonathan Levien, who recalls the wrapping of the toy kits in his parents' factory, and for Nipa Doshi it was the dirty, dusty pink of the Art Deco house in Delhi where she grew up. 'It's amazing how influential colour actually is – that it represents something so deep for you,' she says.

With their different backgrounds and diverse skill sets, these two come together through a devotion to detail, an understanding of the importance of colour and a very personal sense of proportion. Because of this they have created some of the most unique, uplifting domestic objects of recent times. The husband-and-wife team see their differences as an energetic creative driver, which necessitates an openness to change and the need to embrace alternative perspectives.

When they met at London's Royal College of Art, Levien was studying furniture design and Doshi had completed her first degree in industrial design at the National Institute of Design in Ahmedabad, India, where Bauhaus and modernist principles were still the guiding doctrine. Both gained experience after university – Levien with the designer Ross Lovegrove and Doshi with David Chipperfield Architects – before setting up their joint practice in 2000.

One only needs to scroll through their Instagram feed, rich with maquettes, mood boards, material experiments and finished pieces for brands like Moroso, Kvadrat and Kettal, to see the variety and richness of their approach. But the most insightful posts are those showing Doshi's beautiful coloured sketches and collages on the distinctive gridded paper she uses (which inspired the fabric pattern for their

Paper Planes lounge chair for Moroso). Levien points out that Doshi does far more than merely choose colours – 'she's painting and creating colours.'

The successful collision of craft and machine-made precision alongside a highly developed understanding of the role of colour and texture has become the practice's signature. Doshi Levien first garnered the attention of the design world with their experimental Charpoy range for Moroso, comprising four daybeds in different shapes, sizes and fabrics based on the traditional Indian bed of the same name. Following that came Principessa, a daybed of eleven thin mattresses of various fabrics inspired by the story *The Princess and the Pea*, then the ground-breaking My Beautiful Backside sofa (pages 204–05), interestingly also designed with a princess in mind. 'It was really important that no matter what angle you looked at it from, it was poetic, it was sculptural,' Doshi explains.

The couple take their work incredibly seriously but there is always a sense of levity, joy and celebration in everything they do, whether it's a richly decorated rug for Spanish company Nanimarquina or a colourful credenza for BD Barcelona Design. Their animated film *Kvadrat Kabarett* takes two textile families – Jaali, a woollen upholstery textile, and Maya, a diaphanous curtain fabric – and fashions them into abstract characters that swirl and glide across the screen. The charm is undeniable, hinting at the cabaret clubs of the early 20th century, and the beauty of the fabrics and sensitivity of the colour combinations wittily revealed.

'On each project you have to push your idea of colour, otherwise, for me, it wouldn't be challenging or interesting,' says Doshi. 'Finding beauty in unexpected places – that's the core of how I look at colour.'

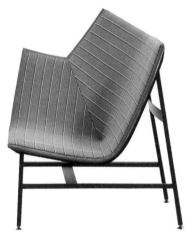

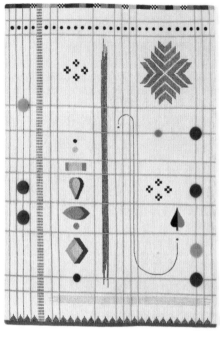

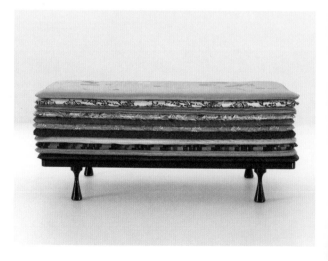

CLOCKWISE FROM TOP LEFT
Chandlo dressing table, 2012, for BD Barcelona
Design; Rabari rug (pattern No. 1), 2014, for
Nanimarquina; Principessa daybed, 2008,
for Moroso; Paper Planes lounge chair,
2010, for Moroso.

OPPOSITE PAGE Doshi Levien (Nipa Doshi
and Jonathan Levien). Portrait by Petr Krejčí.

MY BEAUTIFUL BACKSIDE SOFA — 2008

The combined cultural backgrounds of Nipa Doshi, from India, and Jonathan Levien, from the UK, bring a unique spin to this richly detailed sofa, with a mix of time-honoured and unconventional materials, styles and techniques. Like much of the pair's work, this wonderfully named piece shows strong links to traditional European and Indian craftsmanship, symbols and stories. Inspired by an Indian miniature painting of a princess sitting on the floor surrounded by cushions, the sofa is upholstered in felt and wool reminiscent of English suiting, with metallic foiling, silk cushions and embroidery introducing an opulent Indian element.

WRONGWOODS CABINET

Sebastian Wrong and Richard Woods

2007

Produced in a range of garish colour combinations (and a few more monochrome ones), Wrongwoods is a collaboration between fellow Brits, designer Sebastian Wrong and artist Richard Woods. The collection has steadily grown since the first storage pieces were launched and now includes eight objects ranging from nightstands to dining tables, trays and waste-paper baskets. Woods's painted graphic motif is applied to Wrong's simple 50s-inspired furniture using woodblock contact printing. The manual process of applying paint to the printing block and pressing it onto the plywood surfaces ensures each cabinet is unique.

CONFLUENCES SOFA

Philippe Nigro

Originally shown with each seating block and cushion in different
shades across palettes of blue, pink and yellow, this 'reconciliatory'
sofa was conceived by Nigro to satisfy the seating preferences of
a variety of users. The French designer's approach is revolutionary;
overlapping angled seating components lean seductively into one
another, each featuring a slightly different back height and seat
depth. Available in a number of versions, including one in which
elements face in opposite directions to form a conversation nook,
the design is now also offered in single colours.

2008

DO-LO-REZ SOFA

Ron Arad

2008

The pixel is the inspiration behind this complex modular seating unit – the name, short for 'do low resolution', refers to the way low-resolution images transform smooth lines into a series of blocks. Each sofa, more than 2 metres long, is made up of thirty-six fabric-covered foam blocks of ten different heights to create the stepped arrangement. The design comes in a medley of eight shades for the light and dark red versions, while for pale and dark blue, and light and dark grey, ten shades are used. If this wasn't complex enough, three types of Kvadrat fabric for each tonal palette bring textural variation to the mix.

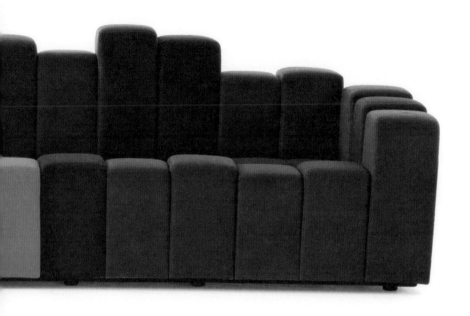

VALISES WARDROBE

Maarten De Ceulaer

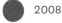 2008

This witty play on the traditional travel trunk began life as a design school graduation project by Belgian designer De Ceulaer titled 'A Pile of Suitcases'.

Initially a student of interior design, De Ceulaer studied at the Sint-Lukas Hogeschool in Brussels, where he developed a keen eye for colour prior to becoming a product designer. With a growing interest in conceptual ideas, he switched disciplines and attended Design Academy Eindhoven, a school well known for its artistic approach.

Inspired by his love of travel, De Ceulaer developed his graduation project, presenting it in variegated green and describing it as 'functioning as a classy wardrobe with a variable composition and well-measured compartments. Steel profiles keep the pile firmly together, leaving ample room for change.' In other words, it could easily be dismantled, transported or reconfigured as required – a far cry from the heavy, static wardrobes of the past.

The piece was immediately taken up by Nina Yashar, founder of the prestigious design gallery Nilufar in Milan and, over the intervening years, has grown into a collection of thirteen different objects (from a mirror with suitcase drawers at its base to a desk of briefcases), all covered in Belgian recycled vintage leathers of exquisite quality.

At the same time as his gallery representation, De Ceulaer was approached by Italian manufacturer Casamania, who saw the potential of the design produced in a less rarefied form. It was subsequently put into production under the new name 'Valises' (French for suitcases) solely in wardrobe form, but in four distinct colour palettes: greens, blues, a pinky beige ensemble and a subtle multicoloured variant. This production version of the design reverts to the original configuration from De Ceulaer's Eindhoven graduation project, delivering an abstract artwork reminiscent of a Sean Scully painting while performing as a functioning wardrobe.

LOLITA LAMPS

Nika Zupanc

2008

Cute yet mischievous, like the heroine of Nabokov's infamous novel, after which they're named, the Lolita lamps are smooth, glossy creations in ABS plastic and polyurethane. While the pendant, table and floor lamps were also released in white, grey and black, it was the candy-pink version that immediately attracted attention and perhaps best suits Lolita's scalloped, lace-like edge – not to mention its name. Dutch manufacturer Moooi has since discontinued grey and black (and recently the floor lamp) and added London Rose, a soft rose-gold colour with a metallic sheen. The inner part of the shade is white for increased light reflection.

SUSHI COLLECTION

Edward van Vliet

Naming a furniture collection after a Japanese national dish is
an unexpected move for a Dutch designer, but Sushi is really an
exercise in wrapping different seating forms in combinations of
fabrics. Manufactured by Italian furniture brand Moroso, the range
consists of a sofa, pouf and chairs. The fabrics were specially
created by van Vliet, who started his career as a textile designer,
and feature an array of delicate digital geometrics, references to
Spirograph art and Moroccan tiles, and even depictions of carp
(now discontinued). Plain fabrics in soft pink and pale blue tones
or faded orange and subdued lime are juxtaposed with the
complex patterns.

2008

RAW CHAIR

Jens Fager

2008

Carved from solid wood using a bandsaw, the Raw chair is painted in three bright colour options – yellow, blue and green – along with a more restrained mid-grey. Referencing the shape of the 18th- and 19th-century 'Captain's chair', Raw highlights the inherent contradiction between its rough-hewn, colourful form and the refined historical objects upon which the design is based. Prototyped in pine and later produced in birch, the chair is part of a collection that also includes a side table in the same shades and a candelabra in white or green. Due to the manual manufacturing technique, each example is unique.

TROPICALIA CHAIR

Patricia Urquiola

Urquiola often looks to traditional craft techniques for inspiration.
With Tropicalia, she playfully combines vibrant colours and geometric
patterns in a string art-like arrangement, in which single threads
overlap to form a three-dimensional design. The chair is part of a
collection of seating pieces based around weaving, which the Spanish-
born, Milan-based designer created using the outline of her earlier
Antibodi chaise as a starting point. In its outdoor form, the design,
made with stainless-steel tubing and UV-resistant thermoplastic
cord, exudes the carefree attitude of summers by the pool.

2008

STACK CABINET

Raw-Edges

2008

Originally presented as a 'tower of floating drawers' in two contrasting colourways – a green palette and a red palette – Stack challenges every aspect of the conventional chest of drawers. Shay Alkalay and Yael Mer of Raw-Edges wanted to create a drawer system that could be accessed from both sides and would present an intriguing irregular composition. Their work revolves around colour and, very often, movement, and Stack's dynamic form embodies the essence of abstract art while appearing to defy physics. Two sizes, of eight or thirteen drawers, are now offered in four lacquered colour palettes as well as neutral tones and mixed wood veneers.

BIG TABLE

Alain Gilles

A dramatic contrast is at play in Big Table. The rakishly angled legs in an array of colours suggest movement while the top is stationary, linear and balanced. Launched by Italian manufacturer Bonaldo at the 2009 Milan Furniture Fair in a Coral Red/Orange/Green/Lilac colourway, it also comes in two other combinations: Powder Pink/Brown/Dove Grey/Amaranth and Bordeaux/Racing Green/Brass Yellow/Royal Blue (pictured here). The laser-cut, folded steel legs, also available in a single colour or metal finishes for a more monolithic appearance, have a vitality regardless of hue, but it's the multicoloured versions that do justice to the theatrical promise of the table's name.

2009

TIP TON CHAIR

Barber Osgerby

2009-11 Approached to suggest seating for a new school in the town of
Tipton, in the UK's West Midlands, Edward Barber and Jay Osgerby
were so underwhelmed by what was available that they ended up
developing a whole new chair archetype. The design features a
small angle on its sled base that allows the chair to be used for close
working when tilted forward or in the conventional dining chair
position. Tip Ton refers both to the school that inspired it and to the
see-saw motion of its dual-position base. The chair has undergone
several colour changes since its release but Glacial Blue, its first
incarnation, has remained a memorable constant.

BOLD CHAIR

Big-Game

It may look as if it was created with pliable pipe cleaners in mind, but the Swiss-designed chair was actually inspired by the tubular steel furniture of the Bauhaus. It takes its name from the 'bold' keyboard command and its dramatic effect. Although the chair appears to be made from nothing but soft upholstery, its outer layer of tight-fitting removable fabric 'socks' covers a tubular steel frame wrapped in foam. Given its playful form, the colour options are equally exuberant and include purple, red, yellow, pink, bright blue and orange, along with three shades of blue and a forest green.

2009

NUANCE CHAIR AND OTTOMAN

Luca Nichetto

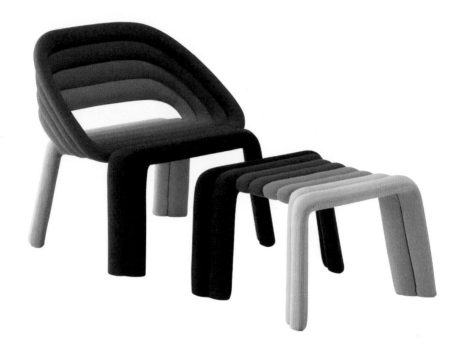

2009

The name says it all, reflecting the subtle gradation of colours that is a hallmark of this design. Placed in bands, the shades run smoothly from dark to light and are available in palettes of blue, green and claret. In a world where high-quality fabric offcuts are too often thrown away, Nichetto conceived of the Pop art-style pieces as a beautiful and ingenious way to use those remnants. The Italian designer describes Nuance as artisan in quality but with an environmentally conscious heart – a rarity in contemporary design.

PEACOCK CHAIR

Dror Benshetrit

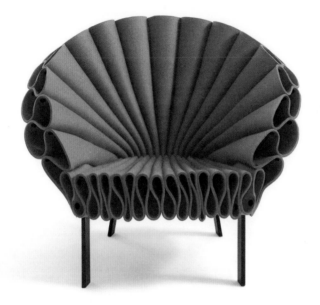

Outside design circles, this chair is best known for its role as the throne in the Rihanna video *S&M*. The Peacock chair is Benshetrit's response to nature's showmanship and, in keeping with the bird's vivid colouring, it is only available in green or blue. The New York-based designer, in exploring how to give cloth enough rigidity without the need for an internal structure, arrived at a solution by manipulating three sheets of felt into tight waves. Without stitching or glue, the generous rolls of fabric are merely clipped together onto the metal base to maintain the concertina-like volume.

2009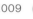

Scholten & Baijings

For Stefan Scholten and Carole Baijings, design is a process with no predetermined end point. The Dutch pair use what they call the 'atelier' method, where models are made in paper or cardboard, painted if necessary, cut and manipulated then taped back together to achieve the desired result. In a similar way, colour, a hallmark of their practice since the beginning, does not come from consulting paint swatches or a particular system, as the designers prefer to create their own from scratch.

In this sense theirs is an old-school manual approach, despite the pair's use of CAD programs and knowledge of cutting-edge technologies. They work along the same lines as studios like that of Charles and Ray Eames, fashioning models and prototypes and exploring various avenues to pursue. 'For us, design is not a cerebral process,' says Baijings. 'Many ideas emerge through the process of working with materials. We call it "thinking through making".'

Scholten studied at the prestigious Design Academy Eindhoven under renowned Dutch designer Gijs Bakker, co-founder of acclaimed conceptual practice Droog Design. Baijings came from a different background, as an assistant director producing big-budget commercials for global brands like Citroën and Coca-Cola. Their talents complemented one another and they founded the studio in 2000.

Interested in the design of functional products with a respect for both craft and mass-production techniques, the couple recognise the importance of taking the time to understand the possibilities that each method can provide to deliver the level of detail and subtlety for which they strive. 'It's not about getting from A to B,' says Scholten, 'we are interested in how we get there.'

An example is their work with Tilburg's Textile Museum, whose laboratory, TextielLab, has both old hand looms and modern computer-operated equipment. Its goal is the continued exploration of textiles, particularly by commissioning artists and designers who then benefit from access to the lab's equipment and expert staff. Through this process, Scholten & Baijings produced the Colour Gradient Blanket in 2005, which was the start of the studio's developing DNA. That design would evolve into the Colour Plaid Blanket and later Colour Carpet, both produced by HAY, the studio's most enduring client. Other products for HAY, Karimoku New Standard and Maharam can be seen as developments from these early colour experiments.

In the case of Darning Samplers, a fabric for Maharam, an introduction to 18th-century Dutch samplers in New York's Cooper Hewitt Museum set the studio on a course of discovery and intense colour and yarn research, inspired by those small squares of fabric intended to teach girls how to embroider and darn.

The pair work on projects for higher end brands such as Verreum, Georg Jensen and porcelain house 1616/arita japan but also for companies like Ikea (who limited their multi-toned mash-up of the Poäng chair to 'just' the first 30,000 customers). Their exquisite crafting and subtle colour combinations have led to seating designs for Moroso and Herman Miller and the extraordinary Amsterdam Armoire (pages 226–27) for Established & Sons, as well as several glassware and ceramics collections, always driven by the same exploration-centred approach.

'Our work is about colour, layering and patterns. We love to mix the geometric with the natural, and the synthetic with the organic, because it's in this mix that you get new things,' says Baijings.

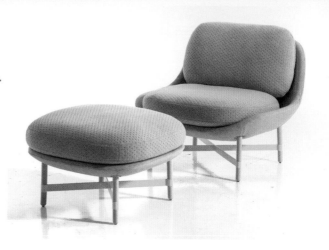

CLOCKWISE FROM TOP RIGHT
Ottoman lounge chair and ottoman, 2016,
for Moroso; Butte containers (turtle, tuna,
tree versions), 2010, for Established & Sons;
Colour Carpet No. 5, 2011, for Hay; L'univers
coloré de Scholten & Baijings porcelain vases,
décor horizontal, 2017, for Sèvres, National
Factory and Museum; Strap chair, 2014,
for Moroso from 2018.

OPPOSITE PAGE Scholten & Baijings
(Stefan Scholten and Carole Baijings).
Portrait by Freudenthal/Verhagen.

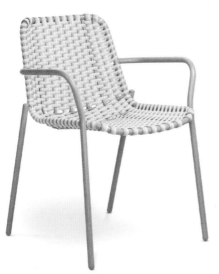

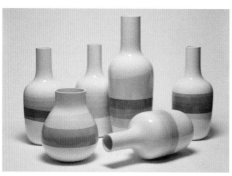

224

SCHOLTEN & BAIJINGS

A declaration of their love for a certain style of offbeat colour, this piece by Stefan Scholten and Carole Baijings cut through the industry reliance on primaries and started what became a global obsession with sophisticated pink and mint tones. Perched on round feet made of pale pink hand-blown glass, with a combination of broad stripes and fine lines, the cabinet has the appearance of an abstract artwork on the outside but reveals a Fornasetti-like, trompe l'oeil effect on the inside of its doors from photographs by Dutch artists Maurice Scheltens and Liesbeth Abbenes. The surprise incorporation of fluoro colour into a pastel palette is a signature of the studio.

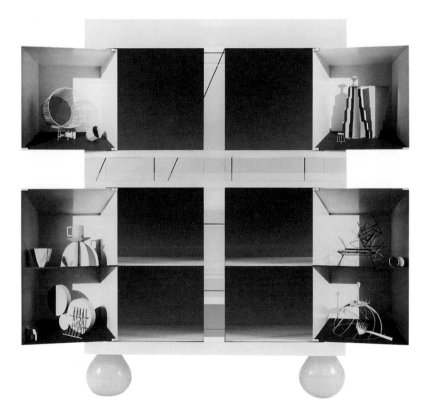

BRICK CHANDELIER

Pepe Heykoop

2009

It doesn't get more colourful – or playful – than a 2.5-metre-wide light made from toy wooden blocks. Dutch designer Heykoop had already experimented with threading recycled blocks onto metal structures for his spindle-back Brick chair, and his gigantic chandelier similarly juxtaposes a familiar form with a surprising treatment. Traditional in shape, with its eight arms holding candles, the design has an appealingly random colour pattern and creaky irregularity courtesy of its found blocks, while its deconstructed look lends the piece a carefree, non-conformist air.

AMULETO TASK LIGHT

Alessandro Mendini

2010

Three circles, in blue, red and yellow, mark the base, joint and head of the lamp, reflecting the Earth, Moon and Sun – the trinity behind Mendini's symbol-laden creation. Ground-breaking in terms of the accuracy of its light, Amuleto was the first domestic lamp to include a slim-ring LED of surgical quality (High CRI, or colour rendering index). Lightweight, with a 51-step dimmer, the lamp has a mechanism based on the articulation of the human arm. Amuleto (Italian for amulet) was dedicated to Mendini's grandson as his own lucky charm. While it's offered in single colours (in red, white or black), Mendini preferred the primary combination of his original design.

SPIN STOOL
Staffan Holm

Taking its name from the lyrical way in which the legs appear to 'spin' off the seat, the design owes a debt to Alvar Aalto's 30s icon, the E60 stool, but Holm has completely reinvented the method of construction. The Swedish designer trained as a carpenter before completing a master's degree in Design at the University of Gothenburg, and both disciplines have contributed to this beautifully resolved creation. Offered in a range of vivid, circus-style colours as well as in natural ash, the stool becomes part of an energetic sculptural artwork of spirals when stacked one upon the other.

2010

JUMPER ARMCHAIR

Bertjan Pot

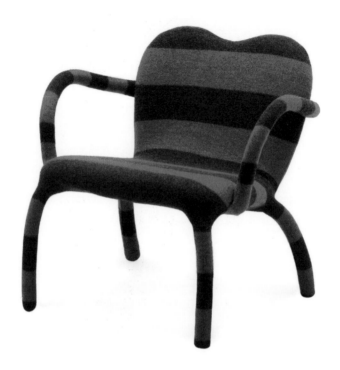

2010

No stitches, no seams, no staples – it's upholstery but not as we know it. Experimenting with felting wool to increase the durability of knitted textiles, Pot created a one-piece covering as an interesting alternative to traditional chair upholstery. Delighted to discover a garment machine in the Tilburg Textile Museum of his native Netherlands that could knit the piece in one go, Pot developed the concept for British furniture company Established & Sons. The palette is red and grey or two-tone grey, with broad stripes to enhance the homemade 'jumper' effect. All four 'arms' slide tightly over the chair's tubular steel legs and arms, with buttons fastening under the seat to join the knitted sleeve.

PEG COAT STAND

Tom Dixon

Releasing an object in fluorescent orange is a brave decision, but then British designer and entrepreneur Tom Dixon is no shrinking violet. While he had already produced pieces in orange, the Peg coat stand and Peg chair (launched the same year) were his first forays into fluoro. A continuation of Dixon's fascination with industrial processes and effective shipping, the coat stand is a flat-pack design described by Dixon as 'a big, generous totem' with eight turned wooden knobs of various sizes that can be fitted in any order. Its hi-vis days behind it, Peg is now available in black, white or the natural finish of soaped oak.

2010

GUICHET WALL CLOCK

Inga Sempé

2010

The captivating concept behind Guichet (French for window) was to provide a visual reference to the passing of time, emphasised by the cut-out aperture in place of the number six, which reveals a moving pendulum. Made from coloured ceramic, the clock has been moulded to remove the need for numbers, with the hours replaced by raised dots and dashes. Launched in beautiful matt blue-grey or olive green with a striped metal pendulum, and a white version with yellow accents, Guichet appears round yet, on closer inspection, is actually oval in shape, as if gravity is slowly taking effect.

CIRCLE FLOOR LAMP

Monica Förster

Originally presented in both sunny yellow and soft white, the Swedish designer's creation takes the half circle as its central motif. The arching stem rises gracefully from a round base to meet a fine metal disc shade that appears poetically draped over the stem. Deceptively simple in profile, from other angles the shade reveals the striking curves of the two semicircles formed after bending the metal disc. Förster created the lamp for iconic Milanese brand De Padova, which was acquired by another Italian brand, Boffi, in 2015, and the Circle floor lamp was sadly discontinued shortly after.

2010

TOOLBOX

Arik Levy

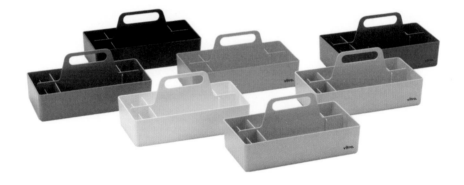

● 2010

A contemporary interpretation of the classic handyman's companion, this streamlined version, created by the Tel Aviv-born, Paris-based designer, is injection moulded in durable ABS plastic. Lightweight and compact, Toolbox is attractive enough to warrant a range of uses outside the shed, and while still extremely simple, the design's friendly appearance, with its rounded corners and raked sides, moves it on from the traditional wooden toolbox. Produced by Vitra in a variety of interesting colours since it was first introduced, the design is currently offered in mint, tangerine, moss grey, rose and sea blue along with white and a near-black tone called Basic Dark.

SPARKLING CHAIR

Marcel Wanders

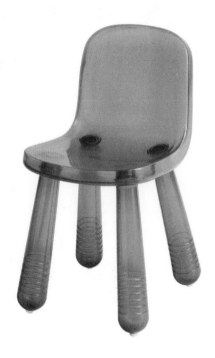

Somewhat obsessed with making the world's lightest chair and
inspired by the production process used for mineral water bottles,
Dutch designer Wanders developed a chair with Italian plastic
specialist Magis that weighed just one kilo using the same blow-
moulding technology and polyethylene plastic (PET) material. Noting
that sparkling water bottles have more resistance than still ones,
he added high-pressure air to his design for strength. Wanders took
the concept even further, designing bottle-shaped legs that screwed
into the seat (as if it were a cap) and choosing 'San Pellegrino'
green as the finished plastic colour.

2010

MASKS

Bertjan Pot

2010 to present

It began as a material experiment – the Dutch designer wanted to make rugs using rope stitched into a coil, but the method was prone to irregular tension, which made the rug edges curl unpredictably. Playing with the curvy samples, the idea was born of shaping the rope into masks, and the experiment soon became a regular activity, with Pot making these one-off assemblages ever since. The colourful masks range from sinister to playful, their shape, palette and pattern possibilities endless as the nautical and mountaineering ropes used to produce the masks come in a huge range of colours and styles.

BAU PENDANT LIGHT

Vibeke Fonnesberg Schmidt

With an appealing constructivist aesthetic, Bau (German for building) is like a child's play set with its different sized discs, each featuring one, two or three slots, clipped together by the user to form a complex three-dimensional form. The Danish designer felt that putting the slots slightly off-centre delivered a more dynamic shape, claiming, 'If I follow the grid it gets too rigid for me ... I need a little bit more chaos.' The light was designed in two sizes (fifty-nine pieces in the small, eighty in the large) and in a combination of primary colours with natural birch plywood, although recently, manufacturer Normann Copenhagen has discontinued the coloured versions.

2010

LIGHT FOREST

Ontwerpduo

2010

Pale lichen green is a rare colour in lighting yet it seems fitting for this intriguing design, which varies wildly in shape from organic and lyrical to geometric and formal. Also offered in white, it is made from aluminium tubing, with either copper or brass inner shades depending on the overall colour chosen, and sprawls across the wall or ceiling in four configurations. Distributed by Danish brand &Tradition from 2015 to 2018, the rights have reverted to Dutch designers Tineke Beunders and Nathan Wierink and the light is now manufactured and distributed in Eindhoven by their new company, Aptum. Custom colours are also possible.

ROOFER (F12) PENDANT LIGHT

Benjamin Hubert

Just like a roof, from which it gets its name, this lamp features 'tiles' clipped onto a lightweight framework. Made from silicon, they have small overlaps to create a slightly textural effect, while their fine vertical grooves catch the light in different ways. The silicon components are offered in four colourways – green, terracotta, grey and white – each with an element of in-built colour variation from one tile to the next that gives the lamp more personality. Roofer, manufactured by Italian lighting company Fabbian, comes in three shapes: cone, low drum and a third that more or less combines the two (pictured here).

2011

LOTEK TASK LIGHT

Javier Mariscal

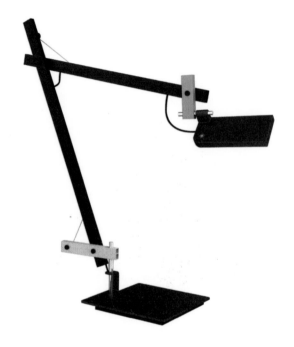

2011

Flattening the look of the traditional early 20th-century task light to a two-dimensional caricature, LoTek combines primary colours and simple rectilinear shapes to deliver an abstract artwork for the table or desk. Two versions are offered by lighting manufacturer Artemide: one with a blue painted steel base, blue aluminium head and select parts in yellow and red, the other in natural aluminium. LoTek's primary colour scheme conjures up the spirit of the Bauhaus while introducing 21st-century materials and processes, including an LED light source. Offering a great deal of flexibility and a desk clamp option, it is also dimmable.

EU/PHORIA CHAIR
Paola Navone

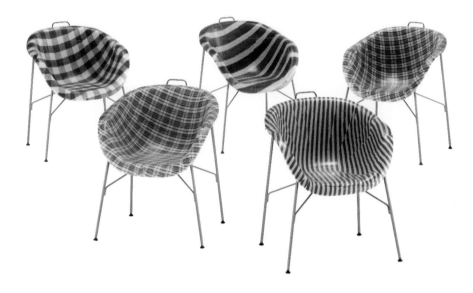

Six years before Balenciaga caused a stir in the fashion world by
basing a tote bag on Ikea's cheap Frakta shopping bag, Italian designer
Navone was taking a similarly tongue-in-cheek approach with her
eu/phoria chair. Here, the low-cost object of reference was the
humble red, white and blue plaid nylon bag that emerged in Hong
Kong in the 60s and has since become a global staple. Eu/phoria's
seat shell is formed from a sheet material made from polypropylene
and powdered wood normally found in car interiors, with the striped
or checked synthetic fabric bonding to it during the moulding process.

2011

GRILLAGE OUTDOOR CHAIR

François Azambourg

2010-11 Distinguishing the outdoor version (in electric blue) from the indoor (in black or white), colour plays a significant role in this piece. The chair is made from a single sheet of metal, perforated in staggered rows then gently folded into an enveloping shape and attached to a bent steel frame. Produced by leading French furniture brand Ligne Roset, the range also includes a two-seater sofa version. While the perforated material provides a small amount of give, for the interior version a thin quilted one-piece seat and back pad can be attached, using integrated magnets, to enhance comfort.

KORA VASE

Studiopepe

Colour is as central to Kora's impact as its form – a striking shape
suggestive of a futuristic Grecian urn. Studiopepe (Arianna Lelli
Mami and Chiara Di Pinto) studied the effect of different colours
on the vase's exotic shape before choosing a palette of seven hues
based on the four-colour (CMYK) printing process. The matt ceramic
vase comes in two heights – 32 centimetres and 52.5 centimetres
– and tones range from Crimson Red, Silk Blue and Deep Orange
in the production version through to coral-pink ombré and graphic
monochrome motifs in the limited-edition releases.

2011

BORGHESE SOFA
Noé Duchaufour-Lawrance

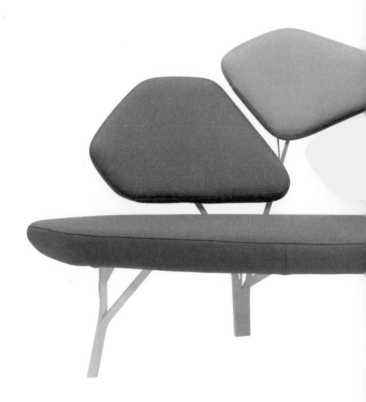

2012

The majestic pine trees of the Villa Borghese gardens in Rome were the inspiration behind this creation by French sculptor-turned-designer Duchaufour-Lawrance. One of the signature pieces at the Milan launch of Paris furniture label La Chance in 2012, the sofa's combination of delicate branch-like metal supports and organically shaped seat and back cushions creates the ideal structure for an upholstery palette of mixed green fabrics. For the colour-shy, Duchaufour-Lawrance has also devised a palette of four stone-grey shades, while custom versions are offered in Kvadrat Hallingdal 65 and Pierre Frey Bridget fabrics.

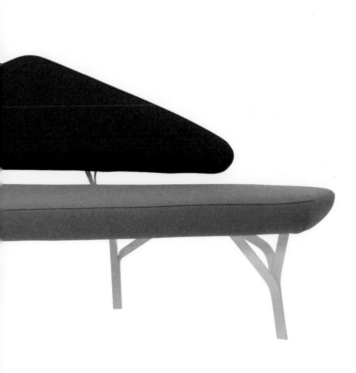

ANEMONE RUG

François Dumas

2012

Inspired by the tentacles of a marine animal, conceived through the expressive brushstrokes of a painting and finished in the softly defined curves of a hand-tufted wool rug, Anemone is a study in colour and movement. Dumas began his design using watercolours to capture the undulation of the anemone's tangle of arms, carving their shapes into the wool to enhance their impact. With an Yves Klein-style blue, a strong red or green and a soft grey, the French designer has condensed the sea creature's rich variation of shades into four powerful colourways.

PAPER PATCHWORK CUPBOARD
Studio Job

Building on the success of their all-white Paper Collection, released by Moooi in 2009, Belgian–Dutch duo Job Smeets and Nynke Tynagel returned three years later with another range using the same archetypal forms but with a new identity – colour. Like the original, this flat-pack collection uses no screws or bolts, just honeycomb cardboard and paper. The cupboard lends itself to the new colour treatment – the door panels, plinth and lintel are defined by different shades, creating dynamic compositions that emphasise each element. Thirteen super-matt polyurethane lacquers are offered with up to ten colours available, as well as the addition of real wood veneer.

2012

MELTDOWN FLOOR LAMP

Johan Lindstén

2012

The unusual shape of the lamp's spheres references the 2011 Fukushima nuclear disaster in Japan, where the Swedish designer was about to travel. Reclaiming beauty from tragedy, Lindstén designed a special mould into which the glass is hand-blown, so when globes are fitted to the finished product, they appear to be 'melting' through the shade. The lamp comes with five or eight glass diffusers in either a mix of complementary tones – amber, tobacco, rose, amethyst, light blue and dove grey – or a single colour. Table and pendant versions are also offered.

WINDMILL POUFS

Constance Guisset

By virtue of their complex dished shape and pie-like segments of
colour, these cheerful ottomans appear to be in constant motion,
hence the name. Guisset imagined them in waiting areas, or forming
a soft play area for children. Inspired by the colour wheel, they were
conceived as part of a project by the Danish fabric house Kvadrat
to celebrate one of its best loved fabrics, Hallingdal 65, designed
in 1965 by Nanna Ditzel. Produced by La Cividina since 2014, the
ottomans are available in three sizes and in varying heights.

2012

KALEIDO TRAYS

Clara von Zweigbergk

2012

With five geometric shapes that can be interlocked or stacked, and more than twelve colours, the placement of these trays offers a source of endless fun from a display perspective but also makes for neat storage. The trays were Swedish graphic designer and art director Clara von Zweigbergk's first foray into product design and became an instant hit. Starting out as a concept realised in cut paper, they ended up being executed by young Danish brand HAY in steel with a finely textured powder-coat finish. The colour options go beyond standard primary shades, with jade, aubergine, apricot and mint playing off the brights.

GEO VACUUM JUG

Nicholai Wiig Hansen

Combining dynamic colour combinations with the graphic interplay
of geometric shapes, this multi-award-winning thermos flask,
manufactured by Danish brand Normann Copenhagen, holds hot
or cold drinks while striking a bold modern pose. Geo's Danish
designer, best known for three massive-selling Ikea products from
the mid-90s (the Jules task chair, Flytta Kitchen trolley and PS
Locker), has looked extensively into the relationship between colour
and form. In addition to its six essentially two-tone colourways in a
matt finish, Geo includes a surprise third hue courtesy of a discreet
push button on the lid, which opens or closes the pouring function.

2012

COMMON COMRADES SIDE TABLES

Neri&Hu

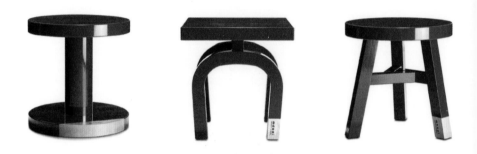

2012

It's a colour long associated with Communism and China, both of which are playfully referenced here. The collection of six tables takes its inspiration from stools traditionally used by age-old occupations in China – seamstress, emperor, merchant, tailor, farmer and scholar. Designed by Lyndon Neri and Rossana Hu, both Harvard graduates now based in Shanghai, Common Comrades was the pair's first product for irreverent Dutch furniture label Moooi. Made from solid birch, either turned or jointed, each table reveals a small section of its natural wood material (and subtle Moooi branding), with the rest drenched in glossy red lacquer.

POKE STOOL

Kyuhyung Cho

2012

True to its name, this brilliant stacking stool was designed so that the legs of fellow stools could be 'poked' through the holes drilled into its seat. The design only allows a stack of three stools high but then cleverly provides for another three to be stacked upside down. Created by the Korean-born, Sweden-based typography designer as an adults' stool with a childish sense of fun, Poke was released in red, green, blue, yellow, black, white and natural oak to promote play and experimentation – a little like building blocks. When stacked, its colourful vertical rods and horizontal bands create an arresting, totem-like display.

PICK 'N' MIX TABLE AND BENCH

Daniel Emma

Like the fun, colourful mixed sweets that coined the name, this
collection is all about personal taste, presented through the unique
visual lens of Australian designers Daniel To and Emma Aiston.
Here, the 'sweets', picked by the user, are the different shapes and
shades of objects that form the support for the table and bench.
Displaying a strong influence from the Memphis movement, the
colours have been carefully selected to emphasise the variety of
geometric shapes. The resulting pieces can appear monolithic in all
black or playful in an assortment of hues. Tops come in concrete,
Carrara marble or black granite.

2013

FLOAT SOFA

Karim Rashid

2012

Part sofa, part room divider, Float is a life raft for the living room, its back extending beyond the seat to form the rear legs. Five available configurations (a two-seater, two low-back three-seaters and two high-back three-seaters) grow to eleven possible variations with the options of straight or angled armrests and left- or right-hand orientations. As well as this, Rashid designed a fabric called Cairo, to be used as headrest and scatter cushions, in three geometric patterns that recall the ceramic tiles of Spain (the country of Float's producer, Sancal). The mix of patterns and plain fabrics in colour combinations like acid green, pink and grey give this sofa a remarkable freshness.

SPIN 1 RUG

Constance Guisset

2013

No less than 200 soft tones make up this mesmerising rug, whose Spirograph-style design uses a series of overlapping arcs to create intersections where colours gently shift in blocks. The first in a pair of circular rugs inspired by the study of geometry and colour mixing, Spin 1, with its delicate, flower-like pattern, is subtler in colour but more decorative than the simpler, spiral-patterned Spin 2. Both rugs are 220 centimetres in diameter and were created by the French designer for leading Italian rug atelier Nodus, whose contemporary and often avant-garde rugs are traditionally hand-knotted in Nepal.

PION TABLES AND STOOL

Ionna Vautrin

Inspired by chess pieces, Pion (French for pawn) presents some
power players in terms of colour and form. The French designer chose
complex tones like mustard, tobacco, sky blue, peach and olive for the
conical bases of her collection, rendering them in high-gloss lacquer.
To create contrast, she introduced natural materials with low-sheen
finishes, using maple for the table tops and colour-matched leather
for the seat. From the original range of two side tables and one stool,
Pion has grown into a large collection including single-, double- and
triple-pedestal dining tables.

2013

Bethan Laura Wood

'A work of art with legs, head and brain' is how Patrizia Moroso, art director of Italian furniture brand Moroso, describes British designer Bethan Laura Wood. Moroso is of course referring to Wood's striking appearance, with her bold, multicoloured make-up and cultural mash-up of bright, intensely patterned clothing, jewellery and footwear.

Despite all this 'visual noise', as Wood herself might call it, Moroso, who invited Wood to exhibit a new body of work at the company's flagship showroom in Brera during Milan Design Week in 2018, discovered that there is a lot more to the designer than her intriguing appearance.

According to Moroso, Wood is 'quite shy ... highly intelligent and sensitive'. Attuned to everything around her, she borrows, reinvents and subverts what she observes, throwing herself into researching relevant materials, methods and palettes to create new fabrics, forms and textures that pay homage to the past while delivering something highly contemporary.

Wood, who hails from Shrewsbury in England's West Midlands, completed an MA in Design Products at the Royal College of Art in London in 2009 under the dual tutelage of Italian designer Martino Gamper and Dutch designer Jurgen Bey. She credits both with encouraging her to embrace her obsession with colour and surface decoration.

During a residency at the London Design Museum in 2010, Wood created Particle–Stack, a series of cabinets inspired by wooden shipping crates but made using elaborate marquetry techniques in plastic laminates supplied by Abet Laminati. Wood has collaborated with the Italian plastics giant since 2009, when she started her Super Fake pieces using laminates cut into precise shapes to form new, complex patterns.

Among her major influences, Wood counts Mexican architectural and cultural landmarks along with the futuristic graphics of the country's 1968 Olympics. A 2013 residency in Mexico City opened her eyes to the unbridled way in which Mexican culture embraces colour and intense pattern, and a number of her works for Moroso, ceramics specialist Bitossi and high-end leather goods company Valexta have been shaped by her experiences there.

Wood is also devoted to the work of artist Eduardo Paolozzi, a co-founder of the British Pop art movement. His glass mosaic murals designed for Tottenham Court Road tube station, completed in 1986, illustrate a democratic design approach to which Wood aspires.

Since her first solo exhibition in 2013 at London's Aram Store, in association with Milanese gallery Nilufar, Wood has had no shortage of limited-edition commissions and installation work for the likes of Hermès, Perrier-Jouët and Kvadrat. While her design ideas are often too complex and labour intensive for mass production, she has in recent years begun to create works that contain her usual decorative power but can be produced in greater numbers.

In 2019, Wood was commissioned by celebrated German ceramics producer Rosenthal to create a new surface decoration for the all-white Bauhaus-era tea set masterpiece, TAC by Walter Gropius. The relationship with Rosenthal led to another project, this time to create her own limited-edition tea service, Tongue, which incorporated subtle references to the Gropius tea set. Wood never lets a learning opportunity go to waste.

While colour and pattern are her true loves, she does not always take a maximalist approach. As Wood explains, 'It is about controlling colour without stifling it. You can't have it so unruly, so noisy that you can't even focus on it.'

CLOCKWISE FROM TOP LEFT
Valextra Iside 'Toothpaste' handbag, Spring/
Summer 2018; Mono Mania Mexico textile for
Moroso, 2018; Tongue tea set for Rosenthal,
2019; Guadalupe vase for Bitossi, 2016.

OPPOSITE PAGE Bethan Laura Wood
at the Moroso showroom, Milan, 2018.
Portrait by Craig Wall.

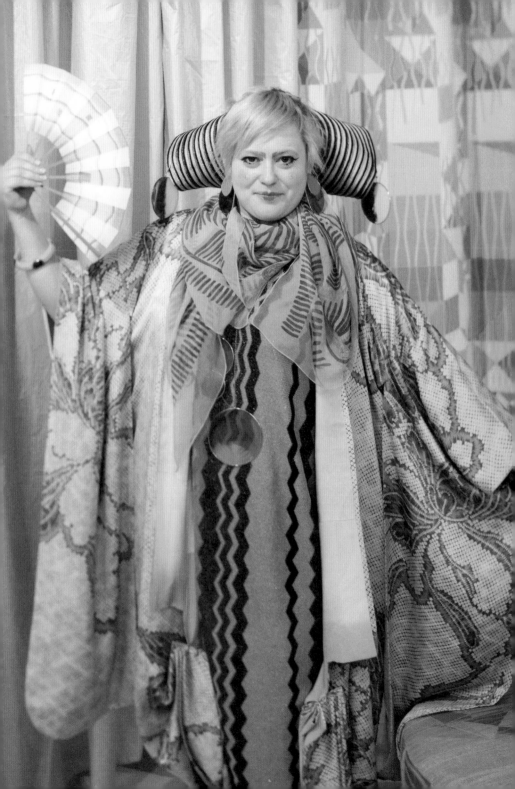

BETHAN LAURA WOOD

Offered in two colourways – aggressive brights and muted tones – the rugs that make up the Super Fake collection for Italian company cc-tapis are based on layered rock forms and represent a continuation of Wood's work in marquetry laminates for renowned limited-edition design gallery Nilufar. Instead of terrazzo made from plastic chips, these pieces render facets of rock in hand-knotted wool. The British designer, herself a living, breathing advertisement for the courageous use of colour, constantly challenges the status quo with her unique marriage of alternative forms and clashing shades. Super Fake is available in four shapes: a triangular shard, a (more or less) classic circle, a runner and a rectangular area rug.

TUDOR CABINET

Kiki van Eijk and Joost van Bleiswijk

2013

Visually arresting in terms of both colour and pattern, this unconventional storage cabinet combines a highly decorative printed fabric with a criss-cross grid of ash woodwork that recalls the stucco-filled facades of English Tudor houses. It was first presented in three palettes (blue, pink and green) and three archetypal shapes (arch, square and low rectangle). Van Eijk and van Bleiswijk, the cabinet's experimental Dutch designers, embroidered its dense, jungle-like fabric with a surprise element – an odd mix of 'hidden treasures' such as beetles, teapots and cotton reels, offering a playful hint of the precious collections that might be kept inside.

AND A AND BE AND NOT SCREEN

Camilla Richter

2012

A non-stop colour maker, Berlin-based Richter developed the intriguingly titled screen using dichroic (colour-changing) glass in fine metal frames. The screen is hinged to allow elements to pivot back and forth, extending or contracting the structure, so the coloured composition of squares and rectangles constantly shifts according to the changing light in the room, directing the coloured light in turn onto various objects and walls around it. Its folding ability also means sheets can stack one in front of the other to create further colour possibilities. First shown at furniture fairs in Cologne and Milan, the screen has sadly never gone into production, remaining a limited-edition piece sold through design galleries.

WOOD BIKINI CHAIR

Werner Aisslinger

2013

It was an abnormally colourful year for the usually quite restrained German designer, who presented the Wood Bikini chair as a prototype alongside his Bikini Island modular sofa system with its patchwork of colourful fabrics. Designed for well-known Italian furniture brand Moroso, the chair was shown in two colour gradients, aqua through acid green to yellow, and red through pink to warm grey, and was one of the stars of Moroso's presentation at the 2013 Milan Furniture Fair. The design is now only available in single colours with various seat and back upholstery options and the grain of the frame's ash wood showing through the matt lacquer.

REDDISH VESSELS

Studio RENS

The result of an experiment in self-colouring ceramics, these pieces were developed by design duo Renee Mennen and Stefanie van Keijsteren with alternative Dutch ceramics house Cor Unum. After their first firing, the vessels are placed in a shallow tray of vermilion-coloured liquid pigment and left for days or weeks, depending on the required effect. The pigment is absorbed by osmosis, with the colour most intense at the bottom and dissipating the higher up the vessel it goes until it reverts to the natural shade of the clay. Cor Unum currently produces four shapes: Vase Up, Vase Down, a wide, shallow bowl called Plate Wide and a small bowl called Original.

2013

CHAIR LIFT FURNITURE

Martino Gamper and Peter McDonald

2014

An example of art in furniture form, these pieces were created as part of an installation called *Chair Lift* for Italian furniture brand Moroso at its flagship showroom in Milan for Design Week 2014. The chairs, ottomans and sofas presented were never produced commercially but have subsequently flitted between design galleries around the world as one-off art pieces. An exciting collaboration between London-based Italian designer Gamper and Anglo-Japanese artist McDonald, the structures were created in the Moroso factory by Gamper while fabrics were either hand-painted separately by McDonald or crafted into assemblages from an assortment of colourful plain fabrics, delivering sculptures that also function as seats.

COLOR FALL SHELVING

Garth Roberts

Using a sequence of differently hued horizontal lines, the Canadian designer has created wall- and floor-mounted shelving that cascades with colour. The name reflects the idea of a surge of colour 'falling' and engaging with the interior around it, conveying the power of a carefully selected group of colours over any individual shade. The ash-veneered cabinets are printed internally in two palettes – an energetic red/orange scheme and a calmer green one that gradually shifts through pinks and purples. Even the internal shelves blend into the overall effect, lacquered in colours that perfectly replicate the stripes.

2014

SEAMS VESSELS

Benjamin Hubert

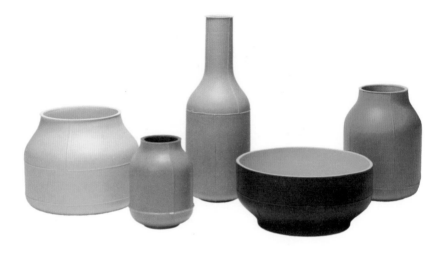

2014

In the slip-cast moulding process of ceramics, a raised seam is normally considered an undesirable mark. Yet the British designer has embraced it here, allowing the seams not only to remain, but also to become an integrated pattern, which he has randomised by simply rotating the individual sections of the moulds so that each piece is unique. Hubert selected a family of five matt-glaze colours for the exterior, with each vessel receiving a complementary internal colour to provide a stronger sense of the form. The five pieces in the collection, made by Florentine earthenware specialist Bitossi, are based on classic jar or bottle shapes.

MOLLO ARMCHAIR
Philippe Malouin

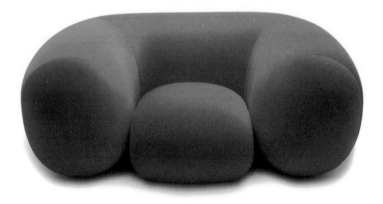

Plump, soft and inviting, Mollo is constructed purely from layers of
upholstered polyurethane foam. Its rounded sausage-like arms and
backrest are simply stitched to the pebble-shaped seat to ensure
a clear delineation of elements. An incredibly strong form in red,
Mollo can appear surprisingly restrained in sophisticated darker
shades like grey and blue, although at nearly 180 x 120 centimetres
it certainly requires a good deal of floor space. The name comes
from '*vas-y mollo*', an old colloquial French term for taking it easy,
something that would be hard to resist in this chair.

2014

GEAR VASE

Floris Hovers

2014-15

Inspired by cast-metal engine blocks and gear housings, Hovers worked with Dutch ceramic specialist Cor Unum to develop a vase made up of different coloured modular components that could then be bolted together. Between each end, separate middle parts can be added to stretch the form to virtually any length. Of the seven versions available, Gear 4 (pictured here) is made up of four central sections and two end components. Each section is available in yellow, mint, olive green, pink, white or dark red. In 2019 Hovers took the concept further to create Four Stage Gear Circle, where twenty vases with tapered sides are bolted together to form a perfect circle, 1.5 metres in diameter, in a sequence of colours – an amazing technical achievement.

ROLY POLY CHAIR

Faye Toogood

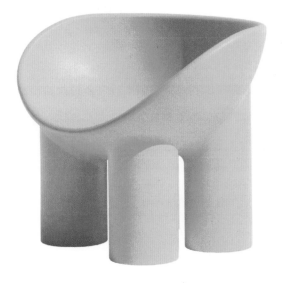

The heavy cylindrical legs and rounded bucket seat of the
wonderfully named Roly Poly couldn't be further in style from
Toogood's other pieces, like Spade, which was the last word in
simple minimalism. The British designer drew on her experiences
of pregnancy and motherhood for this voluptuous piece, which
was handmade in transparent fibreglass for her limited-edition
Assemblage No. 4 range. Now also produced in rotation-moulded
polyethylene by Italian furniture company Driade, the mass-made
indoor/outdoor version retains the charm of the original while
offering it in colours that range from the attractive Ochre (pictured
here) and Red Brick to the rather fitting Flesh.

2014-18

SCREEN HANGING ROOM DIVIDER

GamFratesi

2013-14 Like colourful petals suspended in mid-air, Screen is a collection of
different sized hanging partitions made from thermo-welded polyester
that acts as kinetic sculpture, room divider and sound absorber all in
one. Developed by Danish–Italian duo Stine Gam and Enrico Fratesi
for an exhibition of their work at the 2014 Stockholm Furniture Fair, the
design had the working title Balance, but once licensed to Cappellini
this was changed to the more prosaic Screen. Named according to
the number of petals, Screen 3 is offered in mid-grey, Screen 4 in
dusty pink, and Screen 5 has two multicoloured versions plus a third
colourway in off-white.

WIRE S#1 CHAISE

Muller Van Severen

The sophisticated use of muted colour in open, delicate forms is
a hallmark of Muller Van Severen's work. Fien Muller and Hannes
Van Severen, the pair behind the Belgian design studio, created the
chaise as one of nine sculptural furniture designs for the OFFICE
Solo House project, a series of residences outside Barcelona
showcasing global architectural talent. Produced in surprisingly
vintage hues of jade green, deep red and creamy white, as well as
an uncoated version, the pieces are made from stainless-steel
mesh, which provides resilience while allowing for translucent
volumes in a number of sweeping shapes.

2016

GYRO TABLE

Brodie Neill

2015-16

On a visit home to Australia in 2015, Tasmania-born, London-based designer Brodie Neill was appalled by the amount of plastic he witnessed washed up on Bruny Island, a remote island off Tasmania's coast that he had frequented as a boy. Quickly deciding to create an object to present at the upcoming London Design Biennale that would highlight the ocean's plastic waste problem, Neill's studio started the arduous task of collecting and sifting through tonnes of minuscule bits of plastic.

Gyro is the result of these labours, a spectacular table made by forming micro-plastic into a type of recycled synthetic terrazzo. Tiny pieces of what were once water bottle tops, children's toys, flotsam and jetsam from the commercial fishing industry and various cleaning products have been recovered from beaches around the world and transformed into an object of startling beauty.

The choice of blue is of double significance and poignancy. While blue traditionally represents the colour of the sea, Neill quickly learnt that the largest concentration of ocean plastic is, ironically, also that colour. Contacting the Institute for Marine and Antarctic Studies in Hobart to find out why, he was told that marine life and seabirds tend to be attracted to plastics in warmer colours like red, orange and yellow, mistaking them for small fish and plankton.

The galactic, almost Milky Way-like appearance of the table's surface was a happy coincidence discovered in its early testing stages and perfected over the studio's ongoing experiments. It now defines the piece, and the millions of crystalline pieces that make up the 'ocean terrazzo' signify the immensity of this global problem.

Gyro's name comes from the 'gyres' or vortexes where ocean currents have concentrated debris. Neill hopes not only to develop greater public awareness through exhibitions and articles on the Gyro table but also to keep actively researching ways in which micro-plastic can be utilised in future products and projects.

TOPOGRAPHIE IMAGINAIRE RUG

Matali Crasset

2015

A rug that encompasses both the geometric and the organic, this hand-knotted design was conceived as an imaginary country. Its cartographic stylings reinforce radical French designer Matali Crasset's concept of an aerial view of a fictional landmass, featuring turquoise road-like lines joining dots that might be cities, overlaid with squiggling lines suggesting rivers. Large expanses of green reveal the natural variation of hand-dyeing, while an irregular red border and finger-like fringes complete the rug's 'coastline'. Made in Nepal for Milanese carpet company Nodus from wool, bamboo silk, linen and hemp, the rug incorporates four pile heights (4, 6, 8 and 10 millimetres) to add textural interest and define areas.

MINIMA MORALIA SCREEN

Christophe de la Fontaine

Drawing on the concertina effect of hand-held fans, the three- or four-part floor standing screen uses pleating to catch the light and create graphic patterns that remove any need for further decoration. Made of powder-coated steel and fabric, it was originally shown in Bordeaux red, grey and yellow during Milan Design Week 2015, with classic white and metallic champagne now offered instead of yellow. Created by the co-founder of design brand Dante Goods and Bads, the sophisticated three-dimensional piece, with its fine lozenge-shaped window in the centre of each panel, forms a strong architectural composition within a room and displays the brand's usual emphasis on craft.

2015

SAM SON ARMCHAIR

Konstantin Grcic

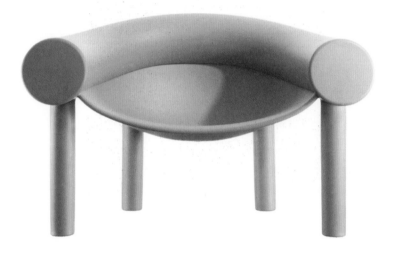

2015

Curry is not a colour one comes across all that often in furniture, but the cartoonish Sam Son rewrites the rules. A small selection of other shades are also offered by the manufacturer, Italian plastics specialist Magis, but only this distinctive yellow and an equally eye-catching bright red seem to deliver the necessary jovial expression to suit what the designer calls the chair's 'horseshoe-shaped sausage' form. Sam Son's two components, both in rotation-moulded polyethylene, offer different levels of resistance – a softer arm and back rest and a stiffer, stronger base.

MARK TABLE AND CHAIR

Sebastian Herkner

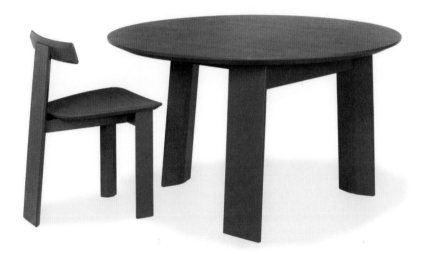

Dutch furniture company Linteloo has never been afraid of colour.
The Mark collection, consisting of a three-legged solid wood table
and chair, comes in seven hues including an unusual 50s-style
shade of green, ochre and pink plus the more common red, blue,
black and white along with natural ash. Made from solid planks of
ash with chamfers and bevels to lighten the look of its wide legs,
German designer Herkner's collection explores how flat planes
and strong colour can combine to create graphic, symbolic objects.
The chair's T-shaped back defines the project and prevents the
bold colours from overwhelming its form.

2016

UTRECHT (637) ARMCHAIR/ BOXBLOCKS FABRIC

Gerrit Rietveld/Bertjan Pot

 2016

It might seem odd to celebrate the ongoing success of a chair originally produced in brown sailcloth by upholstering it in a striking geometric pattern, but this extraordinary Jacquard version is just one of several revitalisations that have been applied to Rietveld's ground-breaking block-like form.

Created in 1935 by the Dutch designer and named after his birthplace, the Utrecht armchair was produced for a short time by renowned Amsterdam department store Metz & Co before World War II interrupted manufacturing of virtually all luxury goods. After the war, the sombre sailcloth upholstery was replaced by a more uplifting selection of coloured wool fabrics and the chair continued for several decades unchanged.

In 1971 Italian furniture brand Cassina purchased the rights to manufacture Rietveld's furniture designs and made some minor cosmetic changes to Utrecht before reissuing the armchair as Utrecht (637) in 1988 with a choice of blanket or zigzag stitching along its seams. For the 90th anniversary of Cassina in 2017, the brand commissioned Dutch designer Bertjan Pot to create a new upholstery fabric especially for Utrecht.

'Most patterns can be classified into two categories,' says Pot. 'One in which the pattern emphasises the shape, like stripes or blocks, and one in which the pattern dazzles the shape, like a camouflage print does or a large flower pattern. The Boxblocks pattern does both.'

Fashioned to fit precisely to the size and shape of the Utrecht chair, the Boxblocks fabric was created in three colourways as part of a limited edition of 270 (with ninety pieces in each colourway). Made on a computer-controlled Jacquard machine to ensure no pattern repeat, the design uses eight coloured threads that combine in pairs to create nineteen colours. The repeating geometric pattern emphasises the chair's volume while mesmerising with its colourful alternating triangles.

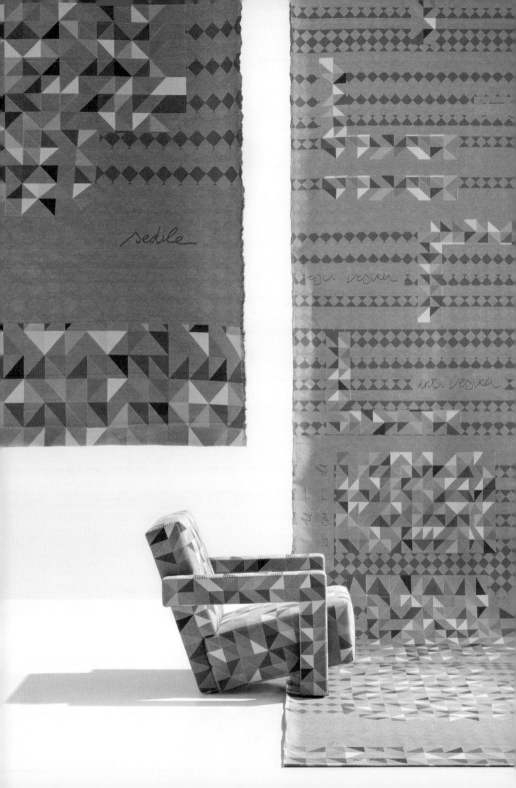

TRICOLORE VASES

Sebastian Herkner

2017

Placing one colour in front of another to create a new shade is a simple yet effective technique in glass. Herkner's Tricolore collection offers three sets of vases (SH1, SH2 and SH3), each utilising two separate and different coloured cylinders that fit one inside the other. The objective during its development process was to refine the colour, size and wall thickness of each vase so this layering was achievable and provided the most impact. Danish brand &Tradition sourced a quality bohemian glassworks to ensure the exotic colours delivered a sense of the precious stones envisaged by the designer and referenced in the vases' colourways: Amber and Lapis, Topaz and Ruby, Malachite (green) and Cornaline (brownish red).

BLUE CANDLEHOLDERS

Thomas Dariel

Indigo blue – the sole colour available for these striking objects – brings intensity and strength to what is otherwise a delicate structural concept in laser-cut and laminated steel. Using subtle asymmetry, the French-born, Shanghai-based designer has delivered a playful alternative to the conventional notion of a matching pair, with one candleholder taller than the other due to the inclusion of a circular motif in its stem. The result elegantly combines a contemporary aesthetic with references to traditional candleholders in the conical drip cups and heavy domed bases.

2017 ●

FILO TABLE LAMP

Andrea Anastasio

2017

When a light range features names like Amethyst Queen and Emerald King, it's clear that colour is a dominant factor in the design. Indeed, the different hues that grace the frame, cords and bead-like shapes of Murano glass give Filo its decorative appeal. Available as a table, wall or floor lamp, with eight colour combinations in each, the light looks as if it has been blown apart then wittily put back together. While most lighting attempts to conceal signs of electrical connectivity, Filo proudly makes a feature of it, with the ample cables appearing as ornamental as they are functional.

FONTANA AMOROSA PARACHUTE LIGHT

Michael Anastassiades

Colour is not always about paint choice – Anastassiades actually avoided using paint for this piece, opting instead for a traditional treatment that turns brass a particular shade of red. The London designer and conceptual lighting genius created Parachute for Milan's Nilufar Gallery as a limited-edition piece in the collection Fontana Amorosa, named after a freshwater pool in his native Cyprus and linked to Aphrodite, goddess of love. The collection is a series of what the designer describes as 'fountains and fireworks' – four pendants, five floor lamps and two wall lamps, each featuring fine, arched arms of patinated brass in a dark crimson hue and multiple mouth-blown opaline glass spheres.

2017

CARYLLON DINING TABLE

Cristina Celestino

2018

The Italian designer has brought her love of colour and decoration to bentwood furniture, a style synonymous with simplicity and restraint. Designing for Gebrüder Thonet Vienna GmbH (GTV), one of the world's most historically significant bentwood producers, Celestino chose to use square rather than the usual round sections of wood for the table's clever interlocking frame. For the intricately patterned table top, she was inspired by the traditional inlay technique of straw marquetry. The table was launched in Rosso Vino, a complex shade of red, and then offered in sixteen hues, with its frame lacquered in solid colour and its ornate surface in a translucent stain.

PLISSÉ ELECTRIC KETTLE

Michele De Lucchi

Designed to add sculptural interest to the kitchen bench, the elegant Plissé (French for pleated) recalls the dynamic lines of an Issey Miyake dress. The triangular grooves gathered around its form provide an ever-changing appearance as light and shadow fall upon the object, while strong geometric elements have also been used in the spout and handle. Restrained in black, white or grey, flamboyant in red, the thermoplastic resin kettle is testament to the architectural background and lifelong interest in colour and pattern of its creator, a key figure of modern Italian design.

2018

TAPE MODULAR SOFA SYSTEM

Benjamin Hubert

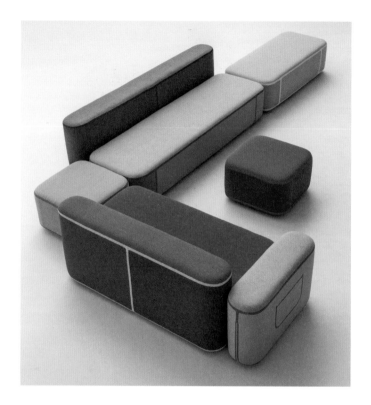

2018

Modular sofas are generally not at the cutting-edge of colour, but Tape is radical in several ways, not least of which being that the sofa's upholstery is made up of offcuts that are taped together not sewn. Working with Moroso, British designer Hubert chose to push the colour envelope not only through the choice of differently hued fabrics for each module but also by using contrasting and complementary coloured thermo-welded polyurethane tape for the fabric joins. This technique is commonly used in making shoes, clothes and equipment for snowboarding, skiing, hiking and mountaineering. The combination of seating blocks and coloured tape emphasises the system's modularity.

GARDEN OF EDEN RUG

India Mahdavi

Inspired by Persian gardens, this design for rug company Golran plays with geometry and repetition to create the illusion of depth and movement. The wild, leafy pattern with its freeform edge is one of two shapes offered – the other, a classic rectangle, centres its leaf motif against a semi-rigid grid. The rugs come in four colourways, named after months and evocative of the seasons: March (pictured here) is a swathe of greens, June the colour of straw, September a blend of autumnal shades and December a starker contrast in off-white and black. Made using traditional hand-knotting and dyeing techniques, each rug has a soft variation across its surface and a low pile to maximise the pattern's optical effect.

2018

BLISS RUG

Mae Engelgeer

2016–18 This distinctive piece is part of a collection of circular, rectangular and asymmetrical rugs whose divine colour palette led the Dutch textile designer to name it Bliss for its 'kind and soft' qualities. Engelgeer's work spans fabric, wallpaper, rugs and, more recently, furniture, but always incorporates her unmistakable way with colour. Exploring circular forms in Bliss, her designs take the bold gestures of Memphis but deliver them in a subtler range of shades. The rugs are made using traditional hand-knotting techniques with Tibetan wool hand-spun and hand-dyed in conjunction with silk to create what Engelgeer likes to refer to as 'jewellery for interior spaces'.

TOTEM FLOOR LAMPS

Studio Sabine Marcelis

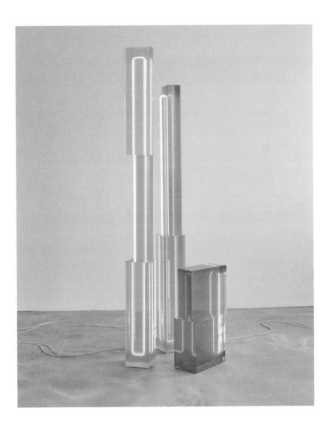

An ongoing fascination with light and the qualities it exhibits while passing through materials is fertile ground for the Dutch designer, whose work frequently involves the use of resin or neon. Totem is a combination of both. Enticing candy-coloured shades, reminiscent of Eastern delicacies like pomegranate, rosewater and orange blossom, are illuminated by the special quality of neon light. The first collection of Totem, created in 2018 for Side Gallery, a Spanish limited-edition venture, established the designer's hybrid of neon tubes and sculptural resin blocks. Her continued exploration of the concept in 2019 resulted in the current Totem forms, which are available in an edition of twelve plus two artist's proofs.

2018-19

DOLLS CHAIR

Raw-Edges

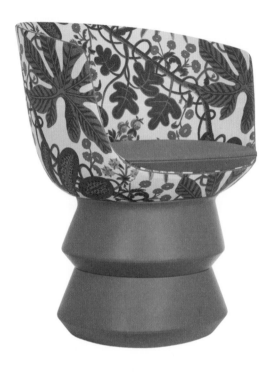

2019

Shay Alkalay and Yael Mer, the husband-and-wife team behind London-based studio Raw-Edges, are leaders in the innovative use of colour, form and material. Key to their approach is the notion of deconstruction and, conversely, construction, achieving new colours through the cutting away or layering of materials. Their limited-edition range of chairs for the experimental Objets Nomades collection of fashion house Louis Vuitton are modular pieces made from three distinct elements – seat, base and shell. Like dressing a doll, the seats can be upholstered in velvet, printed linen or leather, with tropical prints and fur also part of the playful wardrobe.

BUTTERFLY CONSOLE
Hannes Peer

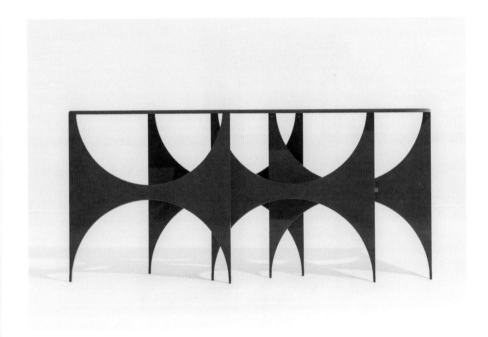

A tribute to the webbed concrete structure of a bridge designed by
Sergio Musmeci in the southern Italian city of Potenza, Peer's console
uses overlapping arches to create a similarly evocative form. The
designer also likens the arches to the 'crests of a free-range rooster
or the hats of hospital nuns in certain dreams of Federico Fellini'. The
bridge analogy is clear when the beech wood console has an opaque
cement resin finish but less obvious in its high-gloss coloured guise.
Three shades are offered – Japanese red, blue and racing green
– creating a surface that resembles glazed ceramic.

2019

APOLLO DINING CHAIR

Lara Bohinc

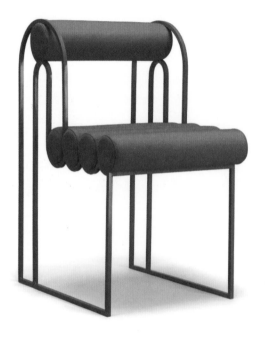

2019

Apollo is part of the Planetaria collection, which continues Bohinc's exploration of 'celestial' shapes begun in an earlier furniture range, Orbit. Where previously the London-based designer had offset fine square-section bronze- and brass-plated frames with contrasting fabrics, here she adds the option of one unifying shade carried across both frame and upholstery. Offered in pillar-box red or petrol blue, this single-colour version emphasises the volume created by the frames. Planetaria includes three chairs (a dining chair and two armchairs), two poufs, a love seat, console and a range of lights, all with space-themed names and a liberal approach to saturated colour. The metal beneath the paint is stainless steel and the repeating cylindrical cushions are upholstered in wool.

DISTRICT FABRIC

Kelly Wearstler

The American designer is known for combining unusual vintage and
contemporary furniture with a collision of strong colours and bold
patterns in her interiors. From her fifth collection for New York textile
house Lee Jofa, this painterly design plays with scale and colour
juxtaposition, delivering oversized blocks in the type of palettes
found in the early Cubist works of Braque and Picasso, where
brighter colours exist within a framework of darker backgrounds.
Printed on pure linen in Italy, the hand-painted design is translated
to seven colourways: Claret (pictured here), Apricot, Cobalt, Tawny
and Tobacco plus the softer blush pinks of Silt and neutrals
of Alabaster. The District design is also offered in wallpaper,
in five colourways.

2019

TALLEO TALLBOY

Adam&Arthur

2019-20

Since presenting their first dazzlingly colourful project, Bloom, at Milan Design Week in 2018, Australian industrial designer Adam Goodrum and French straw marquetry artisan Arthur Seigneur have been pushing their work and palette even further. Talleo is one of three limited-edition objects from Exquisite Corpse, a collection named after a parlour game created by the Surrealists. The game involves the accumulative drawing of body parts and this collection, while far less macabre, follows a similar methodology. Goodrum designed the initial forms and patterns and, through an exchange of ideas and endless adjustments, the pair agreed on the design before applying more than 15,000 hand-dyed pieces of rye straw to each object.

CHUBBY TEAPOT

Laureline Galliot

With its thick interlocking bands of colour, Chubby is typical
of Galliot's designs in that colour and shape are generated
simultaneously. Colour is always an integral part of the structure
of Galliot's work rather than applied later as a surface decoration.
This method takes inspiration from Expressionist painters, who
used paint to create a subject rather than filling in a sketched
outline. In Galliot's case this is made possible by utilising the
emerging technologies of virtual modelling and full-colour 3D
printing. The Paris-based designer creates her limited-edition
objects using a virtual reality mask and a digital painting tool,
taking what she considers a painterly approach and closely
observing the dialogue between ornament and shape.

2020

NOTES

P. 33
'The more we see that colour always deceives us'
Josef Albers, 'My Courses at the Hochschule für
Gestaltung at Ulm', Josef Albers Minimal Means, Maximum
Effect, Fundación Juan March, Madrid, 2014, p. 276,
<https://monoskop.org/images/1/10/Josef_Albers_
Minimal_Means_Maximum_Effect_2014.pdf>.

P. 33
'In Mexico, art is everywhere'
'Josef and Anni Albers artists biographies', The Josef and
Anni Albers Foundation, <https://albersfoundation.org/
artists/biographies>.

P. 45
'mainly made of air'
Harry Bertoia, quoted in 'Diamond Chair', Knoll, 2014,
<https://www.knoll.com/document/1352940812739/
Knoll_BertoiaDiamond_Cutsheet.pdf>.

P. 63
'Girard taught us that business ought to be fun'
Hugh De Pree, quoted in Leslie Piña, Alexander Girard
Designs for Herman Miller, Schiffer Design Books,
Atglen, 1998, p. 10.

P. 63
'Nothing was left untouched'
Braniff International Airways advertisement, Life, 59–26,
24 December 1965, <https://books.google.com.au/
books?id=EEwEAAAAMBAJ&lpg>, p. i.

P. 107
'a milestone in the history of contemporary design'
Guilio Cappellini, quoted in Liam Tilbrook, 'Cappellini
reissues Joe Colombo's classic 1960s Tube Chair',
Dezeen, 31 July 2016, <https://www.dezeen.com/2016/
07/31/cappellini-reissues-joe-colombo-classic-1969-
tube-chair/>.

P. 109
'Most people spend their lives living in dreary,
grey-beige conformity'
Verner Panton, quoted in 'When a designer turns
the chair world upside down', Vitra, 5 April 2019,
<https://www.vitra.com/en-au/magazine/details/
original-cone-chair/>.

P. 125
'three years of ecstasy'
Ettore Sottsass, quoted in 'Oh Ettore, put it away!',
Phaidon, 5 December 2014, <https://au.phaidon.com/
agenda/design/articles/2014/december/05/oh-ettore-
put-it-away/>.

P. 131
'All my objects are like characters'
Alessandro Mendini, quoted in Marcus Fairs,
'There is no more ideology in design', Dezeen, June 26
2015, <https://www.dezeen.com/2015/06/26/alessandro-
mendini-interview-no-more-ideology-design-magazines-
kartell-claudio-luti-proust-chair/>.

P. 131
'I have always treated the matter of colour
in a very instinctive way'
Alessandro Mendini, quoted in Stefano Casciani,
'Interview with Alessandro Mendini', in Rem Koolhaas,
Norman Foster, and Alessando Mendini, Colours,
Birkhauser, 2001, p. 239.

P. 157
'homage to chaos'
Humberto Campana, 'Campana Brothers on the Vermelha
Chair' [video], Youtube (uploaded 7 September 2014),
<https://www.youtube.com/watch?v=S-2pq88ftHk>.

P. 171
'against the flatness of the conventional colour industry'
Hella Jongerius, Q&A at Breathing Colour exhibition,
Design Museum London, 2017, transcript supplied
by the designer's studio.

P. 173
'Experiencing colour is completely dependent on
its physical, visual, artistic and cultural context'
Hella Jongerius, Q&A at Breathing Colour exhibition,
Design Museum London, 2017, transcript supplied
by the designer's studio.

P. 201
'It's amazing how influential colour actually is'
Nipa Doshi, quoted in Melissa Taylor, 'A Culture
of Colour Doshi Levien', Franklin Till, July 2018,
<https://www.franklintill .com/journal/a-culture-
of-colour-doshi-levien>.

P. 201
'she's painting and creating colours'
Jonathan Levien, quoted in Suzy Anettea,
'In Conversation with Doshi Levien', design anthology,
<https://designanthologymag.com/story/doshi-levien>.

P. 201
'It was really important that no matter what angle you
looked at it from, it was poetic'
Doshi Levien, 'Doshi Levien's furniture for Moroso
"challenges perceptions"' [video], Youtube (uploaded
14 November 2014), <https://www.youtube.com/
watch?v=9SGb_9kOgvU>.

P. 201
'On each project you have to push your idea of colour'
Nipa Doshi, quoted in Melissa Taylor, 'A Culture of
Colour Doshi Levien', *Franklin Till*, July 2018,
<https://www.franklintill.com/journal/a-culture-of-
colour-doshi-levien>.

P. 210
'functioning as a classy wardrobe with a variable
composition and well-measured compartments'
Maarten de Ceulaer, quoted in Matylda Krzykowski,
'A Pile of Suitcases by Maarten de Ceulaer', *Dezeen*, 23
October 2008, <https://www.dezeen.com/2008/10/23/
a-pile-of-suitcases-by-maarten-de-ceulaer/>.

P. 223
'For us, design is not a cerebral process'
Carole Baijings, quoted in Louise Schouwenberg,
Reproducing Scholten & Baijings, Phaidon,
London, 2015, p. 42.

P. 223
'It's not about getting from A to B'
Stefan Scholten, 'Design Profiles Scholten & Baijings'
[video], *Cfile.Daily* (uploaded 28 July 2014),
<https://cfileonline.org/video-scholten-baijings-
interview-dutch-profiles/>.

P. 223
'Our work is about colour, layering and patterns'
Carole Baijings. 'Vogue Living The design philosophy
of Scholten & Baijings co-founder Carole Baijings'
[video], *Youtube* (uploaded 17 March 2019),
<https://www.youtube.com/watch?v=ehBafFhKRBo>.

P. 239
'If I follow the grid it gets too rigid for me'
Vibeke Fonnesburg Schmidt, 'Suspension Bau by
Normann Copenhagen (interview Vibeke Fonnesburg
Schmidt) – Made in Design' [video], *Youtube* (uploaded
10 October 2014), <https://www.youtube.com/
watch?v=splfQa0ZBYg>.

P. 263
'A work of art with legs, head and brain'
Patrizia Moroso, 'Bethan Laura Wood + Patrizia Moroso'
[video], *Youtube* (uploaded 22 April 2018),
<https://www.youtube.com/watch?v=0NvwCl4ef4I>.

P. 263
'quite shy ... highly intelligent and sensitive'
Patrizia Moroso, 'Bethan Laura Wood + Patrizia Moroso'
[video], *Youtube* (uploaded 22 April 2018),
<https://www.youtube.com/watch?v=0NvwCl4ef4I>.

P. 263
'It is about controlling colour without stifling it'
Bethan Laura Wood, quoted in Riya Patel, 'A taste
of Bethan Laura Wood', *Icon*, 7 May 2015,
<https://www.iconeye.com/design/features/item/
11875-a-taste-of-bethan-laura-wood>.

P. 284
'horseshoe-shaped sausage'
Konstantin Grcic, 'Sam Son / Easy Chair / Magis',
<https://konstantin-grcic.com/projects/sam-son/>.

P. 286
'Most patterns can be classified into two categories'
Bertjan Pot, 'Boxblocks', <https://www.bertjanpot.nl/
work/boxblocks/>.

P. 299
'crests of a free-range rooster'
Hannes Peer, email interview with the author,
12 August 2019.

Back cover
'One sits more comfortably on a colour that one likes'
Verner Panton, *Notes on Colour*, Danish Design Centre,
1997, p.25.

BIBLIOGRAPHY

Albers, Josef, *Interaction of Color (50th Anniversary Edition)*, Yale University Press, Connecticut, 2013.

Albus, Volker, Reyer Kras, and Jonathan M. Woodham, eds., *Icons of Design: The 20th Century*, Prestel Publishing, Munich, 2004.

Antonelli, Paola, and Steven Guarnaccia, *Achille Castiglioni*, Corraini Editore, Mantua, 2000.

Bem, Merel, Inga Powilleit, and Tatjana Quax, *How We Work: The Avant-garde of Dutch Design*, Lecturis, Eindhoven, 2014.

Bernsen, Jens, *Hans J Wegner: on Design*, Danish Design Centre, Copenhagen, 1995.

Böhm, Florian, ed., *KGID Konstantin Grcic Industrial Design*, Phaidon, London, 2005.

Bosoni, Giampiero, ed., *Made in Cassina*, Skira, Milan, 2009.

 — *Il Modo Italiano: Italian Design and Avant-garde in the 20th Century*, Skira and the Montreal Museum of Fine Arts, Milan, 2006.

Bouroullec, Ronan and Erwan, David Toppani, Claude Aïello and Giulio Cappellini, *Ronan and Erwan Bouroullec*, Phaidon, London, 2003.

Byam Shaw, Ros, *Spectrum: Heritage Patterns and Colours*, Thames & Hudson and Victoria and Albert Museum, London, 2018.

de Dampierre, Florence, *Chairs: A History*, Abrams, New York, 2006.

Darwent, Charles, *Josef Albers: Life and Work*, Thames & Hudson, London, 2018.

Dixon, Tom, *Industry*, Design Research Publishing, London, 2010.

Droste, Magdalena, and Bauhaus-Archiv, *Bauhaus: 1919–1933*, Taschen, Cologne, 2006.

Dry, Susan, *Art Deco and Modernist Carpets*, Thames & Hudson, London, 2002.

Engholm, Ida, and Anders Michelsen, *Verner Panton*, Phaidon, London, 2018.

Fiell, Charlotte and Peter, *1000 Chairs*, Taschen, Cologne, 1997.

 — *Industrial Design A–Z*, Taschen, Cologne, 2016.

Fiell, Charlotte and Peter, eds., *1000 Lights*, Taschen, Cologne, 2006.

Fox Weber, Nicholas, and Martin Filler, *Josef & Anni Albers: Designs for Living*, Merrell Publishers, London, 2004.

Galli, Marta, NCS Colour, Triton, and De La Espada, *COL-OUR*, Nichetto Studio exhibition publication, Milan, 2015.

Gura, Judith, *Post Modern Design Complete*, Thames & Hudson, London, 2017.

Holmsted Olesen, Christian, *Wegner: Just One Good Chair*, Hatje Cantz and Designmuseum Danmark, Berlin, 2014.

Horn, Richard, *Memphis: Objects, Furniture, and Patterns*, Running Press, Philadelphia, 1985.

Junte, Jeroen, *Hands on Dutch Design in the 21st Century*, W Books, Netherlands, 2011.

Klanten, Robert, Sven Ehmann, Andrej Kupetz, and Shonquis Moreno, eds., *Once Upon a Chair*, Gestalten, Berlin, 2009.

Koolhaas/OMA, Rem, Norman Foster, and Alessandro Mendini, *Colours*, Birkhäuser, Basel, 2001.

Lees-Maffei, Grace, *Iconic Designs: 50 Stories About 50 Things*, Bloomsbury Publishing, London, 2014.

Magistretti, Vico, *Le Parole Illustrate*, Fondazione Vico Magistretti, Milan, 2010.

Myerson, Jeremy, and Sylvia Katz, *Conran Design Guides: Lamps and Lighting*, Chapman & Hall, London, 1990.

Neuhart, John, Marilyn Neuhart, and Ray Eames, *Eames Design*, Abrams, New York, 1989.

Oldham, Todd, and Kiera Coffee, *Alexander Girard*, AMMO Books, California, 2011.

Poletti, Raffaella, *Zanotta: Design for Passion*, Mondadori Electa, Milan, 2004.

Polster, Bernd, Claudia Neumann, Markus Schuler, and Frederick Leven, *The A–Z of Modern Design*, Merrell Publishers, London, 2006.

Raizman, David, *History of Modern Design*, Laurence King Publishing, London, 2003.

Remmele, Mathias, *Jean Prouvé/Charles & Ray Eames: Constructive Furniture*, Vitra Design Museum, Weil am Rhein, 2002.

Rouland, Steven and Linda, *Knoll Furniture: 1938–1960*, Schiffer Publishing Ltd, Pennsylvania, 1999.

Rowlands, Penelope, *Jean Prouvé*, Chronicle Books, San Francisco, 2002.

Ryder Richardson, Lucy, *100 Midcentury Chairs and their stories*, Pavilion Books, London, 2016.

Schouwenberg, Louise, *Reproducing Scholten & Baijings*, Phaidon, London, 2015.

Sembach, Klaus-Jurgen, *Modern Furniture Designs: 1950–1980s*, Schiffer Publishing Ltd, Pennsylvania, 1997.

Serraino, Pierluigi, *Saarinen*, Taschen, Los Angeles, 2005.

van Geest, Jan, *Jean Prouvé*, Taschen, Cologne, 1991.

Védrenne, Élisabeth, *Charlotte Perriand*, Assouline, Paris, 2005.

 — *Pierre Paulin*, Assouline, Paris, 2004.

Wilk, Christopher, *Marcel Breuer: Furniture and Interiors*, Museum of Modern Art, New York, 1981.

Wilk, Christopher, ed., *Modernism 1914–1939: Designing a New World*, V&A Publications, London, 2006.

Wolters, Pleun, ed., *Maarten Van Severen: Addicted to Every Possibility*, The Maarten Van Severen Foundation with Lensvelt, Netherlands, 2014.

INDEX

A

Aalto, Alvar and Aino 18, *18*, 19, *19*
Aarnio, Eero 77, *77*
Adam&Arthur 302, *302*
Aisslinger, Werner 270, *270*
Aiston, Emma 257, *257*
Albero Flowerpot Stand 146, *146*
Albers, Anni 33, *34*, *35*
Albers, Josef 33, *36*, *37*
Alessandra Armchair 162, *162*
Alessi 131, *132*, 148, *148*, 161, *161*, 293
Alias 129, *129*
Alkalay, Shay 216, *216*, 298, *298*
Allunaggio Garden Chair 85, *85*
American Modern Tableware 7, 21, *21*
Amsterdam Armoire 226, 227, *227*
Amuleto Task Light 230, *230*
Anastasio, Andrea 290, *290*
Anastassiades, Michael 291, *291*
&Tradition 113, *112–13*, 240, 288, *288*
And A and Be and Not Screen 269, *269*
Anemone Rug 248, *248*
Anglepoise 7, 20, *20*, 100, *100*
Anna G Corkscrew 131, *132*
Ant Chair 109
Antelope Chair 44, *44*
Antibodi Chaise 215
Antropus Armchair 7, 30, *30*
Apollo Dining Chair 300, *300*
Apple 166, *166*
Arad, Ron 156, *156*, 159, *159*, 178, *178*,
 208, *208–9*
arflex 30, 47, 91, *91*, 96, *96*
armchairs
 Alessandra Armchair 162, *162*
 Antropus Armchair 7, 30, *30*
 Braniff International Airways Lounge
 Armchair *64*
 Corallo Armchair 182, *182*
 F51 Armchair 10, *10*
 Feltri (357) Armchair 150, *150*
 Gaia Armchair 91, *91*
 Jumper Armchair 232, *232*
 Karelia Lounge Chair 92, *92*
 Lady Armchair 7, 30, 47, *47*
 Le Bambole Armchair 120, *120*
 Model 4801 Armchair 8, 76, *76*
 Mollo Armchair 275, *275*
 Orange Slice (F437) Armchair 70, *70*
 P40 Armchair 52, *52*
 S33 Armchair *10*
 Sam Son Armchair 284, *284*
 Smock Armchair 187, *187*
 UP5_6 Armchair 102, *103*
 Utrecht (637) Armchair 286, *287*
 Wink (111) Armchair 138, *138*
 Zyklus Armchair 147, *147*
Artemide 79, *79*, 86, *86*, 93, *93*, 128, *128*,
 143, *143*, 242, *242*
Artek 18, *18*
Artifort 68–9, 70, 70, 87, *87*
Aulenti, Gae 80, *80–1*
Azambourg, François 191, *191*, 244, *244*

B

B-Line 114, *114–15*, 117, *117*
B&B Italia 102, *103*, 120, *120*
Baijings, Carole 223, *224*, *225*, *226*,
 227, *227*
Bakker, Gijs 223
Baleri, Enrico 129, *129*
Ball Chair 77, *77*
Ball Clock 28, *28*
Bang & Olufsen (B&O) 116, *116*
Barber, Edward 194, *195*, 218, *218*
Barber Osgerby 194, *195*, 218, *218*
Bartoli, Carlo 91, *91*
Bätzner, Helmut 82, *82*
Bau Pendant Light 239, *239*
Bauer Pottery 21, *21*
Bauhaus Cradle 11, *11*
Bauhaus movement 7, 8, 10, 11, *11*, 33, 219
BD Barcelona Design 125, *125*, *132*, 188,
 188–9, 193, *193*, 202
Becker, Dorothee 106, *106*
Beckmann, Liisi 92, *92*
Béhar, Yves 186, *186*
Bellini, Mario 120, *120*
Belotti, Giandomenico 129, *129*
Benshetrit, Dror 221, *221*
Beolit (400/500/600) Radios 116, *116*
Berthier, Marc 95, *95*
Bertoia, Harry 45, *45*
Beunders, Tineke 240, *240*
Bey, Jurgen 263
Big Table 217, *217*
Big-Game 219, *219*
Bird Chair 45, *45*
Bird Chaise 152, *152*
Bitossi 71, *71*, 263, *264*, 274, *274*
Bliss Rug 296, *296*
Blue Candleholders 289, *289*
Blue Marine Rug 15, *15*
Boborelax Lounge Chair 96, *96*
Boby Storage Trolley 117, *117*
Boeri, Cini 96, *96*
Bofinger Chair 82, *82*
Bohinc, Lara 300, *300*
Bold Chair 219, *219*
Bolle Vases 89, *89*
Bonaldo 217, *217*
Bookworm Shelf 159, *159*
Borghese Sofa 246, *246–7*
Borsani, Osvaldo 52, *52*
Bouquet Chair 199, *199*
Bouroullec, Ronan and Erwan 171, 183,
 183, 192, *192*
Bovist Pouf 171, *172*
Braniff International Airways Lounge
 Armchair *64*
Brauer, Otto 74, *74*
Breuer, Marcel 14, *14*
Brick Chandelier 228, *228–9*
Brionvega 75, *75*
Butte Containers 224
Butterfly Console 299, *299*

C

cabinets
 Amsterdam Armoire 226, 227, *227*
 Calamobio Cabinet *132*
 Color Fall Shelving 273, *273*
 Glove Cabinet 72, *72*
 Homage to Mondrian Cabinet 127, *127*
 Kast Storage Unit *184*, 184
 Krattenkast Cabinet 181, *181*
 Particle Stack 263
 Revolving Cabinet 118, *118*
 Showtime Multileg Cabinet 188, *188–9*
 Stack Cabinet 216, *216*
 Tudor Cabinet 268, *268*
 Wrongwoods Cabinet 206, *206*
Cactus Coat Stand 121, *121*
Calamobio Cabinet *132*
Callimaco Floor Lamp 143, *143*
Calyx Fabric 46, *46*
Campana, Fernando and Humberto 157,
 157, 182, *182*
Campari Pendant Light 180, *180*
candleholders 38, *38–9*, 289, *289*
Cappellini 107, *107*, 118, 127, *127*, 135, *135*,
 144, *144*, 149, 151, *151*, 152, 155, 163,
 163, 167, 176, *176–7*, *191*, 221, 250, 269,
 278, *278*, 289
Cappellini, Giulio 107, 118
Carimate Chair 61, *61*
Carlton Room Divider 136, *137*
Carnaby Vases 99, *99*
Caryllon Dining Table 292, *292*
Casamania 210, *211*
Cassina 12, *13*, 30, 47, *47*, 61, 138, *138*,
 140, *140*, 150, 286, *287*
Castiglioni, Achille 145, *145*, 146, *146*
Castiglioni, Achille and Pier Giacomo 8,
 53, *53*, 85, *85*
Cawardine, George 20, *20*
cc-tapis 266–7, 267, 296, *296*
Celentano, Raffaele 180, *180*
Celestino, Cristina 292, *292*
Centro Progetti Tecno 123, *123*
ceramics
 Bitossi 71, *71*, 263, *264*, 274, *274*
 Cor Unum 271, 276, *276*
 Guichet Wall Clock 234, *234*
 Gustavsberg Ceramics 38, *38–9*
 Jongerius 171, *172*
 Kora Vase 245, *245*
 Reddish Vessels 271, *271*
 Seams Vessels 274, *274*
 Triangle Pattern Bowl and Vase 71, *71*
Ceretti, Giorgio 90, *90*
chairs
 Allunaggio Garden Chair 85, *85*
 Ant Chair 109
 Antelope Chair 44, *44*
 Antibodi Chaise 215
 Apollo Dining Chair 300, *300*
 Ball Chair 77, *77*
 Bird Chair 45, *45*
 Bird Chaise 152, *152*

Boborelax Lounge Chair 96, *96*
Bofinger Chair 82, *82*
Bold Chair 219, *219*
Bouquet Chair 199, *199*
Carimate Chair 61, *61*
Chair Lift Furniture 272, *272*
Chair_One 168, *168*
Coconut Lounge Chair 54, *54*
Corona (EJ5) Chair 73, *73*
Djinn Lounge Chair 84, *84*
Dolls Chair 298, *298*
Egg Chair 57, *57*
Ekstrem Lounge Chair 124, *124*
Etcetera Chair ('Jan Chair') 119, *119*
Eu/phoria Chair 243, *243*
Expo Mark II Sound Chair 94, *94*
Felt Chair 151, *151*
Flag Halyard Chair 40, *40*
Garden Egg Chair 101, *101*
Getsuen Chair 153, *153*
Grillage Outdoor Chair 244, *244*
Hallway Chair 18, *18*
Heart Cone Chair 60, *60*
Karelia Lounge Chair 92, *92*
LCW moulded plywood chair 26
Lutrario Chair 59, *59*
Mark Table and Chair 285, *285*
Mr Bugatti Collection 191, *191*
Modo 290 Chair 88, *88*
Modus Chair 123, *123*
Moulded Fibreglass Chairs
 42–3, *42–3*
Multichair 114, *114–15*
Nuance Chair 220, *220*
Omkstak Chair 122, *122*
Ozoo Desk and Chair 95, *95*
Panton Chair *110*
Paper Planes Chair 201, *202*
Peacock Chair 221, *221*
Pratone Lounge Chair 90, *90*
Proust Chair 131, 135, *135*
Pylon Chair 155, *155*
Rainbow Chair 167, *167*
Raw Chair 214, *214*
Red and Blue (635) Chair 12, *13*
Ribbon (F582) Chair 87, *87*
Roly Poly Chair 277, *277*
S-Chair 88, 109
Sacco Chair 97, *97*
Sindbad (118) Lounge Chair 140, *140*
Slow Chair 192, *192*
Spaghetti Chair (101) 129, *129*
Sparkling Chair 237, *237*
Standard Chair 24, *24*
Stitch Folding Chair 163, *163*
Strap Chair *224*
Talking Chair 94, *94*
Thinking Man's Chair 149, *149*
Tip Ton Chair 218, *218*
Togo Seating 126, *126*
Tropicalia Chair 215, *215*
Tube Lounge Chair 107, *107*
Tulip Chairs 68, *68–9*
Vegetal Chair 183, *183*
Vermelha Chair 157, *157*
Vilbert Chair 160, *160*

Wassily (B3) Chair 14, *14*
Weissenhof Dining Setting 17, *17*
Wire S#1 Chaise 279, *279*
Womb Chair 27, *27*
Worker Chair *172*
Wood Bikini Chair 270, *270*
Zabro table chair *132*
see also armchairs
Chair_One 168, *168*
Chair Lift Furniture 272, *272*
chaise longue 142, *142*, 152, *152*, 215,
 279, *279*
Chandlo Dressing Table *202*
Children's Furniture 26, *26*
Cho, Kyuhyung 256, *256*
CHUBBY Teapot 303, *303*
Circle Floor Lamp 235, *235*
ClassiCon 15, *179*
clock 28, *28*, 234, *234*
coat rack 49, *49*, 121, *121*, 233, *233*
Coconut Lounge Chair 54, *54*
Colombo, Joe 76, *76*, 107, *107*, 114,
 114–15, 117, *117*
Color Fall Shelving 273, *273*
Colour Carpet No. 5 223, *224*
Colour Gradient Blanket 223
Colour Plaid Blanket 223
Colour Wheel Ottoman *64*
Common Comrades Side Tables
 254, *254–5*
Componibili Storage 105, *105*
Confluences Sofa 207, *207*
Cor 147, *147*
Cor Unum 271, 276, *276*
Corallo Armchair 182, *182*
Corona (EJ5) Chair 73, *73*
Crasset, Matali 282, *282*
Cristallo Cupboard *132*
Cubo (TS502) Radio 75, *75*
cupboards *132*, 249, *249*

D
Dalù Table Lamp 86, *86*
Daniel Emma 257, *257*
Dante Goods & Bads 283, *283*
Dariel, Thomas 289, *289*
Day, Lucienne 46, *46*
daybeds 52, 201, *202*
De Ceulaer, Maarten 210, *211*
de la Fontaine, Christophe 283, *283*
De Lucchi, Michele 136, 293, *293*
De Padova 61, *61*, 235, *235*
De Stijl movement 7, 12, 17
Derossi, Pietro 90, *90*
Designer Carpets *110*
desks 31, *31*, 95, *95*
Diana Tables 179, *179*
Dish Doctor 164, *164*
District Fabric 301, *301*
Dixon, Tom 152, *152*, 155, *155*, 233, *233*
Djinn Lounge Chair 84, *84*
Dolls Chair 298, *298*
Do-Lo-Rez Sofa 208, *208–9*
Dombo Mug 169, *169*
Doshi, Nipa 201, *202*, *203*, 205
Doshi Levien 201, *202*, *203*, *204–5*

Double Soft Big Easy Sofa 156, *156*
Drocco, Guido 121, *121*
Droog Design 223
Du Pasquier, Nathalie 136, 142, *142*
Ducaroy, Michel 126, *126*
Duchaufour-Lawrance, Noé 246, *246–7*
Dumas, François 248, *248*

E
Eames, Charles and Ray 26, *26*, 31, *31*,
 42–3, *42–3*, 49, *49*, 63, 171, 233, *233*
Eames Storage Unit 31, *31*
Eclisse Table Lamp 86, 93, *93*
Edra *153*, 157, *157*, 182, *182*
Egg Chair 57, *57*
Ekselius, Jan 119, *119*
Ekstrem Lounge Chair 124, *124*
Ekstrøm, Terje 124, *124*
Engelgeer, Mae 296, *296*
Ericson, Estrid 22
Erik Jørgensen 73, *73*
Established & Sons 194, *195*, 206, *206*,
 216, *216*, 223, *224*, 226, *227*, 232,
 232, 275
Etcetera ('Jan') Chair 119, *119*
Eu/phoria Chair 243, *243*
Euclid Thermos Jug 161, *161*
Eumenes *243*
Expo Mark II Sound Chair 94, *94*
Exteta 80, *80–1*

F
F51 Armchair 10, *10*
Fabbian 241, *241*
fabrics 46, 87, 109, *110*, 135, 142, 171, *264*,
 286, *287*
Fager, Jens 214, *214*
Faience Snurran Vase 38, *38–9*
Fandango (SLR100) Watch 134, *134*
Featherston, Grant and Mary 94, *94*
Felt Chair 151, *151*
Feltri (357) Armchair 150, *150*
Ferrieri, Anna Castelli 105, *105*
fibreglass 37, 42–3, *42–3*, 54, 77, *77*, 79,
 88, 91, 95, 151, *151*, 190, *190*, 277
Fields Wall Light 198, *198*
Filo Table Lamp 290, *290*
Flag Halyard Chair 40, *40*
Float Sofa 258, *258–9*
Flower Vases 141, *141*
Flowerpot Pendant Lights 109, *112–13*, 113
Fontana Amorosa Parachute Light
 291, *291*
Förster, Monica 235, *235*
Foscarini *158*, *190*, 198, *198*, *290*
Frame Outdoor Seating 185, *185*
Franck, Kaj 56, *56*
Frank, Josef 22, *22–3*, 25, *25*

G
Gaia Armchair 91, *91*
Galliot, Laureline 303, *303*
GamFratesi 278, *278*
Gamper, Martino 263, 272, *272*
Garden Egg Chair 101, *101*
Garden of Eden Rug 295, *295*

Gatti, Piero 97, *97*
Gear Vase 276, *276*
Gebrüder Thonet Vienna 292, *292*
Geis, Lester 48, *48*
Geo Vacuum Jug 253, *253*
Geometric Rug 41, *41*
George Nelson Associates 28, *28*, 51, *51*, 54, *54*
Getsuen Chair 153, *153*
Ghyczy, Peter 101, *101*
Gilles, Alain 217, *217*
Giovannoni, Stefano 165, *165*
Girard, Alexander 54, 63, *64*, 65, 66–7, *67*
Gismondi, Ernesto 128, *128*
Gispen 169, *169*
glass 16, 19, *19*, 37, 56, *56*, 74, *74*, 89, *89*, 99, *99*, 158, *158*, 172, 176, *176–7*, 180, *180*, 194, *195*, 227, *277*, 250, *250*, 269, *269*, 288, *288*, 290, *290*, 291, 291
Glove Cabinet 72, *72*
Golran 295, *295*
Goodrum, Adam 163, *163*, 302
Gräshoppa Floor Lamp 29, *29*
Graves, Michael 148, *148*, 161, *161*
Gray, Eileen 15, *15*
Grcic, Konstantin 168, *168*, 179, *179*, 284, *284*
Grillage Outdoor Chair 244, *244*
Gropius, Walter 8, *9*, 10, *10*
Grossman, Greta M 29, *29*
Gruppo Architetti Urbanisti Città Nuova 79, *79*
Guadalupe Vase *264*
Gubi 29, *29*
Gufram 90, *90*, 121, *121*
Guichet Wall Clock 234, *234*
Guisset, Constance 251, *251*, 260, *260*
Gulvvase Bottles 74, *74*
Gustavsberg 38
Gyro Table 280, *281*

H
Haller, Fritz 78, *78*
Hallway Chair 18, *18*
Hang-it-all Coat Rack 49, *49*
Hansen, Fritz 57, *57*
Hansen, Nicholai Wiig 253, *253*
Harper, Irving 28, *28*, 51, *51*
HAY 223, *224*, 252, *252*
Hayon, Jaime 188, *188–9*, 193, *193*
Heart Cone Chair 60, *60*
Henningsen, Poul 16, *16*, 58, *58*, 109
Herbert Terry & Sons 7, 20, *20*, 100, *100*
Herkner, Sebastian 285, *285*, 288, *288*
Herman Miller 31, *31*, 42–3, 43, 49, 49, 51, 54, *54*, 63, *64*, 67, 186, *186*,
Heykoop, Pepe 228, *228–9*
Holm, Staffan 231, *231*
Homage to Mondrian Cabinet 127, *127*
House of Finn Juhl 72
Hovers, Floris 276, *276*
Howard Miller Clock Company 28
Hu, Rossana *see* Neri&Hu
Hubert, Benjamin 241, *241*, 274, *274*, 294, *294*
Hutten, Richard 169, *169*

I
Iittala 19, *19*
IKEA 160, *160*, 223, 243
iMac G3 166, *166*
Ingo Maurer *180*
Iris Table 194, *195*
Isola, Maija 83, *83*
Ive, Jonathan 166, *166*

J
Jacobsen, Arne 57, *57*, 98, *98*, 109
Jensen, Jacob 116, *116*
Jiménez, Vicente Garcia 198, *198*
Jongerius, Hella 8, 171, *172*, *173*, *174–5*, 175
Juhl, Finn 72, *72*
Jumper Armchair 232, *232*

K
Kåge, Wilhelm 38
Kaleido Trays 252, *252*
Kandinsky, Wassily 11, 14, 33
Karelia Lounge Chair 92, *92*
Kartell 75, *75*, 105, *105*, 159, *159*
Kast Storage Unit 184, *184*
Kastrup Holmegaard 74, *74*, 99, *99*
Kauria, Eino 18
Keler, Peter 11, *11*
Kettle 9093 148, *148*
King, Perry 104, *104*
Kinsman, Rodney 122, *122*
Kita, Toshiyuki 138, *138*
Knoll 14, 27, *27*, 45, *45*
Knoll, Florence 27
Kora Vase 245, *245*
Krattenkast Cabinet 181, *181*
Kremlin Bells Decanter 56, *56*
Krenchel, Herbert 50, *50*
Krenit Bowls 50, *50*
Kuramata, Shiro 118, *118*, 127, *127*, 136, 144, *144*
Kvadrat 87, 152, 171, 187, 208, 246, 251, *251*
Kybal, Antonin 41, *41*

L
L'univers Coloré de Scholten & Baijings Vases 224
La Chance 246, *246–7*, 248
La Cividina 251, *251*
Lady Armchair 7, 30, 47, *47*
lamps
 Amuleto Task Light 230, *230*
 Anglepoise 7, 20, *20*, 100, *100*
 Callimaco Floor Lamp 143, *143*
 Circle Floor Lamp 235, *235*
 Dalù Table Lamp 86, *86*
 Eclisse Table Lamp 93, *93*
 Filo Table Lamp 290, *290*
 Fontana Amorosa 291
 Gräshoppa Floor Lamp 29, *29*
 Leaf Personal Light 186, *186*
 Lolita Lamps 212, *212*
 LoTek Task Light 242, *242*
 Meltdown Floor Lamp 250, *250*
 Model 75 Anglepoise Light 100, *100*
 Model 1227 Anglepoise Light 20, *20*

 Nesso Table Lamp 79, *79*
 Orbital Floor Lamp 158, *158*
 PH3/2 Table Lamp 16, *16*
 PXL Light 197, *197*
 Sintesi Lamp 128, *128*
 T-5-G Table Lamp 48, *48*
 Tahiti Table Lamp 136, 139, *139*
 Totem Floor Lamps 297, *297*
 Twiggy Floor Lamp 190, *190*
 Verpan Wire Lamp *110*
Laviani, Ferruccio 158, *158*
LCW moulded plywood chair 26
Le Bambole Armchair 120, *120*
Leaf Personal Light 186, *186*
Lee Jofa 301, *301*
Lensvelt 181, *181*
Levien, Jonathan 201, *202*, *203*, 205
Levy, Arik 236, *236*
lights
 Bau Pendant Light 239, *239*
 Campari Pendant Light 180, *180*
 Fields Wall Light 198, *198*
 Flowerpot Pendant Lights 109, *112–13*, 113
 Fontana Amorosa Parachute Light 291
 Light Forest 240, *240*
 PH5 Pendant Light 58, *58*
 Roofer (F12) Pendant Light 241, *241*
 see also lamps
Light Forest 240, *240*
Ligne Roset 126, *126*, 207, 244, *244*
Lindberg, Stig 38, *38*
Lindstén, Johan 250, *250*
Linteloo 285, *285*
Living Tower *111*
Locus Solus Sunlounger 80, *80–1*
Lolita Lamps 212, *212*
Londi, Aldo 71, *71*
Long Neck and Groove Vases *172*
LoTek Task Light 242, *242*
Louis Poulsen 16, 58
Louis Vuitton 298, *298*
Lütken, Per 74, 99, *99*
Lutrario Chair 59, *59*

M
McDonald, Peter 272, *272*
Magis *164*, *165*, 168, *168*, 237, *237*, 284, *284*
Magistretti, Vico 61, *61*, 86, *86*, 93, *93*, 140, *140*
Mago Broom 165, *165*
Maharam 63, *64*, 171, *172*, 223
Mahdavi, India 295, *295*
Malouin, Philippe 275, *275*
Maly, Peter 147, *147*
Marimekko 83, *83*
Mariscal, Javier 136, 162, *162*, 242, *242*
Mark Table and Chair 285, *285*
Marshmallow Sofa 51, *51*
Masks 238, *238*
Mattioli, Giancarlo 79, *79*
Mattson, Fredrik 199, *199*
Maurer, Ingo 106
Mello, Franco 121, *121*

Meltdown Floor Lamp 250, *250*
Memphis 7, 118, 131, 136, *137*, 139, *139*, *141*, 141–3, 147, *197*, 257, 296
Mendini, Alessandro 131, *132*, *133*, 134, *134*, 135, *135*, 230, *230*
Mennen, Renee *see* Studio RENS
Mer, Yael 216, *216*, 298, *298*
Mezzadro Stool 53, *53*
Minima Moralia Screen 283, *283*
Mira-X 109, *110*
Missoni 154, *154*
Mr Bugatti Collection 191, *191*
Model 75 Anglepoise Light 100, *100*
Model 1227 Anglepoise Light 20, *20*
Model 4801 Armchair 8, 76, *76*
Modo 290 Chair 88, *88*
Modus Chair 123, *123*
Mollino, Carlo 59, *59*
Mollo Armchair 275, *275*
Moooi 212, *212*, 249, *249*, 254, *254–5*, *268*
Moroso 156, *156*, 162, *162*, 178, 187, *187*, 199, *199*, 201, *202*, 204–5, *208–9*, 213, *213*, *215*, 223, *224*, *264*, *265* 270, *270*, 272, *272*, 294, *294*
Moroso, Patrizia 156, 263
Morrison, Jasper 149, *149*, 171
Motley Ottoman 196, *196*
Moulded Fibreglass Chairs 42–3, *42–3*
Mourgue, Olivier 84, *84*
Moustache *219*, *234*
Mulhauser, George 54, *54*
Muller Van Severen 279, *279*
Muller, Fien *see* Muller Van Severen
Multicolrr 114, *114–15*
Muuto *214*
My Beautiful Backside Sofa 201, 204, *204–5*

N
Nanimarquina *202*
Navone, Paola 243, *243*
Neill, Brodie 280, *281*
Nelson, George 28, *28*, 51, 54, 63
Neri&Hu 254, *254–5*
Nesso Table Lamp 79, *79*
Newson, Marc 151, *151*, 164, *164*
Nichetto, Luca 220, *220*
Nielaus 88, *88*
Nigro, Philippe 207, *207*
Nilufar Gallery 263, 267, 291, *291*
Nodus 260, 282
Noguchi, Isamu 28, *28*
Norguet, Patrick 167, *167*
Normann Copenhagen *50*, 239, *239*, 253, *253*
Novembre, Fabio 176, *176–7*
Nuance Chair and Ottoman 220, *220*

O
Objets Nomades collection 298
OMK 1965 *122*
Omkstak Chair 122, *122*
Ontwerpduo 240, *240*
Oozo Desk and Chair 95, *95*
Orange Slice (F437) Armchair 70, *70*

Orbital Floor Lamp 158, *158*
Org Table 176, *176–7*
Osgerby, Jay 194, *195*, 218, *218*
Østergaard, Steen 88, *88*
Ottoman Lounge Chair and Ottoman *224*
ottomans *64*, 102, *103*, 171, *172*, 196, *196*, 220, *220*, *224*, 251, *251*, 272, *272*
Oud, J. J. P. 17, *17*
outdoor furniture 44, *44*, 80, *80–1*, 183, 185, *185*, 215, *215*, 244, *244*, 279
Ozoo Desk and Chair 95, *95*

P
PP Møbler 40, *40*
Panton, Verner 60, *60*, 88, 109, *110*, *111*, *112–13*, 113, 160, *160*
Panton Chair 109, *110*
Paola Lenti 185, *185*
Paolini, Cesare 97, *97*
Paper Patchwork Cupboard 249, *249*
Paper Planes Lounge Chair 201, *202*
Particle Stack 263
Paulin, Pierre 68, *68–9*, 70, *70*, 87, *87*
Peacock Chair 221, *221*
Peer, Hannes 299, *299*
Peg Coat Stand 233, *233*
Pesce, Gaetano 102, *103*, 150, *150*
P40 Armchair 52, *52*
PH3/2 Table Lamp 16, *16*
PH5 Pendant Light 58, *58*
Pick 'n' Mix Table and Bench 257, *257*
Pion Tables and Stool 261, *261*
Pirelli 30, 47
plastic technologies 7, 8, 75, *75*, 166, 236, 237, 263, 280
Plissé Electric Kettle 293, *293*
Plus-linje 60, 109
Poke Stool 256, *256*
Polder Sofa 171, *174–5*, 175
Poltrona di Proust (Proust chair) 131, 135, *135*
Pot, Bertjan 232, *232*, 238, *238*, 286, *287*
Pratone Lounge Chair 90, *90*
Princepessa Daybed 201, *202*
Prouvé, Jean 24, *24*, 171
PXL Light 197, *197*
Pylon Chair 155, *155*

R
Rabari Rug *202*
Race, Ernest 44, *44*
radios 75, *75*, 116, *116*
Rainbow Chair 167, *167*
Ramun *230*
Rashid, Karim 258, *258–9*
Raw Chair 214, *214*
Raw-Edges 216, *216*, 298, *298*
Red and Blue Chair 12, *13*
Reddish Vessels 271, *271*
Repeat Dot Print Fabric *172*
Revolving Cabinet 118, *118*
Ribbon (F582) Chair 87, *87*
Richter, Camilla 269, *269*
Rietveld, Gerrit 8, 12, *13*, 17, 286, *287*
Roberts, Garth 273, *273*
Roche Bobois 95, *95*

Roly Poly Chair 277, *277*
Roofer (F12) Pendant Light 241, *241*
room dividers 136, *137*, 278, *278*
Rosenthal 264
Rosso, Riccardo 90, *90*
Rota, Francesco 185, *185*
Royal Chaise 142, *142*
rugs
 Anemone Rug 248, *248*
 Bliss Rug 296, *296*
 Blue Marine Rug 15, *15*
 Colour Carpet No. 5 *224*
 Garden of Eden Rug 295, *295*
 Geometric Rug 41, *41*
 Rabari Rug *202*
 Spin 1 Rug 260, *260*
 Super Fake 263, *266–7*, 267
 Topographie Imaginaire Rug 282, *282*
 Tropical Rug 154, *154*
 VP08 Rug *110*

S
S33 Armchair 10
S-chair 88, 109
Saarinen, Eero 27, *27*
Sacco Chair 97, *97*
Sadler, Marc 190, *190*
Sam Son Armchair 284, *284*
Sancal *258–9*, *261*
Sancarlo Armchair 145, *145*
Sapper, Richard 75, *75*
Savoy Vase 19, *19*
Schärer, Paul 78, *78*
Schmidt, Vibeke Fonnesberg 239, *239*
Scholten & Baijings 223, *224*, *225*, 226, 227, *227*
SCP 198, *198*
Screen Hanging Room Divider 278, *278*
screens 269, *269*, 278, *278*, 283, *283*
Seams Vessels 274, *274*
Seigneur, Arthur 302, *302*
Sella Stool 8, 55, *55*
Sempé, Inga 234, *234*
shelves 136, *137*, 159, *159*, 273, *273*
Shiva Vase 125, *125*
Showtime Multileg Cabinet 188, *188–9*
Showtime Vases 193, *193*
side tables 176, 179, *179*, 185, 194, *195*, 154, *154–5*, 254, *254–5*, 261, *261*
Sindbad (118) Lounge Chair 140, *140*
Sintesi Lamp 128, *128*
Slow Chair 192, *192*
Smeets, Job 249, *249*
Smock Armchair 187, *187*
sofas
 Borghese Sofa 246, *246–7*
 Confluences Sofa 207, *207*
 Do-Lo-Rez Sofa 208, *208–9*
 Double Soft Big Easy Sofa 156, *156*
 Float Sofa 258, *258–9*
 Marshmallow Sofa 51, *51*
 My Beautiful Backside Sofa 201, *204–5*, 205
 Polder Sofa 171, *174–5*, 175
 Sofa 3031 22, *22–3*
 Sofa with Arms 144, *144*

Tape Modular Sofa System 294, *294*
Victoria and Albert Sofa 178, *178*
Vlinder Sofa 171, *172*
Sofa 3031 22, *22–3*
Sofa with Arms 144, *144*
Sotsass, Ettore 104, *104*, 125, *125*, 136, *137*, 139, *139*, 143, *143*
Sowden, George J. 136, 142
Spaghetti Chair (101) 129, *129*
Sparkling Chair 237, *237*
Spin 1 Rug 260, *260*
Spin Stool 231, *231*
Spotti Edizioni Milano (SEM) 299, *299*
Stack Cabinet 216, *216*
Stacking Tables 37
Stam, Mart 10, *10*
Standard Chair 24, *24*
Stitch Folding Chair 163, *163*
Stölzl, Gunta 33
stools 8, 26, 53, 55, 191, *191*, 231, *231*, 256, *256*, 261, *261*
storage 31, *31*, 78, 105, *105*, 106, *106*, 117, *117*, 181, *181*, 184, *184*
Strap Chair 224
Studio Alchimia 131, 134
Studio Job 249, *249*
Studio RENS 271, *271*
Studio Sabine Marcelis 297, *297*
Studiopepe 245, *245*
Super Fake Rug 263, *266–7*, 267
Sushi Collection 213, *213*
Svenskt Tenn *22–3*, 25
Swatch 134, *134*
Swedese *231*

T
T–5–G Table Lamp 48, *48*
tables
Big Table 217, *217*
Butterfly Console 299, *299*
Caryllon Dining Table 292, *292*
Common Comrades Side Tables 254, *254–5*
Diana Tables *179*, 179
Gyro Table 280, *281*
Iris Table 194, *195*
Mark Table and Chair 285, *285*
Org Table 176, *176–7*
Pick 'n' Mix Table and Bench 257, *257*
Pion Tables and Stool 261, *261*
Stacking Tables 37
Weissenhof Dining Setting 17, *17*
tableware 7, 21, *21*, 252, *252*
Tacchini 145, *145*
Tahiti Table Lamp 139, *139*
Tait 257, *257*
Talking Chair 94, *94*
Talleo Tallboy 302, *302*
Tape Modular Sofa System 294, *294*
Tecno 52, *52*, 123, *123*
Tecta *10*, *11*
Teodoro, Franco 97
textiles
Boxblocks 286, *287*
District 301, *301*
Europost 2 198

Frank prints 22
Girard 54, 63, *64*
Panton 109, *110*
Repeat Dot Print *172*
Textile Manhattan 25, 25
Unikko 83, *83*
Wood 264
Textile Manhattan 25, 25
Thinking Man's Chair 149, *149*
Tigrett Enterprises 49
Tilburg Textile Museum 223, 232
Tip Ton Chair 218, *218*
To, Daniel 257, *257*
Togo Seating 126, *126*
Tom Dixon 152, *152*, 155, *155*, 233, *233*
Tongue Tea Set 263, *264*
Toogood, Faye 277, *277*
Toolbox 236, *236*
Topographie Imaginaire Rug 282, *282*
Totem Floor Lamps 297, *297*
Triangle Pattern Bowl and Vase 71, *71*
Tricolore Vases 288, *288*
Tropical Rug 154, *154*
Tropicalia Chair 215, *215*
Tube Lounge Chair 107, *107*
Tudor Cabinet 268, *268*
Tulip Chairs 68, *68–9*
Twiggy Floor Lamp 190, *190*
Tynagel, Nynke 249, *249*

U
Umeda, Masanori 153, *153*
Unikko Textile 83, *83*
UP5_6 Armchair and Ottoman 102, *103*
Urquiola, Patricia 187, *187*, 215, *215*
USM Haller Storage 78, *78*
Uten.silo Wall Storage 106, *106*
Utrecht (637) Armchair/Boxblocks Fabric 286, *287*

V
Valentine Portable Typewriter 104, *104*
Valextra 264
Valises Wardrobe 210, *211*
van Bleiswijk, Joost 268, *268*
van der Gronden, Mark 181, *181*
van Eijk, Kiki 268, *268*
van Keijsteren, Stefanie *see* Studio RENS
Van Severen, Hannes *see* Muller Van Severen
Van Severen, Martin 184, *184*
van Vliet, Edward 213, *213*
Varier Furniture *124*
vases
Bolle 89, *89*
Carnaby 99, *99*
Faience Snurran 38, *38–9*
Flower Vases 141, *141*
Gear 276, *276*
Guadalupe 264
Kora 245, *245*
L'univers Coloré de Scholten & Baijings 224
Savoy 19, *19*
Shiva 125, *125*
Showtime 193, *193*

Triangle Pattern Vase 71, *71*
Tricolore 288, *288*
Long Neck and Groove *172*
Vautrin, Ionna 261, *261*
Vegetal Chair 183, *183*
Venini 89, *89*
Vermelha Chair 157, *157*
Verpan Wire Lamp *110*
Victoria and Albert Sofa 178, *178*
Vilbert Chair 160, *160*
Vlinder Sofa 171, *172*
Vitra 8, *24*, 26, *26*, 28, *28*, 43, 49, *49*, *51*, 54, 60, *60*, 64, 67, *66–7*, 106, *106*, 109, *110*, 171, *172*, *174–5*, 175, 183, *183*, 184, *184*, 192, *192*, 236, *236*
Vola Tapware 98, *98*
Volther, Paul 73, *73*
von Zweibergk, Clara 252, *252*

W
Wanders, Marcel 237, *237*
wardrobe 210, *210*, 211
Wearstler, Kelly 301, *301*
Wegner, Hans 40, *40*
Weissenhof Dining Setting 17, *17*
Wierink, Nathan 240, *240*
Wilson, Donna 196, *196*
Windmill Poufs 251, *251*
Wink (111) Armchair 138, *138*
Wire S#1 Chaise 279, *279*
Wirkkala, Tapio 89, *89*
Womb Chair 27, *27*
Wood, Bethan Laura 263, *264*, 265, *266–7*, 267
Wood Bikini Chair 270, *270*
Wooden Dolls *66–7*, 67
Woods, Richard 206, *206*
Worker Chair *172*
Wright, Russel and Mary 7, *21*, 21
Wrong, Sebastian 206, *206*
Wrongwoods Cabinet 206, *206*

Y
Yashar, Nina 210
Yoshioka, Tokujin 199, *199*

Z
Zabro Table Chair *132*
Zanini, Marco 136, 141, *141*
Zanotta 53, *53*, 55, *55*, 80, 85, *85*, 92, *92*, 97, *97*, *132*, 146, *146*
Zanuso, Marco 7, 30, *30*, 47, *47*, 75, *75*
Zero Lightning *199*
Zupanc, Nika 212, *212*
Zyklus Armchair 147, *147*

IMAGE CREDITS

Every effort has been made to ensure the information in this book is correct and that all images have been appropriately credited. Where no photography details have been supplied, this information has been omitted. Unless indicated to the contrary, the copyright for all images is held by the supplier of the image.

P. 9 Isometric perspective drawing of Walter Gropius's office at the Weimar Bauhaus, 1923. Design by Walter Gropius, drawing by Herbert Bayer. Image courtesy of the Bauhaus Dessau Foundation (I 14280 G) / © (Gropius, Walter) VG Bild-Kunst, Bonn 2020 © (Bayer, Herbert) VG Bild-Kunst, Bonn 2020. Copyright Agency, 2020. Image by Google.

P. 10 F51 armchair by Walter Gropius. Image courtesy of Tecta, tecta.de.

P. 11 Bauhaus Cradle by Peter Keler. Image courtesy of Tecta, tecta.de.

P. 13 Red and Blue (635) Chair by Gerrit Rietveld. Image courtesy of Cassina, cassina.com, © Gerrit Thomas Rietveld/Pictoright. Copyright Agency, 2020.

P. 14 Wassily (B3) chair by Marcel Breuer. Image courtesy of Cooper Hewitt Smithsonian Design Museum, cooperhewitt.org, © Cooper Hewitt, Smithsonian Design Museum/Art Resource, NY.

P. 15 Blue Marine rug by Eileen Gray. Image courtesy of ClassiCon, classicon.com. Manufacturer ClassiCon authorised by The World Licence Holder Aram Designs Ltd.

P. 16 PH3/2 table lamp by Poul Henningsen. Image courtesy of Palainco, palainco.com.

P. 17 Weissenhof table and chair setting by J.J.P. Oud. Image courtesy of Dorotheum, dorotheum.com. Dorotheum, Vienna auction catalogue 20-06-2017.

P. 18 Hallway Chair by Alvar Aalto. Image courtesy of Artek, artek.fi. Photograph by Aino Huovio.

P. 19 Savoy Vase by Alvar Aalto. Image courtesy of the Alvar Aalto Museum, alvaraalto.fi. Photograph by Martti Kapanen.

P. 20 Model 1227 Anglepoise light by George Carwardine. Image courtesy of Anglepoise, anglepoise.com.

P. 21 American Modern tableware by Russel Wright. Image courtesy of Bauer Pottery, bauerpottery.com.

PP. 22–23 Sofa 3031 by Josef Frank. Image courtesy of Svenskt Tenn, svenskttenn.se.

P. 24 Standard Chair by Jean Prouvé. Image courtesy of Vitra, vitra.com.

P. 25 Textile Manhattan by Josef Frank. Image courtesy of Svenskt Tenn, svenskttenn.se.

P. 26 Children's chairs and stool by Charles and Ray Eames, Vitra Re-edition 2004. Image courtesy of Palm Beach Modern Auctions from 'Urban Culture, Pop & Contemporary Art ' February 24, 2019, modernauctions.com.

P. 27 Womb Chair by Eero Saarinen. Image courtesy of Knoll, Inc., knoll.com.

P. 28 Ball Clock by Irving Harper and George Nelson. Image courtesy of Vitra, vitra.com.

P. 29 Gräshoppa Floor Lamp by Greta M. Grossman. Image courtesy of GUBI, gubi.com.

P. 30 Antropus armchair by Marco Zanuso. Image courtesy of Cassina, cassina.com.

P. 31 Eames Storage Unit (ESU) desk by Charles and Ray Eames. Image courtesy of Herman Miller, hermanmiller.com.

P. 34 Clockwise from top right: *Knot*, 1947, by Anni Albers, gouache on paper (43.2 x 51 cm), © 2020 The Josef and Anni Albers Foundation/Artists Rights Society, New York/DACS, London, photograph by Tim Nighswander/Imaging4Art; *Red Meander*, 1954, by Anni Albers, linen and cotton weaving (52 x 37.5 cm), © 2020 The Josef and Anni Albers Foundation/Artists Rights Society, New York/DACS, photograph by Tim Nighswander/Imaging4Art; *Red and Blue Layers*, 1954, by Anni Albers, cotton weaving (61.6 x 37.8 cm), © 2020 The Josef and Anni Albers Foundation/Artists Rights Society, New York/DACS, photograph by Tim Nighswander/Imaging4Art; design for a 1926 unexecuted wall hanging, n.d.,

by Anni Albers, gouache with pencil on reprographic paper (38 x 25 cm), © 2020 The Josef and Anni Albers Foundation/Artists Rights Society, New York/DACS, photograph by Tim Nighswander/Imaging4Art. Image courtesy of The Josef and Anni Albers Foundation, albersfoundation.org, © 2020 The Josef and Anni Albers Foundation/Artists Rights Society, New York/DACS, London, photograph by Tim Nighswander/Imaging4Art.

P. 35 Anni Albers, c. 1940. Photograph by Josef Albers. Image courtesy of The Josef and Anni Albers Foundation, albersfoundation.org, © 2020 The Josef and Anni Albers Foundation/Artists Rights Society, New York/DACS, London.

P. 36 Josef Albers at Black Mountain College, 1944. Photograph by Barbara Morgan. Image courtesy of Getty Images, © Getty Images.

P. 37 Clockwise from top right: *Park*, c. 1923, by Josef Albers, glass, metal, wire and paint (49.5 x 38.1 cm), © 2020 The Josef and Anni Albers Foundation/Artists Rights Society, New York/DACS, London, photograph by Tim Nighswander/Imaging4Art; Stacking tables, c. 1927, by Josef Albers, © 2020 The Josef and Anni Albers Foundation/Artists Rights Society, New York/DACS, London, photograph by Tim Nighswander/Imaging4Art; *Interaction of Color (50th Anniversary Edition)* by Josef Albers, Yale University Press, Connecticut, 2013, photograph by Craig Wall; *Never Before*, c. 1976, by Josef Albers, screen print (48.3 x 50.8 cm), © 2020 The Josef and Anni Albers Foundation/Artists Rights Society, New York/DACS, London, photograph by Tim Nighswander/Imaging4Art. Images courtesy of The Josef and Anni Albers Foundation, albersfoundation.org, © 2020 The Josef and Anni Albers Foundation/Artists Rights Society, New York/DACS, London, photograph by Tim Nighswander/Imaging4Art.

PP. 38–39 Faience Snurran vase by Stig Lindberg. Image courtesy of Bukowskis, bukowskis.com.

P. 40 Flag Halyard chair by Hans Wegner. Image courtesy of NOHO Modern, nohomodern.com. Photograph by Jeremy Petty.

P. 41 Geometric rug by Antonín Kybal. Image courtesy of Nazmiyal Collection, New York, nazmiyalantiquerugs.com.

PP. 42–43 – Moulded Fibreglass Chairs by Charles and Ray Eames. Image courtesy of Herman Miller, hermanmiller.com.

P. 44 Antelope chair by Ernest Race. Image courtesy of Christie's, christies.com, © Christie's.

P. 45 Bird chair by Harry Bertoia. Image courtesy of Knoll, Inc., knoll.com.

P. 46 Calyx fabric by Lucienne Day. Image courtesy of Robin and Lucienne Day Foundation, robinandluciennedayfoundation.org, © Robin and Lucienne Day Foundation.

P. 47 Lady armchair by Marco Zanuso. Image courtesy of Cassina, cassina.com.

P. 48 T-5-G table lamp by Lester Geis. Image courtesy of Christie's, christies.com, © Christie's.

P. 49 Hang-It-All coat rack by Charles and Ray Eames. Image courtesy of Herman Miller, hermanmiller.com.

P. 50 Krenit Bowls by Herbert Krenchel. Image courtesy of Normann Copenhagen, normann-copenhagen.com.

P. 51 Marshmallow Sofa by Irving Harper. Image courtesy of Vitra, vitra.com.

P. 52 P40 armchair by Osvaldo Borsani. Image courtesy of San Francisco Museum of Modern Art (SFMOMA), sfmoma.org. Photograph by Ben Blackwell.

P. 53 Mezzadro stool by Achille and Pier Giacomo Castiglioni. Image courtesy of Zanotta, zanotta.it.

P. 54 Coconut Lounge Chair by George Nelson Associates. Image courtesy of Herman Miller, hermanmiller.com.

P. 55 Sella stool by Achille and Pier Giacomo Castiglioni. Image courtesy of Zanotta, zanotta.it.

P. 56 Kremlin Bells (KF1500) double decanter by Kaj Franck. Image courtesy of Bukowskis, bukowskis.com.

P. 57 Egg chair by Arne Jacobsen. Image courtesy of Radisson Hotels, radissonhotels.com. Photograph by Rickard L. Eriksson.

P. 58 PH5 pendant light by Poul Henningsen. Image courtesy of Palainco, palainco.com.

P. 59 Lutrario chair by Carlo Mollino. Image courtesy of Galerie Alexandre Guillemain, Paris, alexandreguillemain.com.

P. 60 Heart Cone chair by Verner Panton. Image courtesy of Vitra, vitra.com.

P. 61 Carimate chair by Vico Magistretti. Image courtesy of De Padova depadova.com. Photograph by O. Sancassani.

P. 64 Clockwise from top right: Palio textile, 1964, by Alexander Girard for Herman Miller, image courtesy of Maharam, maharam.com; Colour Wheel Ottoman in Girard's Jacobs Coat textile, 1967, by Alexander Girard for Herman Miller, image courtesy of Herman Miller, hermanmiller.com; hexagonal motif plate, 1955, by Alexander Girard for Georg Jensen, image courtesy of Girard Studio, girardstudio.com; Crosses printed linen textile, 1957, by Alexander Girard for Herman Miller, image courtesy of Girard Studio, girardstudio.com; Braniff International Airways Lounge Armchair, 1965, by Alexander Girard for Braniff International Airways, image courtesy of Vitra Design Museum, design-museum.de, © Alexander Girard/Pictoright, Copyright Agency, 2020, photograph by Jurgen Hans.

P. 65 Alexander Girard pictured in his home studio, Grosse Pointe, Michigan, 1948. Image courtesy of Girard Studio, girardstudio.com. Photograph by Charles Eames © Eames Office LLC.

PP. 66–67 Wooden Dolls by Alexander Girard. Image courtesy of Vitra, vitra.com.

PP. 68–69 Tulip chairs by Pierre Paulin. Image courtesy of Artifort, artifort.com, © Artifort.

P. 70 Orange Slice (F437) armchair by Pierre Paulin. Image courtesy of Artifort, artifort.com, © Artifort.

P. 71 Triangle pattern bowl and vase by Aldo Londi. Image courtesy of Bitossi, bitossiceramiche.it.

P. 72 Glove Cabinet by Finn Juhl. Image courtesy of House of Finn Juhl, finnjuhl.com.

P. 73 Corona (EJ5) chair by Poul Volther. Image courtesy of Eric Jørgensen, erik-joergensen.com.

P. 74 Gulvvase bottles by Otto Brauer. Image courtesy of Bloomberry, bloomberry.eu. Photograph by Erik Hesmerg.

P. 75 Cubo (TS502) radio by Marco Zanuso and Richard Sapper. Image courtesy of Brionvega, a division of SIM2 BV international s.r.l., brionvega.it.

P. 76 Model 4801 armchair by Joe Colombo. Image courtesy of Bukowskis, bukowskis.com.

P. 77 Ball chair by Eero Aarnio. Image courtesy of Bukowskis, bukowskis.com.

P. 78 USM Haller Storage by Fritz Haller and Paul Schärer. Image courtesy of USM, usm.com.

P. 79 Nesso table lamp by Giancarlo Mattioli, Gruppo Architetti Urbanisti Città Nuova. Image courtesy of Artemide, artemide.com. Photograph by Federico Villa.

PP. 80–81 Locus Solus sunlounger by Gae Aulenti. Image courtesy of Exteta, exteta.it.

P. 82 Bofinger chair by Helmut Bätzner. Image courtesy of Metropol Auktioner, metropol.se.

P. 83 Unikko textile by Maija Isola. Image courtesy of Marimekko, marimekko.com.

P. 84 Djinn lounge chair by Olivier Mourgue. Image courtesy of Original in Berlin, originalinberlin.com.

P. 85 Allunaggio garden chair by Achille and Pier Giacomo Castiglioni. Image courtesy of Zanotta, zanotta.it.

P. 86 Dalù table lamp by Vico Magistretti. Image courtesy of Artemide, artemide.com. Photograph by Giovanni Pini.

P. 87 Ribbon (F582) chair by Pierre Paulin. Image courtesy of Artifort, artifort.com, © Artifort.

P. 88 Modo 290 chair by Steen Østergaard. Image courtesy of Nielaus, nielaus.dk.

P. 89 Bolle vases by Tapio Wirkkala. Image courtesy of Venini, venini.com.

P. 90 Pratone lounge chair by Giorgio Ceretti, Pietro Derossi and Riccardo Rosso. Image courtesy of Gufram, gufram.it.

P. 91 Gaia armchair by Carlo Bartoli. Image courtesy of Bartoli Design, bartolidesign.it, and Università Iuav di Venezia – Archivio Progetti, Fondo Mauro Masera, iuav.it. Photograph by Mauro Masera.

P. 92 Karelia lounge chair by Liisi Beckmann. Image courtesy of Zanotta, zanotta.it.

P. 93 Eclisse table lamp by Vico Magistretti. Image courtesy of Artemide, artemide.com. Photograph by Federico Villa.

P. 94 Expo Mark II Sound Chair by Grant and Mary Featherston. Image courtesy of Mary Featherston and the Museum of Applied Arts and Sciences (MAAS), maas.museum.

P. 95 Ozoo desk and chair by Marc Berthier. Image courtesy of Roche Bobois, roche-bobois.com.

P. 96 Boborelax lounge chair by Cini Boeri. Image courtesy of arflex/Seven Salotti SpA, arflex.it.

P. 97 Sacco chair by Piero Gatti, Cesare Paolini and Franco Teodoro. Image courtesy of Zanotta, zanotta.it.

P. 98 Vola KV1 mixer tap by Arne Jacobsen. Image courtesy of Vola, vola.com.

P. 99 Carnaby vases by Per Lütken. Image courtesy of BoButik, bobutik. com.au, and The Modern Object, themodernobject.co. Photograph by Craig Wall.

P. 100 Model 75 Anglepoise light by Herbert Terry & Sons. Image courtesy of Anglepoise, anglepoise.com.

P. 101 Garden Egg chair by Peter Ghyczy. Image courtesy of Bukowskis, bukowskis.com.

P. 103 UP5_6 armchair and ottoman by Gaetano Pesce. Image Courtesy of B&B Italia, bebitalia.com.

P. 104 Valentine portable typewriter by Ettore Sottsass Jr and Perry King. Image courtesy of San Francisco Museum of Modern Art (SFMOMA), sfmoma.org.

P. 105 Componibili storage by Anna Castelli Ferrieri. Image courtesy of Kartell, kartell.com.

P. 106 Uten.silo wall storage by Dorothee Becker. Image courtesy of Vitra, vitra.com.

P. 107 Tube lounge chair by Joe Colombo. Image courtesy of Cappellini, cappellini.com.

P. 110 Clockwise from top left: Wire lamp, 1972, by Verner Panton, image courtesy of Verpan, verpan.com; Curve fabric from the Decor 1 collection, 1969, by Verner Panton for Mira-X, image courtesy of Nazmiyal Collection, nazmiyalantiquerugs.com, © Verner Panton Design AG; Panton Chair, 1958–67, by Verner Panton, produced by Vitra, image courtesy of Vitra, vitra.com; VP08 rug, 1965, by Verner Panton, produced by Designer Carpets, image courtesy of Designer Carpets, designercarpets.com; *Living Sculpture*, 1972, by Verner Panton, image courtesy of verner-panton.com, © Verner Panton Design AG.

P. 111 Verner Panton portrait, c. 1969. Image courtesy of verner-panton.com, © Verner Panton Design AG.

PP. 112–13 Flowerpot pendant light by Verner Panton. Image courtesy of &Tradition, andtradition.com.

PP. 114–15 Multichair by Joe Colombo. Image courtesy of B-Line, b-line.it. Photograph by Alberto Parise.

P. 116 Beolit (400/500/600) radios by Jacob Jensen. Image courtesy of Bang & Olufsen (B&O), bang-olufsen.com.

P. 117 Boby storage trolley by Joe Colombo. Image courtesy of B-Line, b-line.it. Photograph by Alberto Parise.

P. 118 Revolving Cabinet by Shiro Kuramata. Image courtesy of Cappellini, cappellini.com.

P. 119 Etcetera chair by Jan Ekselius. Image courtesy of Artilleriet, artilleriet.se.

P. 120 Le Bambole armchair by Mario Bellini. Image courtesy of B&B Italia, bebitalia.com.

P. 121 Cactus coat stand by Guido Drocco and Franco Mello. Image courtesy of Gufram, gufram.it.

P. 122 Omkstak chair by Rodney Kinsman. Image courtesy of OMK 1965, omk1965.com.

P. 123 Modus chair by Centro Progetti Tecno. Image courtesy of Tecno SpA, tecnospa.com.

P. 124 Ekstrem lounge chair by Terje Ekstrøm. Image courtesy of Varier Furniture, varierfurniture.com.

P. 125 Shiva vase by Ettore Sottsass Jr. Image courtesy of BD Barcelona Design, bdbarcelona.com.

P. 126 Togo seating by Michel Ducaroy. Image courtesy of Ligne Roset, ligne-roset.com.

P. 127 Homage to Mondrian cabinet by Shiro Kuramata. Image courtesy of Cappellini, cappellini.com.

P. 128 Sintesi lamp by Ernesto Gismondi. Image courtesy of Artemide, artemide.com. Photograph by Aldo Ballo.

P. 129 Spaghetti chair (101) by Giandomenico Belotti. Image courtesy of Alias, alias.design.

P. 132 Clockwise from top left: Cristallo cupboard, 2018, by Alessandro Mendini for BD Barcelona Design, image courtesy of BD Barcelona Design, bdbarcelona.com; Anna G corkscrew by Alessandro Mendini for Alessi, image courtesy of Alessi, alessi.com; Zabro table chair, 1984, by Alessandro Mendini, re-editioned by Zanotta 1989, image courtesy of Zanotta, zanotta. it; Calamobio cabinet, 1985, by Alessandro Mendini, re-editioned by Zanotta 1989, image courtesy of Zanotta, zanotta.it.

P. 133 Alessandro Mendini in his studio in Milan, 1997. Portrait by Gitty Darugar. Image courtesy of the photographer, gittydarugar.com.

P. 134 Fandango (SLR100) by Alessandro Mendini. Image courtesy of Swatch, swatch.com.

P. 135 Poltrona di Proust by Alessandro Mendini (production version). Image courtesy of Cappellini, cappellini.com.

P. 137 – Carlton room divider by Ettore Sottsass. Image courtesy of Memphis Srl, memphis-milano.com. Photograph by Angelantonio Pariano.

P. 138 Wink (111) armchair by Toshiyuki Kita. Image courtesy of Cassina, cassina.com.

P. 139 Tahiti table lamp by Ettore Sottsass. Image courtesy of Memphis Srl, memphis-milano.com. Photograph by Angelantonio Pariano.

P. 140 Sindbad (118) lounge chair by Vico Magistretti. Image courtesy of Cassina, cassina.com. Photograph by M. Carrieri.

P. 141 Flower vases: 'Victoria' and 'Tanganyika' by Marco Zanini. Image courtesy of Memphis Srl, memphis-milano.com. Photograph by Charlotte Hosmer.

P. 142 Royal Chaise by Nathalie Du Pasquier. Image courtesy of San Francisco Museum of Modern Art (SFMOMA), sfmoma.org. Photograph by Katherine Du Tiel.

P. 143 Callimaco floor lamp by Ettore Sottsass. Image courtesy of Artemide, artemide.com. Photograph by Aldo Ballo.

P. 144 Sofa With Arms by Shiro Kuramata. Image courtesy of Cappellini, cappellini.com.

P. 145 Sancarlo armchair by Achille Castiglioni. Image courtesy of Tacchini, tacchini.it. Photograph by Andrea Ferrari.

P. 146 Albero flowerpot stand by Achille Castiglioni. Image courtesy of Zanotta, zanotta.it.

P. 147 Zyklus armchair by Peter Maly. Image courtesy of Vintage Addict, vintage-addict.be.

P. 148 Kettle 9093 by Michael Graves. Image courtesy of Alessi, alessi.com.

P. 149 Thinking Man's Chair by Jasper Morrison. Image courtesy of Cappellini, cappellini.com.

P. 150 Feltri (357) Armchair by Gaetano Pesce. Image courtesy of Cassina, cassina.com.

P. 151 Felt Chair by Marc Newson. Image courtesy of Cappellini, cappellini.com.

P. 152 Bird Chaise by Tom Dixon. Image courtesy of Tom Dixon, tomdixon.net.

P. 153 Getsuen chair by Masanori Umeda. Image courtesy of Edra, edra.com, © Edra. Photograph by Emilio Tremolada.

P. 154 Tropical rug by Ottavio Missoni. Image courtesy of Missoni, missoni.com/it/missoni-home.

P. 155 Pylon chair by Tom Dixon. Image Courtesy of Tom Dixon, tomdixon.net.

P. 156 Double Soft Big Easy sofa by Ron Arad. Image courtesy of Moroso, moroso.it.

P. 157 Vermelha chair by Fernando and Humberto Campana. Image courtesy of Edra, edra.com, © Edra. Photograph by Emilio Tremolada.

P. 158 Orbital floor lamp by Ferruccio Laviani. Image Courtesy of Foscarini, foscarini.com.

P. 159 Bookworm shelf by Ron Arad. Image courtesy of Kartell, kartell.com.

P. 160 Vilbert chair by Verner Panton. Image courtesy of Bukowskis, bukowskis.com.

P. 161 Euclid thermos jug by Michael Graves. Image courtesy of the Taglietti family. Photograph by Craig Wall.

P. 162 Alessandra armchair by Javier Mariscal. Image courtesy of Moroso, moroso.it.

P. 163 Stitch folding chair by Adam Goodrum. Image Courtesy of Cappellini, cappellini.com.

P. 164 Dish Doctor by Marc Newson. Image courtesy of Magis, magisdesign.com.

P. 165 Mago broom by Stefano Giovannoni. Image courtesy of Magis, magisdesign.com.

P. 166 iMac G3 by Jonathan Ive. Image courtesy of A Design Studio, adesignstudio.com.au. Photograph by Craig Wall.

P. 167 Rainbow chair by Patrick Norguet. Image courtesy of Cappellini, cappellini.com.

P. 168 Chair_One by Konstantin Grcic. Image courtesy of Magis, magisdesign.com.

P. 169 Dombo mug by Richard Hutten. Image courtesy of Gispen, gispen.com.

P. 172 Clockwise from top right: Vlinder sofa, 2018–19, by Hella Jongerius for Vitra, image courtesy of Vitra, vitra.com; Bovist pouf (Pottery version), 2005, by Hella Jongerius for Vitra, image courtesy of Vitra, vitra.com; Worker Chair, 2006, by Hella Jongerius for Vitra, image courtesy of Vitra, vitra.com; Long Neck and Groove vases, 2000, by Hella Jongerius, self-produced, image courtesy of Jongeriuslab, jongeriuslab.com, © jongeriuslab. Photograph by Gerrit Schreurs; Dot Repeat Print fabric, 2002, by Hella Jongerius for Maharam, image courtesy of Maharam, maharam.com.

P. 173 Hella Jongerius in her Berlin studio, 2018. Portrait by Roel van Toer. Image courtesy of Jongeriuslab, jongeriuslab.com.

PP. 174–75 Polder sofa in green by Hella Jongerius. Image courtesy of Vitra, vitra.com.

PP. 176–77 Org table by Fabio Novembre. Image courtesy of Cappellini, cappellini.com.

P. 178 Victoria and Albert sofa by Ron Arad. Image courtesy of Moroso, moroso.it.

P. 179 Diana tables by Konstantin Grcic. Image courtesy of ClassiCon, classicon.com.

P. 180 Campari pendant light by Raffaele Celentano. Image courtesy of Ingo Maurer GmbH, ingo-maurer.com.

P. 181 Krattenkast Cabinet by Mark van der Gronden. Image courtesy of Lensvelt, lensvelt.nl.

P. 182 Corallo armchair by Fernando and Humberto Campana. Image courtesy of Edra, edra.com, © Edra. Photograph by Emilio Tremolada.

P. 183 Vegetal chair by Ronan and Erwan Bouroullec. Image courtesy of Vitra, vitra.com.

P. 184 Kast storage unit by Maarten Van Severen. Image courtesy of Vitra, vitra.com.

P. 185 Frame outdoor seating by Francesco Rota. Image courtesy of Paola Lenti, paolalenti.it. Photograph by Sergio Chimenti.

P. 186 Leaf Personal Light by YvesBéhar/fuseproject. Image courtesy of YvesBéhar/fuseproject, fuseproject.com.

P. 187 Smock armchair by Patricia Urquiola. Image courtesy of Moroso, moroso.it.

PP. 188–89 Showtime Multileg Cabinet by Jaime Hayon. Image courtesy of BD Barcelona Design, bdbarcelona.com. Photograph by Rafael Vargas, Estudiocolor.

P. 190 Twiggy floor lamp by Marc Sadler. Image courtesy of Foscarini, foscarini.com.

P. 191 Mr Bugatti collection by François Azambourg. Image courtesy of Cappellini, cappellini.com.

P. 192 Slow Chair by Ronan and Erwan Bouroullec. Image courtesy of Vitra, vitra.com. Photograph by Paul Tahon/Ronan and Erwan Bouroullec.

P. 193 Showtime Vases by Jaime Hayon. Image courtesy of BD Barcelona Design, bdbarcelona.com. Photograph by Rafael Vargas, Estudiocolor.

P. 195 Iris 1200 table by Barber Osgerby. Image courtesy of Established & Sons, establishedandsons.com. Photograph by Mark O'Flaherty.

P. 196 Motley ottoman by Donna Wilson. Image courtesy of SCP, scp.co.uk.

P. 197 PXL light by Fredrik Mattson. Image courtesy of Zero Lighting, zerolighting.com.

P. 198 Fields wall light by Vicente García Jiménez. Image courtesy of Foscarini, foscarini.com.

P. 199 Bouquet chair by Tokujin Yoshioka. Image courtesy of Moroso, moroso.it.

P. 202 Clockwise from top left: Chandlo dressing table, 2012, by Doshi Levien for BD Barcelona Design, image courtesy of BD Barcelona Design, bdbarcelona.com; Rabari rug (pattern No. 1), 2014, by Doshi Levien for Nanimarquina, image courtesy of Nanimarquina, nanimarquina.com; Principessa daybed, 2008, by Doshi Levien for Moroso, image courtesy of Moroso, moroso.it; Paper Planes lounge chair, 2010, by Doshi Levien for Moroso, image courtesy of Moroso, moroso.it.

P. 203 Doshi Levien portrait by Petr Krejčí. Image courtesy of the photographer, petrkrejci.com.

PP. 204–05 My Beautiful Backside sofa by Doshi Levien. Image courtesy of Moroso, moroso.it.

P. 206 Wrongwoods cabinet by Sebastian Wrong and Richard Woods. Image courtesy of Established & Sons, establishedandsons.com. Photograph by Peter Guenzel.

P. 207 Confluences sofa by Philippe Nigro. Image courtesy of Ligne Roset, ligne-roset.com.

PP. 208–09 Do-Lo-Rez sofa by Ron Arad. Image courtesy of Moroso, moroso.it.

P. 211 Valises wardrobe by Maarten De Ceulaer. Image courtesy of Horm Casamania, horm.it.

P. 212 Lolita lamps by Nika Zupanc. Image courtesy of Moooi, moooi.com.

P. 213 Sushi Collection by Edward van Vliet. Image courtesy of Moroso, moroso.it.

P. 214 Raw chair by Jens Fager. Image courtesy of Bukowskis, bukowskis.com.

P. 215 Tropicalia chair by Patricia Urquiola. Image courtesy of Moroso, moroso.it.

P. 216 Stack cabinet by Raw-Edges. Image courtesy of Established & Sons, establishedandsons.com. Photograph by Peter Guenzel.

P. 217 Big Table by Alain Gilles. Image courtesy of Bonaldo, bonaldo.it.

P. 218 Tip Ton chair by Barber Osgerby. Image courtesy of Vitra, vitra.com.

P. 219 Bold chair by Big-Game. Image courtesy of Moustache, moustache.fr.

P. 220 Nuance chair and ottoman by Luca Nichetto. Image courtesy of Nichetto Studio, nichettostudio.com. Photograph by Fausto Trevisan.

P. 221 Peacock chair by Dror Benshetrit. Image courtesy of Cappellini, cappellini.com.

P. 224 Clockwise from top right: Ottoman lounge chair and ottoman, 2016, by Scholten & Baijings for Moroso, image courtesy of Moroso, moroso.it; Butte containers (turtle, tuna, tree versions), 2010, by Scholten & Baijings for Established & Sons, image courtesy of Established & Sons, establishedandsons.com; Colour Carpet No. 5, 2011, by Scholten & Baijings for HAY, image courtesy of HAY, hay.dk; L'univers coloré de Scholten & Baijings porcelain vases, décor horizontal, by Scholten & Baijings, 2017, produced by Sèvres, image courtesy of Sèvres, sevresciteceramique.fr, © Gérard Jonca / Sèvres, National Factory and Museum; Strap chair, 2014, by Scholten & Baijings, manufactured by Moroso, 2018, image courtesy of Scholten & Baijings, scholtenbaijings.com.

P. 225 Scholten & Baijings portrait by Freudenthal/Verhagen. Image courtesy of the photographer, freudenthalverhagen.com.

PP. 226–27 Amsterdam Armoire by Scholten & Baijings. Image courtesy of Established & Sons, establishedandsons.com. Photograph by Peter Guenzel.

PP. 228–29 Brick chandelier by Pepe Heykoop. Image courtesy of the designer, pepeheykoop.nl.

P. 230 Amuleto task light by Alessandro Mendini. Image courtesy of RAMUN, ramun.com.

P. 231 Spin stool by Staffan Holm. Image courtesy of Swedese, swedese.com, © Swedese.

P. 232 Jumper armchair by Bertjan Pot. Image courtesy of Established & Sons, establishedandsons.com. Photograph by Peter Guenzel.

P. 233 Peg coat stand by Tom Dixon. Image courtesy of Tom Dixon, tomdixon.net.

P. 234 Guichet wall clock by Inga Sempé. Image courtesy of Moustache, moustache.fr.

P. 235 Circle floor lamp by Monica Förster. Image courtesy of De Padova historical archive, depadova.com.

P. 236 Toolbox by Arik Levy. Image courtesy of Vitra, vitra.com.

P. 237 Sparkling chair by Marcel Wanders. Image courtesy of DAAST Design, daast.com.au. Photograph by Craig Wall.

P. 238 Mask by Bertjan Pot. Image courtesy of Studio Bertjan Pot, bertjanpot.nl. Photograph by Marjolein Fase.

P. 239 Bau pendant light by Vibeke Fonnesberg Schmidt. Image courtesy of Normann Copenhagen, normann-copenhagen.com.

P. 240 Light Forest by Ontwerpduo. Image courtesy of Ontwerpduo/Aptum, ontwerpduo.nl, aptumlighting.com.

P. 241 Roofer (F12) pendant light by Benjamin Hubert. Image courtesy of Fabbian, fabbian.com.

P. 242 LoTek task light by Javier Mariscal. Image courtesy of Artemide, artemide.com.

P. 243 Eu/phoria chair by Paola Navone. Image courtesy of Eumenes, eumenes.it.

P. 244 Grillage outdoor chair by François Azambourg. Image courtesy of Ligne Roset, ligne-roset.com.

P. 245 Kora vase by Studiopepe. Image courtesy of Studiopepe, studiopepe.info. Photograph by Silvia Rivoltella.

PP. 246–47 Borghese sofa by Noé Duchaufour-Lawrance. Image courtesy of La Chance, lachance.paris.

P. 248 Anemone rug by François Dumas. Image courtesy of La Chance, lachance.paris.

P. 249 Paper Patchwork Cupboard by Studio Job. Image courtesy of Moooi, moooi.com.

P. 250 Meltdown floor lamp by Johan Lindstén. Image courtesy of Cappellini, cappellini.com.

P. 251 Windmill poufs by Constance Guisset. Image courtesy of La Cividina, lacividina.com.

P. 252 Kaleido trays by Clara von Zweigbergk. Image courtesy of HAY, hay.dk.

P. 253 Geo vacuum jug by Nicholai Wiig Hansen. Image courtesy of Normann Copenhagen, normann-copenhagen.com.

PP. 254–55 Common Comrades side tables by Neri&Hu. Image courtesy of Moooi, moooi.com.

P. 256 Poke stool by Kyuhyung Cho. Image courtesy of the designer, studio-word.com.

P. 257 Pick 'N' Mix table and bench by Daniel Emma. Image courtesy of Tait, madebytait.com.au.

PP. 258–59 Float sofa by Karim Rashid. Image courtesy of Sancal, sancal.com.

P. 260 Spin 1 rug by Constance Guisset. Image courtesy of Nodus, nodusrug.it. Photograph by Marco Moretto.

P. 261 Pion tables and stool by Ionna Vautrin. Image courtesy of Sancal, sancal.com.

P. 264 Clockwise from top left: Valextra Iside 'Toothpaste' handbag, Spring/Summer 2018, by Bethan Laura Wood for Valextra, image courtesy of Valextra, valextra.com; Mono Mania Mexico textile, 2018, by Bethan Laura Wood for Moroso, image courtesy of Moroso, moroso.it; Tongue tea set, 2019, by Bethan Laura Wood for Rosenthal, image courtesy of Rosenthal, rosenthal.de; Guadalupe vase, 2016, by Bethan Laura Wood for Bitossi, image courtesy of Bitossi, bitossiceramiche.com.

P. 265 Bethan Laura Wood at the Moroso showroom in Milan, 2018. Portrait by Craig Wall. Image courtesy of the photographer, craigwall.com.

PP. 266–67 Super Fake rug in Super Rock shape and Moon colourway by Bethan Laura Wood. Image courtesy of cc-tapis, cc-tapis.com.

P. 268 Tudor cabinet by Kiki van Eijk and Joost van Bleiswijk. Image courtesy of Moooi, moooi.com.

P. 269 And A And Be And Not screen by Camilla Richter. Image courtesy of Cappellini, cappellini.com, © Cappellini.

P. 270 Wood Bikini chair by Werner Aisslinger. Image courtesy of Moroso, moroso.it.

P. 271 Reddish vessels by Studio RENS. Image courtesy of the designer, madebyrens.com. Photograph by Lisa Klappe.

P. 272 Chair Lift furniture by Martino Gamper and Peter McDonald. Image courtesy of Moroso, moroso.it.

P. 273 Color Fall shelving by Garth Roberts. Image courtesy of the designer, garthglobal.com. Photograph by Greta Brandt.

P. 274 Seams vessels by Benjamin Hubert. Image courtesy of Bitossi, bitossiceramiche.it.

P. 275 Mollo armchair by Philippe Malouin. Image courtesy of Established & Sons, establishedandsons.com. Photograph by Peter Guenzel.

P. 276 Gear 4 vase by Floris Hovers. Image courtesy of Cor Unum, cor-unum.com.

P. 277 Roly Poly chair by Faye Toogood. Image courtesy of Driade, driade.com.

P. 278 Screen hanging room divider by GamFratesi. Image courtesy of Cappellini, cappellini.com.

P. 279 Wire S#1 chaise by Muller Van Severen. Image courtesy of Muller Van Severen, mullervanseveren.be.

P. 281 Gyro table by Brodie Neill. Image courtesy of the designer, brodieneill.com.

P. 282 Topographie Imaginaire rug by Matali Crasset. Image courtesy of Nodus, nodusrug.it. Photograph by Marco Moretto.

P. 283 Minima Moralia screen by Christophe de la Fontaine. Image courtesy of Dante Goods and Bads, dante.lu.

P. 284 Sam Son armchair by Konstantin Grcic. Image courtesy of Magis, magisdesign.com.

P. 285 Mark table and chair by Sebastian Herkner. Image courtesy of Linteloo, linteloo.com.

P. 287 Utrecht (637) armchair Collectors' Edition by Gerrit Rietveld with Boxblocks fabric by Bertjan Pot, released for C90 (Cassina's 90th anniversary). Image courtesy of Cassina, cassina.com, © Gerrit Thomas Rietveld/Pictoright. Copyright Agency, 2020. Photograph by Beppe Brancato.

P. 288 Tricolore vases by Sebastian Herkner. Image courtesy of &Tradition, andtradition.com.

P. 289 Blue Candleholders by Thomas Dariel. Image courtesy of Cappellini, cappellini.com.

P. 290 Filo table lamp by Andrea Anastasio. Image courtesy of Foscarini, foscarini.com.

P. 291 Fontana Amorosa Parachute pendant light by Michael Anastassiades. Image courtesy of Nilufar Gallery, nilufar.com. Photograph by Daniele Iodice.

P. 292 Caryllon Dining Table by Cristina Celestino. Image courtesy of Gebrüder Thonet Vienna GmbH (GTV), gebruederthonetvienna.com.

P. 293 Plissé electric kettle by Michele De Lucchi. Image courtesy of Alessi, alessi.com.

P. 294 Tape modular sofa system by Benjamin Hubert. Image courtesy of Moroso, moroso.it.

P. 295 Garden of Eden rug by India Mahdavi. Image courtesy of Golran, golran.com.

P. 296 Bliss rug by Mae Engelgeer. Image courtesy of cc-tapis, cc-tapis.com.

P. 297 Totem floor lamps by Studio Sabine Marcelis. Image courtesy of the designer, sabinemarcelis.com. Photograph by Pim Top.

P. 298 Dolls chair by Raw-Edges. Image courtesy of Louis Vuitton, louisvuitton.com.

P. 299 Butterfly console by Hannes Peer. Image courtesy of SEM/Spotti Edizioni Milano, sem-milano.com. Photograph by Delfino Sisto Legnani.

P. 300 Apollo dining chair by Lara Bohinc. Image courtesy of the designer, bohincstudio.com.

P. 301 District fabric by Kelly Wearstler. Image courtesy of Lee Jofa, kravet.com/lee-jofa.

P. 302 Talleo tallboy by Adam&Arthur. Image courtesy of the designer, adamandarthur.com, and Talarno Galleries, talarnogalleries.com. Photograph by Jennifer Chua.

P. 303 CHUBBY teapot by Laureline Galliot. Image courtesy of the designer, laurelinegalliot.com, © Laureline Galliot/ADAGP, Paris, 2020. Copyright Agency, 2020.

ACKNOWLEDGEMENTS

This book relies on the ingenuity and creativity of designers and architects past and present. Without them, our lives would be far less interesting and certainly less colourful. Thank you for making the world a richer place.

I would also like to thank the following people for their help in making this project come to life:

Kirsten Abbott for having faith in the project and allowing us the freedom to do it our way.

Sam Palfreyman for calm oversight in the face of a looming deadline.

Fiona Daniels for your incredible editing skills and wonderful way with words, which have made my love of designed objects readable.

Lily Lanahan for your endless patience and perseverance in sourcing elusive images.

Evi Oetomo for staying with it for the long haul and delivering such an impactful design, and Nicole Ho for your good-natured response to many shifts and incremental changes.

Fran Moore for your ability and experience in navigating the world of publishing.

Trevor Jost from Splitting Image for your excellent retouching work.

Craig Wall for your generous help with photography and being my Milan accomplice.

Alex Fitzpatrick, Jonathan Richards, Andrew Southwood-Jones, Alexander Kashin, Marie Hauerslev, Paul McInnes and the Taglietti family for supplying vintage items to photograph.

Amy Jean Porter from The Josef and Anni Albers Foundation for all your help and generosity.

Kate Nissen Moeller from Verner Panton Design AG for your patience and understanding.

Aleishall Girard Maxon from Girard Studio for keeping the memory of Alexander Girard alive.

Margherita Pellino from Fondazione studio museo Vico Magistretti for your kind assistance in finding images and verifying design dates and details.

Beatrice Felis from Atelier Mendini for putting up with my endless questions.

Amanda Fitz-James from Jongeriuslab for supplying everything we asked for and more.

Bukowskis auction house for your kind assistance with supplying images of hard-to-source items.

YouTube for late-night musical support.

All the PR and marketing people, vintage dealers and auction houses who have generously supplied images and information.

And Karen McCartney, for everything.

THE AUTHOR

PHOTO BY SAM McADAM-COOPER

David Harrison is a Sydney-based design journalist and interiors stylist. He is the founder of designdaily.com.au, a blog that covers all manner of subjects related to design both in Australia and internationally. He has been contributing to Australian interiors magazines *Belle*, *Vogue Living*, *Inside Out* and *Habitus* for twenty years and has recently undertaken interior design projects and the design of an outdoor furniture range under the Design daily brand.